BECOMING AUDIBLE

ANIMALIBUS
OF ANIMALS AND CULTURES

Nigel Rothfels, *General Editor*

ADVISORY BOARD:
Steve Baker (University of Central Lancashire)
Garry Marvin (Roehampton University)
Susan McHugh (University of New England)
Kari Weil (Wesleyan University)

Books in the Animalibus series share a fascination with the status and the role of animals in human life. Crossing the humanities and the social sciences to include work in history, anthropology, social and cultural geography, environmental studies, and literary and art criticism, these books ask what thinking about nonhuman animals can teach us about human cultures, about what it means to be human, and about how that meaning might shift across times and places.

BECOMING AUDIBLE

Sounding Animality in Performance

AUSTIN MCQUINN

THE PENNSYLVANIA STATE UNIVERSITY PRESS

UNIVERSITY PARK, PENNSYLVANIA

A version of chapter 4 previously appeared as "The
Scandal of the Singing Dog," in *Antennae: The Journal
of Nature in Visual Culture*, no. 27 (Winter 2013).
Lyrics from "The Minotaur" by David Harsent
Copyright © 2008 David Harsent. Reproduced by
permission of Boosey & Hawkes Music Publishers
Ltd.

"Songs of Praise" by Derek Mahon appears by kind
permission of the author and The Gallery Press,
Loughcrew, Oldcastle, County Meath, Ireland, from
New Collected Poems (2011).

Library of Congress Cataloging-in-Publication Data

Names: McQuinn, Austin, 1967– author.
Title: Becoming audible : sounding animality in
 performance / Austin McQuinn.
Other titles: Animalibus.
Description: University Park, Pennsylvania : The
 Pennsylvania State University Press, [2020] |
 Series: Animalibus: of animals and cultures |
 Includes bibliographical references and index.
Summary: "Explores the phenomenon of human
 and animal acoustic entanglements in art and
 performance"—Provided by publisher.
Identifiers: LCCN 2020039414 | ISBN 9780271087962
 (hardback) | ISBN 9780271087979 (paper)
Subjects: LCSH: Human-animal relationships in the
 performing arts. | Human-animal relationships
 in art. | Animal sounds. | Performance art.
Classification: LCC PN1590.A54 M35 2020 | DDC
 791—dc23
LC record available at https://lccn.loc.gov
 /2020039414

To my father,
Terence McQuinn

CONTENTS

Preface (ix)

Introduction (1)

1 Becoming Audible: Listening in Between Species (10)

2 Becoming Acoustic: Concealing and Revealing Voices
 in Hunting and Performance Interactions (36)

3 Becoming Botched: Play, Tactical Empathy, and
 Neo-Shamanic Acoustic Legacies in Performance (61)

4 Becoming Canine: The Scandal of the
 Singing Animal Body (87)

5 Becoming Lingual: Primate Trouble in the
 Academy of Speech (110)

6 Becoming Resonant: Sounding the Creatural
 Through Performance (133)

Coda (154)

Acknowledgments (155)
Notes (157)
Bibliography (167)
Index (187)

I am woken by a fly. Or the sound of a fly. It is trapped in the room and is trying to get out by buzzing against the glass of the window. Outside the birds have been singing since dawn, each one claiming its territory with songs both simple and elaborate. This will go on all day long.

In the field opposite the house where I live, on a very rural mountain slope in Tipperary, Ireland, a bull is complaining loudly. Bawling and howling, he wants company other than the other male cattle he is forced to herd with. This too will go on all day.

When I get up to the studio there are more flies, more birds, and a neighbor's horse whinnies from time to time. In the field beside the studio, some sheep have broken into fresh grass. They are letting the other sheep know where the gap is. Then the bull starts up again. Some of the cattle join in. A dog barks back. A pheasant croaks on the lane. I am silent and listening, working, writing this.

Inside the studio, the walls and tables and shelves are teeming with both human and animal images and references. Bats, dogs, cats, bees, flies, apes, and many human figurines with ape heads appear in paintings, drawings, small sculptures, and video projections. A stuffed squirrel wears a pair of wings made from wire. There is a cow's skull and a rib fashioned into a kind of violin. There are also other skulls that were found on the mountain, one with a bullet hole in it. Stored on the shelves are masks of birds, monkeys, and apes; a faux-fur blanket; a real fur blanket made from disowned coats; a sad plastic parakeet; a hard plastic bull; a raffia donkey head; and a collection of small plastic nocturnal animals from Tasmania. A ceramic tiger stands outside the door, teeth bared, a sort of guardian.

My rural childhood was defined by a closeness to the living world of nonhuman beings. My father taught me, in his country schoolhouse, how animals were central to his own farming childhood. In my school friends' farmyards I witnessed many births, many deaths. When I moved to the

city, I noticed every living creature there as well, especially the vocal ones such as seagulls. In early art-school days I made paintings of fantastical creatures, surrealist hybrid humanimals who expressed something of the complexity of becoming a human adult. They suffered, they flew, they cowered, they rejoiced in their strangeness. More recent projects questioned human and animal cultures and how they might relate to each other. So animals have always occupied my life and work as themselves and also as symbols or metaphors—of otherness, of fear, of outsiderness, of intimacies, of creatureliness, of ambiguity.

Steve Baker's book *The Postmodern Animal* (2000) introduced me to what has been called "the animal turn" in art and philosophy, a concept that questions any received wisdom about animals' position in culture and how we relate to them, domesticate them, exploit them, and fetishize them. Through further reading into animal studies and performance studies, philosophy, and art theory, I found a framework to expand and develop what was happening in the studio. I began to listen differently to what I was hearing in the fields and the forest, in opera, in dance music and world music, and in live art performance and theater. Now living in the countryside again, acoustic creatures, both wild and domestic, surround me. The farm animals here spend most of the year outside. It is impossible not to be aware of their existence, particularly cattle, sheep, and horses. With this constant singing, bawling, and buzzing, these animals persist in reminding me that we are all creaturely—animal, artist, insect.

INTRODUCTION

Becoming audible means finding ways of crossing species boundaries through sound. Being creaturely means being alive and part of a living world—animal, human, insect. Being an acoustic creature—by becoming audible—is a means of signaling, through sound, all manner of sexual, territorial, or cultural messages. In these pages, a cellist duets with a nightingale, finches play guitars, women sound like birds, shamans bark to become seals, dogs learn to sing, apes give lectures, and baritones bawl as bulls. These creatures appear in different performance modes—live, recorded, artificial, hidden, broadcast—but always through a human agent/artist. That human figure sometimes functions as a type of sorcerer or shaman in order to enter the in-between spaces among species. Shamans and sorcerers were traditionally the contact agent with the extra-human world. The artists in this book continue to find ways to preserve that connection and use creaturely acoustics as their method of accessing an other-than-human consciousness. They involve themselves in actions that generate human-animal-technological personae, sounding their concerns in sets of relations to themselves and others—relations that are often messy or murky, but always vital. Out of these murky, messy actions and liberated ways of thinking, resonances occur. Music, singing, and amplified sounds—human and nonhuman—move fluidly through the air and enter

the open, vulnerable, listening body. To resonate with sound, one can both create and receive sonic vibrations and reverberations. To resonate is to be in sympathy with another body. Resonance is sympathetic, and to resound is to receive, to become resonant.

When human and animal sounds resonate together, in performance, what occurs? When the animal voice and body are used as tools to describe difference and otherness, both magical and dreadful, how do these actions relate to ongoing scholarship in nonhuman animal acoustics in the arenas of bioscience, technoscience, and cultural anthropology? Are creative actions involving animal vocalizations obligated to refer to contemporary scientific discoveries in the realms of, say, insect communication intelligence, primate social grammar, or aquatic sonar worlds? Or is the historical archive of animal tropes continually being used to retell and reperform mirrors and illuminations of human experience? Is it, in fact, impossible not to anthropomorphize animals in creative culture? These broad questions are anchored by a proposition: that sound worlds are shared worlds and always have been—between epochs, between bodies, between species. The artists that populate this book desire to get into the spaces between species. They flex vocal muscles to overcome anthropocentrism and to find new routes into a broader, creaturely, sonic world.

Becoming Audible claims that human listening and sounding, hearing and speaking, silence and song, are part of a cross-species, zoo-acoustic experience of the world. As David B. Dillard-Wright reminds us, all communication and acoustic life is gestural, ambivalent, mobile, extra-human, social, and vital. These elements are also central to the phenomenon of acoustics and communication in performance practices and performance theory. Dillard-Wright's phenomenological method of placing human experience inside a broader, creatural world is his way of "thinking across species boundaries."[1] This book is an accumulation of both thinking and writing across boundaries of disciplines brought together in a selection of material from arts and performance practices, alongside ideas and influences from animal studies, zoomusicology, zooarchaeology, cultural anthropology, and philosophy. Listening, responding, reacting, and resonating across boundaries are the transterritorial, transdisciplinary actions that dictate the main threads of the discussion here. My own live art performance practice, my interest in opera and its contradictions, and recent debates in animal studies, cultural anthropology, and philosophy have provided the framework on which to build the core argument—that

humans and animals are engaged in acoustic resonances that reverberate across species boundaries and throughout performance practices. A key component of live performance is vulnerability. To be vulnerable is to be creatural, and an awareness of vulnerability opens thinking into a shared creaturely territory, both interior and exterior.

My concepts of creaturely acoustics and interspecies resonances in performance are deepened by my engagement with the philosophies of Gilles Deleuze and Felix Guattari. In the jointly penned *A Thousand Plateaus*, first published in 1980, the writers encourage a severance with traditional ways of perceiving animals, in psychoanalysis, as metaphors for human problems. In their chapter "1730: Becoming-Intense, Becoming-Animal, Becoming-Imperceptible," they advocate a process of overcoming our limited human selves by entering into a multiplicity of proximities to animal life, beginning with the swarms of molecular entities that freely cross boundaries between our bodies and the interiors and exteriors of other living species.[2] Theirs is a kind of counter-individual consciousness of the collective, the multiple, or the swarm. Becoming-animal is an openness to fluid sensations of being in the world. It is a rhizome, a structure of nonlinear thinking, which operates laterally and without hierarchical discrimination, moving in omnidirectional modes. Deleuze and Guattari write, "We are not in the world, we become with the world; we become by contemplating it. . . . We become universes. Becoming animal, plant, molecular, becoming zero."[3] In short, to be consciously alive is to become.

The animals that fascinate Deleuze and Guattari are wild and move in packs or herds. The mobile freedom of entering and leaving territories and natures brings energy to the theory of becoming. Deterritorialization and reterritorialization in animal behavior correspond with liberation in the words, signs, sounds, and ideas in art. Like the birds, horses, wolves, and insects that populate their theory, Deleuze and Guattari strongly advocate that artists also enter into a becoming-intense, becoming-animal, becoming-imperceptible state as a method to break away from the normative and the static. Their featured artists, composers, and writers are active in a fierce relationship of rhizomatic movements with the living world.[4] With their example of Franz Kafka, metamorphosis replaces metaphor. Animals no longer merely represent or symbolize a human quality or trait. Spontaneity, liveness, and openness to contest change are the creative methods of getting access to a larger, non-anthropocentric energy. Artists seek to become-animal in order to stake out an interior territory of ideas—not a

fixed world. Becoming is moving and changing. In this way art can access a porous environment where received definitions of identity and hierarchy are collapsing and *all* beings are in a state of multispecies awareness and change.

Becoming is a metaphysical, psychological experience, a process of passaging through territories and zones of proximity, where entities, molecules, and ideas affect one another without exhausting their core identities. It is an interior place of uncertainties and unknown relations, of indeterminate territories at the edge of the human and the nonhuman consciousness, where creative processes generate metamorphosis. Becoming-animal blurs distinctions between human and animal for Deleuze and Guattari. It is a state where "each deterritorializes the other, in a conjunction of flux, in a continuum of reversible intensities."[5] In the chapters that follow, I use their theory of becoming to explore labyrinthine sound structures in art and performance practices. I write about works that are concerned with the coming together of bodies, sounds, reverberations, frequencies, and ideas and that generate intensities of becoming for both the performer and the spectator. These works reveal the nonlinear, or rhizomatic, approach taken by artists and performers to expose their own enriched awareness of what they are doing in performance. They enter zones of proximity as a means of realizing performances that truly matter, have tangible materiality, and are fully alive. For me, becoming audible in art and in performance reaches toward a vital, spontaneous connection to the living mind and body of both human and animal in ways that are always challenging.

The subject of animal participation in human entertainment—which extends to circuses, aquatic world entertainment, and, perhaps especially, zoos—is complex and troubled by many important and valid questions of welfare, speciesism, and ethics. These questions have also been applied to the use or perceived misuse of animals in art and performance practices, where many see no place whatsoever for animals. Many informed scholars and theorists deplore how some artists claim exemption from the ethical questions that surround humans' use and abuse of animals. Some question whether it is ethical or moral even to depict an animal in an artwork or a performance in any form. There is a view, therefore, that artists are not to be trusted in their use of living, dead, or even already stuffed animal bodies—that animals' bodies should not be objectified for human cultural consumption.

However, art is messy, complicated, and risky. Art is not about accommodating opinions. The artists under my scrutiny here take animal lives

seriously and do not back away from serious questions about our relationships with other creatures, past, present, and future. Artists have always had to zigzag around fixed rules and regulations to get to the meaning, or the potential collapse of meaning, in order to question social norms. Even those artists who advocate social change on issues of animal welfare and animal rights use confrontational images and materials in order to get to the core of the very problems they seek to change. For example, Angela Singer's reworking of trophy taxidermy to make sculptures and "memorials" of each of the animals' deaths has been criticized for fetishizing the very thing she claims to abhor. But for her, it is a confrontation, in her studio, with the material animal body and how its death, often brutal, can somehow be commemorated in order to effect change.[6] Equally, the use of live animals in installations and performances has faced criticism and serious questioning.

Very few of the artworks I discuss use live animals, and when they do, I examine all aspects of their use—but not judgmentally. Regarding the practices of hunting that are investigated in the opening chapters, my focus is on how the artists and, specifically, the artworks they produce explore the connections they claim to be making with living and dying nonhuman animal histories. Their works are linked, I argue, by how they propose to position the human in a much larger creatural world. Throughout this book, I follow cultural anthropologist Garry Marvin's approach, in which he states—in his essay on fox-hunting as performance—that "those interested in human-animal relationships should consider these practices (ie. *hunting and zoos*), because they involve complex sets of images and representations of animals and the natural world and complex structures of engagements with those animals and that world."[7] As entertainment spectacles in zoos, or in the field and forest of the hunter, the animals being hunted or looked at are already in a very complex "web of significance."[8] Animals will always be drawn into human culture where art defines what it might mean to be human.

In chapter 1, the cultural history of listening to birdsong and ornithological studies of bird vocal behavior run parallel to the history of musical technologies, instrumentation, and recording. The artists that use the techno-acoustic innovations of their time push and extend the limits of these technologies. Beatrice Harrison adopts radio; Olivier Messiaen accumulates cassette tapes; and Jonathan Harvey reworks synthesizers as methods of listening to animal sounds and adapting them. Composers Bartok and Rautavaara are among the artists using birdsong in a desire for timelessness.

In a more contemporary context, Céleste Boursier-Mougenot places sound and birdsong at the center of his installations, creating a sonic territory and a new immersive way of listening in between species. Marcus Coates's epic *Dawn Chorus* explores the ventriloquisms inherent in birdsong, and his interpretation becomes entangled with human singing in fascinating and poignant ways. In the gaps and chasms of being and becoming audible, the keen disposition and intense auditory rigor of these artists produces avant-garde performances of acoustic daring.

The acousmatics of animal acoustics—the sound we can hear without seeing or even knowing its origin—are the subject of chapter 2. Here birdsong is used in historical and contemporary performance in ways that are connected to both hunting and art practices. I analyze how both practices have co-evolved and coexist alongside each other and how they remain conjoined within the staging of the artist-becoming-animal. In the example of Daniela Cattivelli's recent sound actions and compositions, her investigations of birdsong and its impersonation by Italian bird hunters, called chioccolatori, provide a point of departure into some unsettling and often beautiful sound actions. These in turn redefine terms like capture, territorialization, and release as they relate to bird communication. In Cattivelli's techno-vocal soundscapes, some of the dangerous inheritance of hunting lingers where she cajoles her audience into complicated thinking about how we use animal vocals (and then bodies) for both entertainment and entrapment. She enters what Jennifer Parker-Starbuck calls a "becoming-animate" which initiates "catalysts for reformations of humanity's relationship with the non-human."[9]

Chapter 3 explores the deeper elements of human-animal encounters in the work of Marcus Coates. Here, connections emerge with the tactical, empathic techniques of the hunter/performer alongside those of the shaman in Northern circumpolar communities and the aesthetic and performative legacies of these practices. Coates has riveted audiences with his live art and recorded artworks that engage with concepts of shamanism, schizophrenia, and becoming-animal in a Deleuze-Guattarian exploration of personhood. This chapter explores the multiplicities of selfhood, personhood, mimesis, and magical alterity that I see provoked in the work of Coates and other artists who are deeply invested in performance actions and who engage with the material values of creatural acoustics.

Animal becomings are tested in chapter 4 in the theatrical contexts of stage and laboratory and in the mergers between science and art in

Alexnder Raskatov's 2010 opera *A Dog's Heart*. The opera multiplies the themes of the stray dog and the sacrificial lab animal, eugenics, Bolshevism, and biopolitics in an extravagance of musical anarchy. The dog character in this opera breaks with the history of the onstage canine, which traditionally has promised stereotypically silent obedience. This profane, scandalous creature is a vocal revelation as he goes through surgical procedures that transform him from dog to man and back to dog, violating every speech-act promise along the way. The problematized ethics of both the laboratory and the onstage animal are exposed in plain-speaking ways in both Mikhail Bulgakov's novella of the same name (1924), which inspired the opera, and in the staging of the work by ENO in London's Coliseum. The voice of the animal is most scandalizing in how he expresses his indifference to what is happening to him. Raskatov's opera ultimately declares with great irreverence that there is no hierarchy in speech, that the phenomenon of the voice emanating from the body can override or even dissolve the meaning of the words that are being sung, and that this crying out is both angelic and animalistic at the same time. In the acoustic exclamation of the operatic dog, the vocalized carnal interior becomes exterior and exposes its vulnerability in what Walter Benjamin calls the "creaturely voice," which emerges "from the mysterious interior of the organic" and, he maintains, is the foundation structure of opera.[10]

Hierarchies of vocalization in human-simian cultural co-evolution define both Eugene O'Neill's *The Hairy Ape* and Franz Kafka's *A Report to an Academy*, the focus of chapter 5. Both narratives were created in the post-Darwinian period of the early twentieth century. These "primate dramas"[11] produce triadic tropes of humans, apes, and cages in which many shared biological similarities between species—the muscles of communication, the larynx, the lungs, and the tongue—become organs of special meaning for questioning human consciousness and culture. For example, through Colin Teevan's 2009 theatrical adaptation of Franz Kafka's 1917 short story, I consider Kafka's own unflinching investigation of animal muteness as confinement and human and animal vocalization as freedom. The play, *Kafka's Monkey*, and Kathryn Hunter's solo performance of this work, exposed, on the surface, a familiar human fascination with this specific animal. Red Peter is a captured great ape who learns to speak in order to escape the caged torture in which he finds himself. Breaking into the world of human speech and reason, he finds another version of imprisonment. The ape's refusal to accept the accolade of achievement the

academy wishes to bestow on him lies at the painful center of Red Peter's situation. Red Peter's ultimate tragedy is that, now that he has learned how to become human, he can never return to being fully animal.

Chapter 6 explores Harrison Birtwhistle's opera *The Minotaur* (2009), in which the labyrinth home of the caged man-beast becomes the chamber for re-sounding the monstrous tragedy of the hybrid creature. Inside this structure, the rules of language do not apply, and so the trio of monsters in the opera—female buzzard, male priestess, and bull-man—find their voices and devour the air of the opera house. The labyrinth becomes a macrocosm of the human/animal interior of both the heart and the ear. In bass singer John Tomlinson's portrayal of the Minotaur, the edifice of language comes crashing down to an almost zero point of meaning. The resounding bawl of the bull is supported by the screaming of the priestess and bird-women and the babbling of the chorus. I follow acoustic routes—corporeal, instrumental, architectural—that tunnel into this exploration of both resonance and becoming, going deep inside the human-animal acoustic exchanges that shape this concluding chapter. As Tomlinson's bull-man monster lies dying, he groans the last line of the opera: "Between man and beast, next—to—nothing."[12] His dying statement is that there is *almost* nothing separating the species. In a concluding network of resonant becomings that come together in this performance—such as the willing spectatorial body, the architectural body of the opera house, the bodies of musical instruments, and the vocalic bodies of the singers—the human-animal acoustic entanglements re-sound their materiality of lungs, muscles, and larynx in an ecology of singing and listening and becoming resonant.

Derek Mahon's poem *Songs of Praise*, which I place as a coda at the end of this book, opens with a sound-image of hymns being sung in a small church by the sea. An outside broadcast unit is recording the service for radio. The sound of the singing rises, floats outside, and reaches the rocky shore where the "conflicting rhythms of the incurious sea" absorb the thinning "tunes" into the ocean's own soundscape of crashing waves, swelling into the immensity of deep sea. Below the surface, in the silent depth of the ocean, another broadcast is being transmitted: "the trombone dispatches of the beleaguered whale."[13] Mahon's twelve lines, crafted with great understanding, manage to capture this cosmic moment. We have the sense of him there on the shore, experiencing this collision of worlds—human, technological, animal—as a sonic event, a "soundscape" that resonates deeply for him. Mahon's mastery brings the sounds of the hymns, the sea,

and the whale together in a form of zoomusicological fusion. He leaves us with the trombone-like message from the whale as a kind of prophecy. He speaks of how the sea is not curious about our tiny ritual voices and how it seems equally indifferent to the troubled world of the whale. His alertness to the sonic human-nonhuman-animal continuum reveals a moment of becoming resonant. The phenomenon of sound vibrates through material bodies, rocks, seas, and whales. Like Mahon's poem, in what follows I envisage this physical and phenomenological push, in and out of states of being aware, being there, and becoming sonically connected with everything that is alive.

BECOMING AUDIBLE
Listening in Between Species

Birds are psychopomps.
—MIRCEA ELIADE

In the stage directions for the last scene of Terry Johnson's play *Cries from the Mammal House* (1993), "all the characters gather around a crate that David opens: from the crate there issues an absurd cry which echoes around the mammal house" (116). Earlier, the character of David told the other members of his family, who have inherited a small zoo, of the arrival of the crate and its contents: "It was a Dodo. It looked at me, I swear to God, and it opened its beak and it made the daftest sound I've ever heard" (116). In the denouement of *Cries*, the Dodo is both the last straw and last hope for this dysfunctional family that is falling apart and about to become, in a way, extinct. The cry from inside the crate is metaphorical, imaginary, and like no animal sound that exists—it is an absurdity—but its echo around the other animal houses is the inspired turning point of the story, not only for the family but also for the animals and the zoo in general. For Una Chaudhuri, the play's ending reveals its "dodo *ex machina*" in her (and the play's) argument for the "reintegration of the animal into modern consciousness" before it is too late.[1] The zoo is bankrupt and rapidly losing its animals. David is dispatched to Mauritius in search of some new specimens. He returns with an animal agent who is going to save this family's dying world. By placing the Dodo (which we never see) inside the crate, Johnson places our strange and complex

relationship with animals at the center of his dramaturgical mirror box. The animal that was hunted to extinction is the one that could save us—or, at least for a while, save our moral conscience. David has found not only a new/old species but, more than that, a sound that we understood to be lost forever. We can wonder at the supposed stuffed Dodo in the Natural History Museum in South Kensington. It is in fact an assemblage, a taxidermy of swan, goose and plaster based on an early painting, and so it remains a tragic, mythologized, dried object of something once seen and heard. The idea that it could be alive and squawking in a crate onstage in the center of London is a thrilling example of what can be imagined and produced in a performance context.

The sound of the bird coming from a box can be seen as a disembodied vocal signal woven into cultural manifestations of human anxieties. Johnson's Dodo is a vivid example of the various kinds of ventriloquisms featured in this chapter. Birds are uniquely ventriloquistic in this way; as familiar, everyday vocalizing presences, birds enchant and charm us with their eternal twittering, to which we can attach any number of meanings and interpretations. Modern sound technologies have been expertly engaged in reproducing imagined bodies through resonances and multiplications of various disembodied voices in countless performance contexts. This chapter tracks the technological development of recording and transmitting birdsong through the last century, in which many have produced and performed various ventriloquisms—dislocated, omnidirectional sounds coming from a box (or computer, CD player, radio, amplifier, or stage). Steven Connor suggests that this "ventriloquial" body "is not located so much as distributed in space."[2] The vocal distribution of the bird body through technology raises the stakes from visual dependency to aural liberation. The world, for Connor, is "apprehended primarily through hearing, or in which hearing predominates," and is "much more dynamic, intermittent, complex, and indeterminate" than the visual world.[3] The indeterminacy is the crucial factor in our eternal attraction to birds and their soundings and our curiosity about where their sound begins and ends, or where precisely it is coming from. Acoustic detachments from the corporeal are loaded with archaic resonances, as warnings, exhortations, instructions, celebrations, awakenings, and premonitions. They evoke a world of nontemporal powers and presences, a world in between materiality and ephemerality. A voice without a visible source can be the voice of powers above and beyond the visible. Hiding the sources of sounds onstage,

like Johnson's Dodo, is a standard conceit used to heighten the sense of enchantment with the disembodied.

Animal sounds have long been entangled within the major acoustics of the stage: in musical instrumentation, in recordings of birdsong, and in the voice of the singer. In what follows, we will see how animal sounds impact us as potential voices, and, if we use them for that purpose, how they acquire the potential to contain meaning. What may be more significant is that we, as humans, are listening to the sounds of other species that are not intended for our understanding and that we have found multiple methods of incorporating their voices into our acoustic imagination. In a development from R. Murray Shafer's coining of the word "soundscape" in the 1960s, the term "zoomusicology" describes an opening study of animal sounds through musicological methods. In Dario Martinelli's important essay, "A Whale of a Sonata," he describes both whale sounds and birdsong as examples of animal communication that can and should be included in the study of music, just as human singing and aesthetic sounds can be brought into the zoomusicological realm.[4] By thinking zoomusicologically, a blurring of the dichotomies of nature and culture diffuses species boundaries. For example, both whales and birds can have two or more variations of their songs—a repertoire, one could say. Martinelli, Martin Ulrich, and other musicologists interested in sharing ideas about human animal sonic dispatches promote an openness, listening and learning and thinking across species when considering our shared acoustic world.

The history of listening to animals and then performing animal voices runs parallel to the history of musical technologies. Through listening and learning, we have produced music using voice, material objects, and instruments, moving sound from muscles in the body to extending the voice and breath outward through simple instruments. Beginning with the 40,000-year-old flutes made from vulture bone that produced a frequency range similar to a contemporary piccolo, we have developed instruments of increasing complexity, incorporating fingering, stringing, bowing, plucking, and now synthesized, digitized musical sound technologies that continue to demand an acuteness of listening. In *Listening and Voice* (2007), Don Ihde calls this trajectory "a phenomenology of instrumentation," where through millennia the body holds its moment in time through repeatedly listening to and playing music. The history of instrumental innovation is also the history of technology and the history of listening and responding to our sonic environment. None of these histories are fixed; all are changing

and continue to change. As Ihde states, "all technologies are non-neutrally transformational, including musical ones."[5] Just as the nature and styles of performance continue to change and develop, the recording of this activity runs alongside and keeps up with the changes. The nature of recording is not neutral; the hundreds of hours in editing suites spent listening, tuning, enriching, accentuating, and achieving intimacy is a subjective, creative practice. The sound engineers and artists working at this intensity of listening are attuned to sound and "noise" at a highly sensitive level, breaking sound down into images, parts, files and bits, and then reassembling and reconstructing them into new creative sound worlds. Within the continuum of performance, recording technologies become fluid agents of the acoustic world, always ready to be manipulated, reinvented, recycled, and transformed. When we explore the possibilities of combining animal communication and technology as a product of the phenomenon of listening, Idhe suggests, "we are leaving the sense of metaphor and entering the neighborhood of voice at its center."[6] The artists featured in what follows are specifically listening to birdsong. Through their interpretation and manipulation of avian acoustics and contemporary technologies, they create neighborhoods of voice by placing birdsong at the center of these newly claimed territories.

Nightingales, Cellos, and Bombers

On the night of May 19, 1942, a BBC Radio live broadcast crew was camped in a garden in Surrey, England, to record and transmit the sound of a nightingale singing. However, the broadcast was complicated by a low, rising hum coming from the sky. It slowly became clear that the noise was coming from a fleet of aircraft bombers en route to Germany.[7] The sound engineers stopped the live broadcast because of security risks, but the recording survives. Listening now to the eight-minute recording, in which the slow movement from the sounds of nature and nostalgia is overtaken by the ominous acoustics of impending war and loss, is listening to a culture in transition. This pivotal moment of auditory experience signaled the end of one era and the birth of a new postwar world. The nightingale in the transmissions from bucolic Surrey, then an annual radio tradition, was being drowned out by the hum that was to define the Second World War period in Britain, the bomber plane heralding a changing cultural and sonic world.

By cutting short the transmission, not even the BBC could be relied upon to uphold tradition for its listening audience. Instead, the audience heard this relatively new medium submit to inevitable change. Radio was still in its infancy, and while it was breaking down many social barriers, it was still in the process of defining whom or what it was for. Alice Goldfarb Marquis calls these first years of radio "the Era of Wonderment." It was a time when listening to the myriad live sounds "emerging from a box" was still a strange and thrilling novelty in which "sound—any sound—emerging from a box seemed like a miracle."[8] In spite of the stringent principles of a board of directors led by John C. W. Reith, who firmly maintained that what the nation was listening to should be aligned with contemporary concepts of righteousness, propriety, and good taste, the commercialization of programming would influence a broadening cultural range of transmissions. The demand for filling airtime dictated an ever-widening spectrum of material. Marquis comments that "no medium of enlightenment, information or entertainment had ever gobbled up material so speedily."[9] The audience was becoming accustomed to hearing and now experiencing their world newly performed on radio, with an air of authority that claimed reliability and some decidedly patriotic truthfulness. In the approach to the war, the radio quickly became a force for the unification of a country like Great Britain, defending as much of the old order as it could. The annual nightingale broadcast became an object of nostalgia for an acoustic present and soon-to-be past. Now, through technology, it is possible to "listen back" and identify this recording as a repository of the threshold of cultural change, where the acoustics of one individual animal can perform and reperform pivotal cultural actions by becoming an agent of memory. The individual animal voice here sings of its own world, its own avian drama, most likely oblivious to the human drama unfolding around it. It is almost certainly indifferent to the significance of its position in the recorded aural/aerial history of human sociocultural events. The nightingale is almost certainly listening for another nightingale. The audience is involved in an entirely other kind of listening—for nostalgia, for sentiment, for a position in time, in land and air, and in newly shared acoustic space.

There are demands on the birdsong at work in this recording, which I will unpack shortly, but it is important to expand a little further on the notion of listening back. As I listen now to the recording of the nightingale in the garden and the hum of the bomber planes, in the full knowledge of what was to follow after that night in 1942—the fateful war, the invasions,

and the millions of lives lost—I note that the audience of the time had little recourse to control their acoustic world. Indeed, the new medium of radio was very much a real-time experience in which immediacy and synchronicity of sound transmission across all social barriers was somewhat revolutionary. Marquis elaborates on how radio programmers were stretched to capacity to fill volumes of airtime with ambient atmospherics that might plug the gaps between important news bulletins, an activity that could not possibly be imagined in our media-saturated environment. As an example, she describes the following event:

> For the funeral of George V in January 1936, the coverage was by pure sound, uninterrupted by commentators. Listeners heard the rhythmic steps of the navy ratings pulling the gun carriage on which the king's coffin rested, the solemn commands of officers and the muffled gun salutes as the king was laid to rest. On the evening before the king died, the BBC maintained total silence, except for the sound of a clock ticking and every quarter of an hour the dignified words of chief announcer Stuart Hibberd: "The king's life is moving peacefully toward its close."[10]

What was, precisely, at stake in the recording of the nightingale in 1942? First, there is the circumstance and history of the live broadcast itself. The radio crew was not randomly encamped in this county garden. It had been home of Beatrice Harrison (1892–1965), a British musician who was the leading cellist of her time. She gave debut performances of many important compositions, such as Delius's *Cello Sonata* at the Wigmore Hall in 1918. In 1920, Beatrice and her sister May Harrison delivered the first performance of Delius's *Double Concerto*, which was dedicated to the memory of all artists who had been killed in the First World War. Harrison also debuted Edward Elgar's *Cello Concerto* and was the soloist chosen to make the first HMV gramophone recording of the same work in 1926, with Elgar himself conducting. Alongside this repertoire, for which she became well known to a listening radio audience of the period, Harrison developed a routine of practicing outdoors in her country garden in Oxted, Surrey. Nightingales were, and still are, regular migrating visitors to the region, and during Harrison's rehearsals, the birds sang as she played.[11] On May 19, 1924, BBC Radio transmitted one of the first live outdoor broadcasts from the garden, featuring Harrison performing the folk song *The Londonderry*

Air and *Chant Hindu* by Nikolai Rimsky-Korsakov. The event was subsequently recorded on vinyl, but it was the live broadcast that was to become so popular—she received fifty thousand fan letters—that the BBC returned to the garden for the next twelve years to repeat the performance, with and without Harrison. Even after she moved in 1936, the broadcasts of a singing nightingale continued each May, right up until the last broadcast in 1942 and the arrival of the bombers.

The popularity of the broadcasts is loaded with romantic rhetoric, most significantly the notion that the cellist and the birds were "duetting." The standard versions of the story describe Harrison performing and the bird listening before joining in and echoing the tune. Analyzing the recordings now with less romance and more information, it is clear that the bird is not responding to *Chant Hindu* but most likely trying to vocalize above the drone of the invading instrument. Studies of territorial songbirds, especially nightingales, have shown that amplitude and pitch behavior is in fact "noise-dependent."[12] Studying captive birds in increasingly noisy urban environments, it is not surprising to find that they sing more loudly. Nightingales have one of the broadest and most complex repertoires of signals or "songs" of all migrating birds. In studies of signaling patterns counteracting noisy environments, songs change significantly to shorter song phrases and longer repetitions before beginning the next song. Shorter signals and narrower frequencies in songbirds with large repertoires also occur in nonurban environments, such as high-winded forests and the vicinity of waterfalls. Therefore, if a nightingale ever "sang in Berkeley Square," it was more likely remembered because of its pitch and repetition of short phrases in competition with its environment than for the complex variety of its vocal repertoire.[13]

What is important for the songbird is not so much its rich repertoire, although of course this plays a part in seasonal mating behavior, but more so the fact that it gets its messages through to its "audience." Who is listening, and what challenges are facing them in this multiacoustic environmental drama of perception, selection, creativity, and evolutionary urgency? How does the receiver extract the information it needs to either survive (alarm calls) or to find a mate (individual repertoires and physical attributes)? The noisier the environment, the shorter and more repetitious the phrases become, and the higher the chances the signaler has of getting its messages across. Similarly, with the Harrison recordings and subsequent annual broadcasts, what messages are being listened to by the radio audience

and, more precisely, what is being heard? Judging by the popularity of the nightingale broadcasts and recordings in the 1920s and 1930s, the audience of that time heard a timeless, bucolic evocation of their country, of a territory as reliable and consistent as the land itself. The post–World War I environment was a period of reestablishing constants, an in-between time of flourishing industry and progressive cultural statements. A profoundly nostalgic sentiment also prevails and, indeed, supersedes any of the ornitho-musicological likelihoods at work in the Surrey garden. The exquisite birdsong combined with the beautiful, young, aristocratic cellist playing classical British compositions, combined with the grainy crackle of early radio technology, delivers a uniquely poignant "signal" to the listening audience in its own time. In Aniruddh Patel's neuroscientific studies of nationalistic relationships that he identifies in speech and song, he argues that Western classical music composed in the late nineteenth and twentieth centuries relates not only to the sociopolitical ambitions of the period but, more directly, to the identifying speech cadences of specific populations.[14] Patel and his colleagues identified speech rhythms in recordings of UK radio broadcasters and made correspondences with popular classical compositions of the period. The patterns of spoken language, rhythms, and inflections that characterize a "national voice," are also reflected in music, or what science writer Phillip Ball calls the "concerto for the mother tongue."[15] In this clustering of airborne messages, the illusion becomes iconic, both then and now—a call-and-response duet of an artist who articulates the most English of notated musical voices on the cello with the romantically acoustic expositor of the English countryside in a performance that both engages and transcends physical time.

But what about the listening bird? What do the recordings tell us of its sonic world? Ornithologists would certainly ascribe some extraordinary abilities in birds to tease apart qualities in song that they may find either most attractive for selection or most essential for survival.[16] The critical factor is the significance of location, of territory, and of the accuracy of territorial description. Among these elements are sets of universals for songbirds—pitch, tone, size, repertoire, frequency, timbre, and so on—the musical structures that form the grid onto which individual embellishments and variations can be attached. These terms are, of course, human or anthropological in origin; the terms and definitions used in studies of birdsong are always informed and directed by structures that define human musicology. Unlike zoomusicologists such as Martinelli and Ulrich, the

listener here is the ornithologist or naturalist who has been categorizing bird sounds and songs according to human musical notation systems since the early period of evolutionary science.[17] While the study of birdsong has been a consistent source of valuable information for scientists on many subjects—including sound production, soundwaves, communication behavior, and learning—the focus has shifted relatively recently from analysis of vocal complexity toward how birds learn and the implications this may have for neurobiological and neurobehavioral research, both avian and human. For example, the ongoing research and debate on the subject of mirror neurons in birds and primates proposes that these neurons are responsible for imitation in early learning.[18] Cecilia Heyes has argued that mirror neurons are more a product of social interaction than a neurobiological given, or something that one is born with. This broadens the study rather widely into more general ideas about nature/ nurture, imitation/instinct binaries.[19] Either way, the most remarkable phenomenon about mirror neurons is the way in which they fire not only when one performs an action oneself, like picking up an object, but also when one observes another performing the same action. Heyes describes the event like the bridging of a gap between one agent and another, where actions are performed and understood in very significant, highly sensory ways. Up until recently, most research into the phenomenon of mirror neurons has been understood to be visually based—hence the term "mirror." However, as studies of bird neurobiology have established that birds need to be able to listen in order to achieve full vocal maturity, and that this "auditory feedback" is essential to acquire, maintain, and develop songs, some more controversial hypotheses have emerged on the subjects of imitation, language acquisition, and theory of mind in birds as well as other vocally minded species. While the field's propositions have been contested more recently because of lack of evidence, the appeal of what may yet be discovered will encourage further neurological study of mirror neurons and animal vocalization behavior.[20]

But what can emerge from these definitions of birdsong and advances in understanding of how we listen to animals and what we are listening "for"? The Harrison nightingale performances can be read as an example of how the nature of listening changes according to the circumstances and needs of an audience, which may seem obvious except for one detail. When it comes to the animal acoustic that is being heard—in this case, the songbird—what I may wish to hear is something timeless and universal, whereas in fact

I am hearing a sound that is constantly changing and evolving alongside our own human cultural voices. This is what complicates the processes of creating and experiencing art that uses birdsong and makes me question what we are listening to and for what reason. There is a case to be made that at the core of these extraordinary art and sound works is a desire for the otherworldly or the universal. Even with the extensive ornithological knowledge that many of the artists in the first half of this book possess, the work they produce is both highly specialized and broadly universalizing at the same time, perhaps none more so than that of the French composer, ornithologist, and devout Catholic Olivier Messiaen (1908–1992).

Listening for Messiaen: Seeing Sound, Hearing Color

In his fascination with birdsong, Messiaen understood the essence of creaturely acoustics, and his work is indispensable to any discussion of modern zoomusicological performance. Although his huge output is largely classified as thoroughly modern, progressive, serialist, and even surrealist, his supposed ornithological romanticism was the most accessible trait for his audience and the most frustrating for his critics. But the methods that Messiaen developed for listening to and recording birdsong are worth examining here, along with how his approach opens avenues of thinking through animal acoustics in radical and lasting ways.

What was "listening" for Messiaen? What was he listening for? Unlike many composers before Messiaen's time who occasionally incorporated birdsong into works, often as musical "jokes" or clever displays of virtuosity and mimicry, Messiaen breaks the tradition of imitation and creates new methods of listening, interpreting, and creating art for a postwar world.[21] The young scholar was already a keen ornithologist, as well as a musical prodigy, when he entered the Paris Conservatoire at age eleven. But it was during his wartime experience that birdsong first entered his compositions. In David Rothenberg's version of this oft-recounted story, his acoustic awaking began in the trenches: "The twenty-nine-year-old Messiaen was on dawn watch in the French army in 1940, stationed in Verdun. The sun was rising and all the birds began to sing together. 'Listen to them,' he told fellow sentry Etienne Pasquier, a cellist, 'they're giving each other assignments. They'll reunite tonight, at which time they'll recount what they saw during the day.' . . . There was also a clarinetist in the regiment, an Algerian

named Henri Akoka. After many days of dawn watches Messiaen began writing a solo piece for him, *Abyss of the Birds*."[22]

Before Akoka had even tried to play *Abyss of the Birds*, the German forces invaded, and Messiaen and his fellow soldier-musicians were captured and taken to a prisoner-of-war camp near Görlitz, called Stalag VIII A. It was there that the premiere performance of the finished piece took place. Much has been made (and mythologized, not least by Messiaen himself) of the story of the first performance in the camp. The *Abyss of the Birds* became the third movement of what would be Messiaen's most celebrated work, completed in captivity, the *Quartet for the End of Time* (1941). The limited materials available to the composer in these circumstances (provided by the Red Cross) resulted in a most unorthodox arrangement for a quartet of cello, piano, clarinet, and violin; with the cooperation of the Nazi officers, three thousand prisoners listened in rapt attention to this unusual premiere performance. All these elements contribute in varying degrees to the birth of this work and to its legendary status. The context of its creation in a Nazi prisoner-of-war camp undeniably haunts most readings of the work, to the extent that they are sometimes imposed on or associated with histories of extermination camps. To clarify, Messiaen certainly may have known of German anti-Semitism, but as the worst atrocities against Jewish people began in the second half of 1941, he most likely could not have known about the scale of what was to come. Therefore, even though the work is often now associated with the Shoah, we might say instead that the work is more prophetic of the Holocaust than a direct commentary on it.[23]

Messiaen's intentions for the piece were profoundly musical, universal, eternal; Rothenberg describes the work as soaring, birdlike, upward "towards a sonic Heaven . . . and the solo clarinet in the third movement is a musical attempt to link the endless enthusiasm of singing birds with the long, dark weight of eternity."[24] For Messiaen, birds and their voices are the opposite of time; they are transcending time in their heralding of the dawn, and therefore they become continuous in their sonic presence. This eternal "voice of nature" is of great consolation to the devout believer that Messiaen was; he saw "the End of Time" as the gate to eternity, where his God awaited him. Messiaen's own long life was not without suffering, and still he says, "In my hours of gloom, when I am suddenly aware of my own futility . . . what is left for me but to seek out the true, lost face of music somewhere off in the forest, in the fields, in the mountains or on the seashore, among the birds."[25] This listening was not a passive activity.

Over a lifetime of local and global birding excursions in the field, Messiaen produced his enormous, seven-volume treatise, *Traité de rythme, de couleur et d'ornithologie* (1992), two volumes of which amount to twelve hundred pages of birdsong transcriptions, mostly done without any technology except a piano.[26] His notation style was oriented toward the future musician or performer: transcribing rhythms, tones, and any irregularities that would be useful to the interpretation of each song. In his epic *Catalogue d'oiseaux* (*Catalogue of the Birds*, 1958), each of the thirty-eight pieces refers to a specific bird, in a particular place and at a noted time of day, environment, and ambience. To my ear, only the closest reading of the composer's notes could give any indication that we are now at the seashore, that the wind is from the east, that waves are crashing against the cliffs nearby, and so on. The music is complex, abstract, and riveting, and only the *oiseaux* in the title pricks one's ears to its origins in an almost-obsessive interest in ornithology. Indeed, contemporaneous critics of the *style oiseaux* cycles use the composer's fidelity to birdsong as a charge of mimicry and kitsch, or of imitation and not interpretation. Robert Fallon has summarized the general tone of disdain as "Messiaen's music sounds like birdsong; birdsong is not music; therefore Messiaen's music is not music."[27] Even the more appreciative Trevor Hold was frustrated by the choice of instrument. The piano could not be an appropriate means of interpretation, as "it cannot crescendo through a sustained note, or play intervals smaller that a semitone, or make a true glissando between notes— all of which birds do."[28] For Hold, the details of where the music originated was a tiresome distraction, and he called instead for more attention to the purely musical freedom and "impressionistic verism" that marks the work as outstanding. Hold's reference to impressionism was more than descriptive.[29] Messiaen had a condition called synesthesia, which meant that when he heard musical sounds he saw colors, and vice versa. In the *Catalogue*, it is the range of musical "color" that is so astonishing and surprising. The detail of the tones, subtlety of values, thrilling explosions, and dark, deep shadows confirm the work's unique and original visual aesthetic. The pianist and musicologist Peter Hill describes his method of interpreting the work as "examining some vast and magnificent sculpture—the west front of Chartres would be appropriate—inch by inch by torchlight."[30] Prior to Hill's acclaimed performances and recordings of all of Messiaen's piano works, he had several opportunities to meet with the composer and discuss approaches to interpretation. He says that "Messiaen's approach

is to *translate* from nature, *inventing* parallels or 'metaphors,' which have their own purely musical intensity."[31] The performer can be mindful that Messaien foregrounded both his quasi-scientific methods of fieldwork and his efforts to encapsulate specific aural experiences—the curlew in the evening, or the lark rising from the gorse, for example. Messiaen always requires such attention. But for the performing artist who is challenged with interpreting the actual notated manuscript, the concern is not so much allegiance to the ornithological details of species representation as an obligation to match the composer's hypersensitivity to the experience of listening to the "color" of birdsong.

Peter Hill writes of the composer that, "in performance, nothing does his music a greater disservice than an approach which achieves accuracy (in the literal sense) at the expense of imagination, that fails to explore the music in terms of its meaning and atmosphere, through those nuances of rhythm and sonority which bring the notes on the page to life."[32] In order to achieve this life, Hill stresses Messiaen's "virtuosity in the balancing of color," the impulsive use of light and shade, nuance, coolness, neutral tones, sharpness, texture, luminosity, and gesture. The language is of that of the painter's palette. Perhaps for these reasons, Messiaen has been called "an Audubon in Sound" for the likenesses of his song portraits.[33] The origins of the work are intensely researched, devoted to translation with as much accuracy as is possible without depending on recordings, and imbued with a fascination and consuming respect for the vocalizations of other species. However, in order for this accumulation of ideas, emotions, and experiences to become a work of art, the musician (in this case Peter Hill) leaves these concerns with the composer to a respectful extent and pushes on with the task of bringing this collection of notes to life, as he would do with any composer's work. In his essay on his experience of recording *Catalogue d'oiseaux*, Hill does not detail any ornithological investigations that he may have carried out for himself, nor does he mention the recommended forest walks and dawn listening sessions advised by the maestro, or indeed any firsthand experience at all of the cries of the tawny owl or the elusive wren. Hill is more focused on achieving the kind of coloratura and balance between genius and obsession that he identifies in the manuscript before him. For him, the scores are "so complex in their detail" that they seem "not so much a representation of sounds but a recipe for *physical action*, a set of instructions which have only to be followed (as far as possible) to the letter."[34]

For Messiaen, however, learning how to listen remained of primary importance both for himself as an artist and for his students and audience. Even though his piano interpretations may not have the accuracy, pitch, speed, or "glissando" of a real bird, the intensity of his listening produces the extraordinary *Catalogue* and transcends any obligation to recreate faithfully the sound of a bird. The scrutiny and attentiveness to the action of listening itself is crucial for Messiaen. As Jean-Luc Nancy phrases it: "Listening must be examined—itself auscultated—at the keenest or tightest point of its tension and its penetration. The ear is stretched by or according to meaning."[35] Messiaen challenges us to stretch our listening into his auditory field, into his neighborhood of sound, through his music.

In this analysis of the qualities of listening between species, in gaps and chasms of being and becoming audible, Messiaen's keen disposition is exceptional because he was uniquely an in-between being himself. He was always listening to the sounds coming across the human-animal trenches in his postwar world of struggle and reimagining, carrying over his education of classical and romantic musical pedagogy into the avant-garde movements of the mid-twentieth century. He listened intensely in the spaces between species. He created music out of these spaces. And he also knew that the creaturely acoustics would always be a means of entry, not into another world, but more deeply into a shared zoomusicological experience of this world.

In the words of Mircea Eliade, on aspects of shamanism: "Becoming a bird oneself or being accompanied by a bird indicates the capacity, while still alive, to undertake the ecstatic journey to the sky and beyond."[36] Messiaen's encouragements to his students on the value of time spent in the valleys and forests, listening for the rumble and rhythm of life, are often held up as examples of his "firsthand" method and as evidence of his ability to translate birdsong with such speed and accuracy. His extensive collection of recordings is less well known. In spite of the attention given to his field-work pen-and-ink notations of songs, Messiaen himself had no objection to learning from recordings, and friends around the world provided him with cassette tapes of birds that he would never have had the opportunity to hear in the field. Recordings of the maestro himself are equally rare, although a tape from 1959 recently turned up in a Paris archive. In this recording of a lecture by Messiaen, he instructs his students on to how to listen to the horned owl. He describes his listening experience in the field in this way: "And then, in that amphitheater of mountains at the end of the

night we had the great horned owl—I must show you this figure because he is a major figure. . . . He was huge. And his cry was truly remarkable. I'm going to try to do it for you, don't laugh. [Messiaen emits a sort of animal howl.] A sort of serious, muffled growling, it echoes at night among the cliffs, it's very odd . . . and very difficult to capture musically, because it isn't music, it's a noise."[37]

Capturing bird "noise" was an aim not only for the composer but for the ornithological community at large, and while Messiaen's evocative descriptions were being recorded in the Paris Conservatory, major changes were happening in England in the laboratories of biological and behavioral science at the University of Cambridge. The introduction of the sound spectrograph, used to provide a visual representation of birdsong by W. H. Thorpe, Professor of Animal Ethology, in Cambridge in 1954, was the pivotal moment in ornithology when descriptive data using musical terminology became outdated in favor of the new, visual objectivity of the sonogram. The device was originally developed during World War II as a method of identifying enemy voices over the radio. Translating pitch, rhythm, and timbre into readable images provided the break with past methods deemed necessary for ornithology to progress in line with developments in postwar science.

Before the spectrograph, recordings of unusual or long, complicated, and highly ornamental birdsongs were much sought after (not least by Messiaen, who also had friends mail him tapes of native New Zealand species like kokako, kea, tui, and "the strange and primitive calls of the North Island kiwi").[38] However, the original spectrograph of the 1950s had a very limited recording time, initially as little as two to four seconds. The choice of bird species most commonly used in the laboratory today, the chaffinch and zebra finch, were equally prioritized as good recording subjects at the time of the arrival of the spectrograph because of their learning behavior (limited) and repetitive song repertoire (short). The zebra finch was favored as a study model right up until the 1970s, when the first digital audio technologies allowed for considerably more recording time. Current digital recording capacity is almost unlimited, and therefore so too is the capacity for listening to recordings of, say, a whole afternoon of the yellowhammer in season. Ornithologists and behavioral neuroscientists, it seems, have much to learn from the generations of finches and canaries still populating their laboratories. Research into the fundamental biological mechanisms of how and why birds sing is ongoing, and many unanswered

questions remain, according to C. K. Catchpole and P. J. B. Slater in the conclusion to their survey of more than one thousand papers for their well-known, comprehensive textbook *Birdsong: Biological Themes and Variations.*[39] The subjective interpretations of birdsong that have held sway since Darwin's *Descent of Man* (1871) are now stabilized by scientifically objective visual data.[40] Where musical notation has qualities of illustration, such new spectrographic images of (nonhuman) language surpass subjective interpretation. In the jump from musical notation to visual language, ornithology came onstream with emerging new practices in the study of linguistics and learning. How birds learn songs is now readable as text, and as hearing became seeing, listening for music became looking at the accumulating data. However, capturing bird sounds, and the analysis of the capture, takes as much time as it always has: the bird is still netted or caged, transcribed or "caught" with the close-range or long-range "gun" microphones in use today, and the digitally captured material can then be downloaded into any number of visual languages. Musical references such as tone, melody, timbre, and pitch still run through biological studies of bird signals. Certainly, some of the ways in which we now listen to birds has changed, and largely because of technology. The impact of these new auditory resources on artists' interpretations of birdsong has been significant—as a resource—and artists have certainly not resisted the arrival of the spectrograph and its technological descendants.

Downloading a Swan

When the University of Oulu commissioned Finnish composer Einojuhani Rautavaara (b. 1928) to compose a work announcing their first doctoral degree, he incorporated tape recordings of whooper swans into his three-movement orchestral piece, which would become his best-known work. The *Cantus Arcticus: Concerto for Birds and Orchestra* (1972) also features the slowed-down recording of a shore lark in the second movement. The final movement finishes with the sounds of swans and orchestra fading as the birds continue north on their migration path. In Rautavaara's composition, the swan recordings from the Arctic Circle and the bogs of Finland are rhythmically in sequence with the orchestration, but the two elements remain quite independent, respectfully sounding alongside each other rather than becoming an integrated whole. When listening to variations of

this work, I was most taken with a recording from 1997 with Max Pommer conducting the Leipzig Symphony Orchestra. While downloading the music file from iTunes, I "watched" the music on YouTube, or at least photographs of the region of Finland in which the piece is set, while listening to the recording. Then I looked at a video of actual whooper swans arriving on icy Finnish shores, calling in their distinctive way. That led me to more videos of swans landing in Japan and in Canada, and in no time I was drawn into the world of the snow goose. A promotional video from a website named performancecalls.com promised multiple methods of "making you a better caller!" Here I could purchase any number of calling devices and a CD that promised to explain "all the calls needed to effectively hunt the Canada goose." A more practical and immediate option, I thought, was the Snow Screamer, a plastic horn that "will have you barking, crying, and hiccupping [*sic*] like a dominant old snow goose at a realism level that is nothing short of extreme."[41] Three hundred thousand people had viewed this page. The Snow Screamer certainly offered performative possibilities to an artist easily excited by new and practical technologies on the fringes of research into animal voices. However, I postponed this distracting enticement in favor of a more instantly gratifying opportunity to hear real swans; I turned instead to the BBC, which then offered sixty-one different recordings of whooper swans from various parts of Scotland (each recording was approximately five minutes long and cost an average of four pounds sterling). In the end I chose number 19, whooper swan (*Cygnus cygnus*), whooperswancall27036 .wav; length, 1:48; year, 1989; location, Caerlaverock, Solway, Scotland. The description reads, "Calls *Cu* and Reassurance Calls While Feeding on Bank."[42] My swan bears only a passing resemblance to the carefully edited swans in *Cantus Arcticus*. The sounds of the distinctive *Cu* calls are there, but in my downloaded swan they are fleshed out with barking and hiccupping and snorting and some splashing on the shore. I satisfied my curiosity in that I had at least heard what a real whooper swan sounded like, and I mulled over whether or not I could, in all subjectivity, say if it was music or noise. Listening with Messiaen in mind, it was both music *and* noise, or perhaps a means of entering a zoomusicological realm. At my computer, I was transported to a muddy bank in Scotland for four minutes via the trembling urgencies of a recording of a whooper swan. In *Cantus Arcticus*, Rautavaara's elegiac and dreamlike orchestrations are of course not to be compared to an outdoor BBC broadcast; it is an interpretation with no obligation to realism. But nowhere in the piece is the swan's call translated

into music *per se*. The sound of the swan is there beside the violins and the oboes, sounding very much like a swan. But it is not as close by as my Scottish swan, who is snorting and *Cu*-ing and sloshing in the water while other swans can be heard in the distance, and the wind sounds freezing. The atmosphere is evocative of the physical reality of this large bird, of its own avian drama and its experience of a place, near Caerlaverock, and of what it might sound like for a swan to be a swan.

The English composer and experimentalist Jonathan Harvey (b. 1939), with his recordings of Californian songbirds, takes the possibilities of digital recording considerably further than Rautavaara. Using synthesizers that contain samples of birdsongs that are manipulated in performance by connecting them to a concert piano, Harvey wrote and scored *Bird Concerto with Pianosong* (2001) to be performed using live electronics in real time with a seventeen-piece ensemble, an accordion, and a metal percussionist. In a recording of the piece performed live at the Warsaw Autumn Festival in 2009, the result is a seamless exuberance of sound with no trace of the formidable technical challenges the work presents to the performers—especially the pianist, who is working from both a written score on paper and a digital screen showing the song samples, one placed above the other on top of the piano.[43] In contrast to these technological advances, there is an increasing interest among a contemporary generation of artists in sound recording equipment that is obsolete, unusual, and invariably predigital.[44] Aleksander Kolkowski (b.1959) has featured wax cylinders of recordings in his performances, along with phonograph recordings, a rotating horned string quartet, a Serinette (or bird organ), and, for a commissioned piece titled *Mechanical Landscape with Bird* (2004), eight live canaries along with a cluster of unusual, outdated sound equipment.[45] Artists such as Kolkowski, who use birdsong in music compositions, performances, and arrangements, have access to a wealth of information that has come from the laboratories of neuroscience or from the fieldwork of biologists. Like Messiaen's, these artists' worlds are prioritized and defined by their aural senses. Perhaps questions remain about the methods of interpretation. Using recordings of birds in compositions and live performances, and even live birds on occasion, the birdsong is being *attached* to compositions in the works cited above. The orchestrations may be looser, more abstract, and closer in rhythmic structure to birdsong, but ultimately these works have more in common with *Pines of Rome* (1924) by Ottorino Respighi, the first composer to use a recording of a nightingale in the live performance of his

symphonic poem. The effect is delightful but decorative, and in Respighi's case this was its function, as the nightingale was not the subject of his piece.

A recording of a bird in a performance context does not move a work of art any closer to understanding or illuminating the experience of listening to a bird or, for that matter, to the experience of what it is like for a bird to listen to another bird, however incidental that may be to the major or minor dramatic intentions of the work. Bringing live birds to perform in the concert hall or art gallery distances them even further, as they become the uncanny "other" onstage. There the bird will always be the generalized animal object, a fetishized other with remote allegiances to its sonic origins and, more importantly, its vocalized intentions, if there is openness to the idea that animal sounds have intentionality. If artists employ animal sounds in the manifestation of their ideas, even if these ideas are concerned with an analysis of animals or human and animal relations and comparisons, it is in the translations and transformations of material like avian communication behavior that artists and performers can bring a listening audience closer to understanding what it is they hear and what they may be listening for—whether it is via a piano, a flute, a glass harmonica, or a musical saw. The pathway from animal throat to human ear to composer's hand, using digital wizardry, creates the notated music that will be embodied in the musician's physical performance and in the singer's control of the larynx. This transformational activity gets us inside the gaps between species.

In Rachel Mundy's essay "Birdsong and the Image of Evolution," (2009) she states that the arrival of the spectrograph in ornithology meant the creation of a new abyss "in allowing the question of aesthetics to disappear in the unbridgeable gap between the sciences and the study of aesthetics we so tellingly term 'the humanities.'"[46] Mundy aligns some of this shift to the prominence of linguistics in postwar French theory especially and has genuine concerns about hierarchies that have emerged between language, illustration, and sound. Her analysis can be expanded further, beyond the spectrogram and its early influences. In the mid-1970s, animal bodies began to reenter the realm of arts practices, often through the new medium of live art, with the specific intention, in many cases, of resisting notions of hierarchies within the art world and the world of commerce. One of the questions to emerge from this period was the importance of "liveness" and what Philip Auslander has called the "evangelical fervor" for the "purity" of the live performance—and even more so for its resistance to technologized, televised and mediatized representations.[47] The work of artists who have

integrated technologies of sound into their interpretations of animal voices shows how these essential mechanisms that have captured, interpreted, and performed animal vocalizations have made possible a continuum as well as an evolution of our responses to the sonic realm we inhabit with other species.

Finches and Guitars

Between 1999 and 2007, the French artist Céleste Boursier-Mougenot made five different versions of his installation *From Here to Ear*, which involves another merger of songbirds, stringed instruments, and sound transmitters. The staging of the work in a gallery space positions a flock of thirty or more zebra finches, piano strings, and electric guitars connected to microphones and amplifiers. Birdseed, water feeders, and nesting boxes are also distributed about the space, through which visitors can wander at will, interacting with the birds and the auditory field they produce by landing occasionally on the musical instruments. The context, intention and result could not be more different from the Harrison rural garden, even though the essential elements remain the same. In *From Here to Ear*, the new habitat is a modern, architectural, urban interior; invariably a white cube space with restricted entry and exit for both humans and birds.[48] The stringed instruments have departed entirely from their designed function, becoming passive objects that are animated solely when perched upon by the birds. As for the zebra finches, these twittering, excitable birds are very far from the Surrey nightingale, the Keatsian "winged dryad of the trees."[49] All the birds used in Boursier-Mougenot's installations were bred in captivity. So what are we listening to, then? And why has this particular performance installation had so many reprises and considerable critical attention?

To begin with, there is the absence of the human performer/musician, in any literal sense. The human audience is certainly performing an action as witnesses to the live event. But here the animal dominates the activity, and the sound of that animal is at the center of concern. The discordant crashing, fluttering, and chirping of the flock that greets the visitor/listener (as one hears the sounds before entering the space) is an entirely postmodern acoustic—chaotic, defying classification, unpredictable and unexpected. Musical territories have been broken down to produce a radically new soundscape that is reflective of its time. The

Gibson electric guitar, which has defined many musical genres of the late twentieth century, is made almost redundant in relation to its design or intention. The modern art gallery is overtaken by animal vocals that sound chaotic to human ears. The pristine art gallery is strewn with bird food and droppings, grass lawns and birdhouses, sound equipment and electronics. The sound transmitters are uncontrollably producing every random tic and crash with no editorial structure or scheme. In musicological terms, all the rules and systems are flung out in favor of a newly exposed, raw sound reality. Within this auditory field there is a breakdown of one of the principles of performing music—directionality. Standing inside the installation, it is hard to predict from where the sound will come next, and the sound is what we are there to experience. The birds are unpredictably fast; they do not all move or sing together; and some move very little. The sound structure is closer to a forest experience than a concert hall. In an auditorium, both eye and ear can focus selectively, and fringe phenomena—whispering, coughing, people leaving and entering—are in balanced ratio to each other's and to one's own shifting interests. The listener hears what he or she wants to hear, or, as Idhe says, we listen intentionally. While attempting to analyze this fringe-focus ratio in *From Here to Ear*, I am also aware of the lightness of the bird and the heavy industrial twang of the guitar, which is transmitted live through another kind of box/radio—the amplifier. I am listening for this crash of unlikely media to be articulated and for the artists' intentions and my own to synchronize. In this way, I am prioritizing within my auditory field. I am therefore listening intentionally and, in some ways, like the bird, teasing apart all of the acoustics at play, then reassembling them to find my own listening intentions at the center of this barrage of sound. However, the attempt is confounded by the constant slippage away from the particular and into the abstract. Is this therefore a metaphysical musical "universal"? Possibly. But certainly it is a sound that could not have been imagined or produced before its time. Céleste Boursier-Mougenot stringently asserts that this is music. He began his career as a composer and musician, and between 1985 and 1994 he held a position as composer for the Pascal Rampart Theatre Company. He later created installations in contemporary art spaces that focused on a live sound experience—randomly evolving soundscapes that reflected and responded to the environments in which they occurred. Before using birds, his materials

came from quotidian urban life—vacuum cleaners, electric fans, dinner plates and bowls, delivery trucks, and so on. James Trainor aligns this artist's process "with the biological processes of natural selection," which result in an open-ended, continuous branching and dividing of sounds that "build, cluster and die out accordingly, the cadences, interludes and codas of an infinite number of non-events describable as music."[50]

In many ways, the zebra finches in these installations can be described as quotidian objects. Zebra finches constitute the highest percentage of songbirds used in laboratories and other artificial environments for scientific study. Fifty-one percent of neurobiological studies of birdsong are based on analysis of captive zebra finches. Some of the reasons for their popularity are the species' relatively limited repertoires, the lack of regional dialects, and the virtual inability to mimic recently heard sounds or to manipulate and develop songs. The zebra finch is a "close-ended" learner and therefore especially suited to the search for universals sought by certain branches of science. The problem here is that basing any theory of human speech learning on the imitative vocal behavior of captive zebra finches only reveals the tight corners into which this process has wedged itself. Given the diversity of songbirds available for study and the multiple environments that impact the qualities and functions of each species' vocal patterns, alongside the visual and territorial physical actions and reactions of birds, what the zebra finch brings to neuroscience is as limited as the environment in which it is being analyzed.

These details were not lost on Boursier-Mougenot in his choice of bird for his exploration of the contemporary auditory field. He chose his materials precisely because of their universalizing qualities. The cacophonous, if continuous, stream of bird sounds in *From Here to Ear* eliminates any individual concerns of animal personhood, vocalizing of self, or individuation of any kind on the part of the animal. Boursier-Mougenot's flocks of finches, groups of guitars, and stacks of amplifiers drown out any possibility of the singular, and instead every element, including the listening human visitor, becomes a polyphonic whole. Like the broadcasts of the cellist and the nightingale, *From Here to Ear* presents a slice of contemporary acoustic experience, this time an urban one, in which machine, science, and nature enmesh within their own time and come together to reveal our listening selves to ourselves.

Creating a Chorus

When Don Idhe writes about the "phenomenology of voice," he begins by questioning the definition of what "singing" might be by turning first to the recording of a whale and asking, "What does the whale do? Does he sing like a bird? . . . Or does he speak the voices of language and communicate with his kind? Or all of these?"[51] Idhe is open to the idea that we may not know everything about whale acoustics but warns, gently, that if we "allow the whale's voice to be domesticated as singing," it may limit the possibilities of thinking about listening. While Idhe's celebration of the spectrum of sound phenomena is crucial to any discussion of cultural acoustics, it is notable that here he assumes the bird's communication to be "singing," and that there is nothing strange about this. More significant, perhaps, is how he locates animal "voices" at the center of the origins and definitions of singing, language, and all vocal communication. This he calls "the voice of things" that are more than merely material but are expressive, active, emotive, and critically "communitarian in voice." These various communities in communication with each other—be they coyotes, geese, or baboons—behave more like choirs than individuals, and therefore, Idhe writes, "for animals as with humans, voice is an active expressing of relations with others and the environment."[52]

This fluidity of definitions about what is sonic, what is music, and what is meaningful are precisely the concerns of the British artist Marcus Coates (b. 1968) in his epic sound and video installation *Dawn Chorus* (2007). Coates's shamanic works are explored in more detail in chapter 3. But a short discussion of this particular piece allows for both a conclusion and opening out of the themes and ideas of this early foray into acoustic creatureliness, including ventriloquism, the birth of radio, the nationalizing of birdsong, and how technology and its developments have also traced the sonic world of birds. Alongside its use of the changing technologies of nature sound recording, *Dawn Chorus* also demonstrates developments in ornithology that have changed perceptions and definitions of what is individual and what is communal, of what is signaling and what is singing. For Coates, who identifies as both an artist and a self-taught ornithologist, birdsong has always been a complex communication of territorial dominance, aggression, and seduction in which each individual bird struggles, through sound, to survive. His highly attuned interest in birds, and British wildlife in general, has allowed him to develop a particular skill for differentiating and then

learning the songs and signals of birds. Using film and sound technology, he discovered that if he slowed down his recordings of birdsong from the field, lowering and lengthening the pitch and tone, the slowed song became closer to human voice tone. By recording his own voice singing a blackbird melody and then speeding it up, he suddenly heard himself singing quite like a blackbird. This discovery was the foundation for *Dawn Chorus*—a fourteen-screen immersive sound and video installation, recreating a dawn chorus of birdsong with human singers—first shown at the Baltic Gallery in 2007 and again at Fabrica Gallery, Brighton, in 2015.

In both venues, the visitor heard the installation before experiencing it. In Brighton, one could hear it out on the street. To return to Connor's ventriloquial body at the beginning of this chapter, Coates's installation is uniquely ventriloquistic in this way. When the singers are revealed onscreen in the gallery, twitching and bobbing as each sings the song of the species they are trying to capture and emulate, the first cautious response of the viewer is often that the singers are miming the recording of a bird. Slowly it becomes clear that they are indeed singing from their own bodies, the twitching and birdlike movements and heaving chests being the result of the speeding up of the recording. Each singer—soprano, alto, tenor, bass—was selected by Coates from amateur choirs in Bristol and then matched with an individual recording of a bird species. Coates had made the fourteen different recordings in a Northumberland wood with sound specialist Geoff Sample. It is worth noting the scale of the sound recording equipment required for this project in the context of the combinations of birdsong and technology, which has been the main thread of this chapter. Inside their camper van, Coates and Sample recorded 576 hours of birdsong over eight days on fourteen individual microphones, positioned in the woodland through a twenty-four-track digital recorder powered by crates of batteries. They were then able to dissect the actual "chorus" into individual species such as wren, finch, blackbird, song thrush, robin, whitethroat, and pheasant. Each choir singer was then given their slowed-down birdsong to listen to (through an unseen earphone) and asked to record two and a half hours of singing in front of a camera in a "habitat" of their own choice—office, bathtub, car park, garden shed. Their recordings were then restored to "bird speed," resulting in twenty onscreen minutes, with each screen positioned in the gallery as the birds were in the original woodland. The installation is captivating, not because of how closely the singers imitate or interpret the birdsong, but because of how their own humanity and individuality is

so poignantly revealed through the transformative phenomenon of each performance.

The initial ventriloquism of hearing the sound before seeing its source in the gallery is not meant as a trick, but as a further layer of richness in Coates's enquiry. Every actual dawn chorus is experienced primarily as a pure sound event. The ventriloquial bird body is, as Connor says, distributed in space, unseen. In my own experience, living beside a large forest, when I have made the effort to rise early and immerse myself inside the auditorium of the woodland, I rarely, if ever, see any of the birds I am listening to. This is also the birds' priority. Their territorial declarations and amplified serenading of mates takes priority over any visual display. Instead, my dawn forest experience is "apprehended through hearing, or in which hearing predominates."[53] Equally, entering the *Dawn Chorus* installation, the ventriloquism of the birdsong becomes radically overtaken by the large-scale projections of each singer and the discovery that they are the collective source of the chorus. In this shift from the ornithological to the anthropological, Coates's aim is not at all to suggest something as glib as "we too are animals" or that the films show our "inner bird." This approach, which many artists have explored, more often plays too casually with important and enormous differences between species and results in confirming an inevitable anthropocentricism that is all too alive in human culture. Coates is far more interested in stretching our experience of the world toward how animals make their worlds. By exploring these interstitial spaces—with sound specifically—in several installations, he encourages us to enter into a more phenomenological consciousness of being and "becoming-animal." As Ron Broglio perceptively writes of Coates's achievement in *Dawn Chorus*: "While previous works allowed Coates to become animal and bring the otherworldly to culture, here the community itself unravels into a becoming: the commonplace and daily routine is leveled as to be configured within the animal world."[54] Taking this idea even further, Coates also configures both species into a zoomusicological realm, where human song is approached from an ornithological discipline while birdsong enters into anthropological discourse. He does this through his intense capacity to listen.

This particular installation encapsulates and perhaps challenges much of the music-bird-technological history that has been featured in this chapter, which began and ended with the ventriloquistic voices of birds. In their weightless, visually absent way, birds expose an acoustic dimension

that often quickly becomes filled with our eagerness to listen for answers to our own evolving needs and desires. For Jean-Luc Nancy, "to be listening is to be always on the edge of meaning, or in an edgy meaning of extremity, and as if the sound were precisely nothing else than this edge, this fringe, this margin."[55] Like the Dodo in the crate, the zebra finch and the electric guitar, the nightingale and the cello, or the chorister chirruping in the bathtub, each performance is an attempt to use current and new technologies in order to meet ourselves halfway, in between our vocal instruments and birdsong, somewhere between signaling and singing, sounding out in the air between land and sky and in the folds of speech and song, in between noise and communication, in between human and animal.

BECOMING ACOUSTIC

Concealing and Revealing Voices in
Hunting and Performance Interactions

Their song takes effect at midday, in a windless calm.
The end of that song is death.
—JANE ELLEN HARRISON, *PROLEGOMENA*

At the opening presentation of *Bungalow Germania*, an installation in the German pavilion for the fourteenth International Architecture Biennale in Venice (2014), the choreographer William Forsythe produced an acoustic event titled *Birds, Bonn 1964*, in which he merged hunting, music, mimicry, and architectural space. The installation melded the interior of the German pavilion (1914) with a reproduction of the interior of the Kanzler Bungalow (Bonn, 1964), the German Chancellor's parkland residence, to produce a century-spanning intervention in which the architects Alex Lehnerer and Savvas Ciriacidis attempted to be in several places at once—in Venice, in Bonn, in a domestic living room, and inside a grand marble-lined exhibition hall.[1] Within these deceptions, Forsythe's intention was to reproduce the experience of listening to songbirds in a park in Bonn as well as inside the Venetian pavilion. He commissioned the sound artist Daniela Cattivelli and some local Italian songbird imitators, or *chioccolatori*, to move about the pavilion, warbling and chirruping while behaving as casually as the visitors to the exhibition. Positioning the acoustic performance of Cattivelli and the singers throughout the pavilion, Forsythe's assemblage combined cultural objects, sound objects (birdsong), performing bodies, and actual buildings in real time.[2] The bizarre and beautiful mixture of architectural styles, materials, and spaces found an acoustic echo in the encounter with

the chioccolatori, men who sing like birds and use a hunting technique dating from the medieval traditions of the Veneto region. The installation, and this chapter, presents these sounds and spaces in multiple layers of political, social, and animal temporalities. The concern is to reflect strategically on our own acoustic histories and to think about how we might approach performance strategies that respond to animal death as a cultural event.

Prior to their work with Forsythe in *Birds, Bonn 1964*, the chioccolatori, specifically Camillo Prosdocimo and Giorgio Rizzo, performed a similar performance intervention for the American artist Pae White for her installation in the Arsenale in the Venice Biennale in 2009.[3] White proposed that the thirteenth-century warehouse where her installation of string sculptures and chandeliers was exhibited be complemented with a sound from the medieval tradition of the chioccolatori. The warbling men moved through the installation, discreetly singing to each other much as they would later at the German pavilion. Before these happenings, my first encounter with the phenomenon of the chioccolatori was in a public library in Tipperary, Ireland, where they appeared on small screens in Janet Mularney's installation *Cortocircutio* (2006). In these works by Mularney and White, the skill of the warblers and the history of their sound are diluted, because the inclusion of animal ventriloquisms here is, more than anything, an entertaining surprise. The artists engage the chioccolatori as folk novelties gleaned from the rustic world and present them as anthropomorphic metaphors of the man-as-animal trope.[4] By bringing the chioccolatori into their performance installations primarily for their exotic allure, Mularney and White, and perhaps even Forsythe, reveal limitations in their engagement with the problematic layering of histories, animals, meanings, and metaphors that are already at work in the actions of the warbling men.

As Joseph Roach has suggested, every performance is positioned at a junction: "Choosing the right moment to look back and the right moment to look forward is the crux of any successful performance, which must combine invention with memory: invention without memory is irresponsible; memory without invention is deadly."[5] The combinations presented in the pavilion by both Forsythe and the architects were certainly inventive: how the bungalow was dropped into the center of the pavilion, where leather couches disappeared into marble walls and glazed sliding exterior doors opened onto airless interior courtyards. In this uncanny space, the acoustics of the singers acted as a memory trigger: is this what a blackbird in a park in Germany might have sounded like? How would birdsong have articulated

these glass rooms and empty inner courtyards? And, most immediately, where is the sound of the singing bird coming from, and what is it doing here? This installation and other works by Cattivelli present a range of ideas that center on what has been termed the *acousmatic* voice—the voice we can hear without seeing or even knowing its origin.

One of the aims of this chapter is to introduce animal acoustics to the study of contemporary acousmatics, a subject that has been revisited many times since its coinage, by Pierre Schaeffer in 1966, as a term to describe modern sound art and composition. The territory of acousmatic sound is invariably either ritualized, mythologized, urban, industrial, and profoundly human; or virtual, cinematic, and technologically uncanny. For example, in R. Murray Schafer's first major study of the histories involved in our current sonic environment, animal acoustics are always primal, originating in a "pastoral soundscape" complete with bees buzzing and shepherds piping to one another, interrupted only by war and religion (calls to arms or to prayer, both sounded by the village church bell). The predominant sound that Schafer experienced on his last visits to the countryside was "a vast silence."[6] The study of animal acoustics and acousmatics, for the most part, has not been addressed in the contemporary concerns of these sound theorists, who are focused on the spatial and temporal separations of sounds from the human/urban sources they identify in contemporary music, in sound studies, and in sound art theory. With Cattivelli's work, I see an opportunity to open these disciplines up to an alternative way of listening via human and animal sonic entanglements. The historical, primal origins of acousmatic animal sounds come to the fore in a contemporary performance such as *Birds, Bonn 1964* in the German pavilion in Venice. The intervention of the singers cuts through the thickening geologies of past and future cultures that the architects presented to us. By invoking and recreating an atmosphere and memory of another time and place through their interpretations of birdsong, both the chioccolatori and Cattivelli acousmatically bring together the experience of the space as a sound repository of history. The territories where human and animal sounds and their functions conjugate are the central intricacies that have, I think, been left aside in the theoretical expansion of Schaeffer's original "*acousmatique*."[7]

Essential acousmatic techniques are central to sounding animality in hunting and performance practices, where they maintain their original qualities, histories, and values. Both the hunter and the artist must become

like Steven Connor's ventriloquial body in order to capture and render, to consume and become bird. These actions further problematize the deeper points of sameness and difference that the interaction of sound and body, human and animal, landscape and culture present. Visibility and invisibility are shared traits, but spatiality and territoriality play a far stronger role in defining what counts as an acousmatic event.

Animal acoustics are always already acousmatic. Spatial circumstance and continual interactions of deterritorialization and reterritorialization of the sonic self determine how human and animal acousmatics become entangled. These phenomenological theories, developed by Gilles Deleuze and Felix Guattari, focus on non-anthropocentric creative relationships with the material world. Their theory of becoming-animal emerges from an inquiry into blurred boundaries and zones of proximity in the hyphenated experience of being a human-animal-molecule, all of which have a bio-acoustic dimension. In Cattivelli's projects with the chioccolatori, she creates a terrain from inside of which creaturely acousmatics are given room to emerge, to reterritorialize, and to challenge sonic boundaries.

What Are Acousmatics?

The etymological origins of acousmaticism are especially relevant to any examination of vocal performance. The Acousmatics were the students of Pythagoras who followed his teaching from behind a curtain, so as not to be distracted by the physical perfection of the philosopher himself. Pythagoras's own education toward idealism involved extended periods of what we might now call veganism as well as long years in a cave without any care for anything as banal as day or night. The beauty of his theorems was so overwhelming to his audience that he developed his own method of teaching from behind a veil. Numbering in the thousands, the Acousmatics assembled to listen to "the divine" teacher (who, after he died, was referred to as "that man"), a mathematician who eschewed everyday sluggishness above all and directed his disciples toward a comprehension of themselves "in symphony, harmony, rhythm and all things that procure concord."[8] The Pythagorian veil disembodied the narrator from his text and from his spectators, who were so astonished at the visual beauty of his theorems that they were more content to become "auditors" and listen to his teachings in the auditorium. Pythagoras's veil, in the first instance, removed the

physical image of the orator entirely and disembodied knowledge from physical presence. Further, Pythagoras's veil articulated a drive to intensify the reception and perception of ideas. In the acousmatic intensities of the performances that are under scrutiny in this chapter, concealing and revealing different kinds of human and animal vocalizations become the methods by which artists realize their ideas.

At the 2012 *Documenta* art festival in Kassel, Germany, collaborators Jennifer Allora and Guillermo Calzadilla installed their work *Raptor's Rupture* in the Weinberg Bunker, a series of shelters tunneled deep into limestone and open to guided visitors. While the installation was ultimately a visual experience, it was primarily an acousmatic event. Allora and Calzadilla's film projection could only be accessed through the maze of tunnels, and the sound of a flute and the flapping of wings were heard long before they were seen. The video shows a flautist playing a replica of a thirty-five-thousand-year-old flute made from the bone of a Paleolithic griffon vulture in the company of an actual vulture, an evolutionary descendant that is currently threatened with extinction. The artists' intention was to combine human cultural histories and avian destinies informed by the disciplines of zoology, ecology, archaeology, musicology, and classical myth. The flautist, Bernadette Käfer, tries to provoke a reaction from the bird while attempting to produce some percussive and melodic sounds from the flute. The bird's indifference and the timidity of the flute music ensure that "the performance is a failure. Echoing the species' existential predicament, all the musician can draw from the delicate perforated bone is a soft wheeze."[9] However, for those who experienced the installation at *Documenta*, the sensation of finding one's way into the deep caverns while being led by the sound of the bone flute proved to be the most memorable aspect of the work. The anticipation of seeing the vulture and the enigmatic flute and hearing the strange piping and percussion echo through the cave-like spaces was a powerful, theatrical experience that depended on these creaturely acousmatics.

Acousmatics, by their nature, incorporate Connor's ventriloquial voices. The history of the dislocated, disembodied voice often begins with expressions of supernatural authority, always commanding and admonishing: the voice of ritual and fear. Issues of identity, power, and ownership have always been worked out ventriloquistically within performance practices.

For Connor, "all performance is broadly ventriloquial, in a double move-
ment whereby the performer gives his or her voice to another" and in turn
raises broader contemporary ethical concerns or "proprietary thematics"
of the voice and violations of its ownership. While the familiar figure of
the ventriloquist's dummy may be our closest association with the term,
that comic, anarchic puppet has its history in unseen voices of terror. With
the dummy, Connor literally *sees* the end of ventriloquism as the voice
that was once disembodied, omnipotent, and fantastical and is relocated
and resounding in the banal body of the dummy. Now that we can *see*
where the voice has gone, Connor suggests, the dummy becomes a trope
of mourning for "the loss *of the loss* of the voice. We have been severed,
not from our voices, but from the pain of that severance."[10] The particular
technical details of ventriloquism limit its scope within the broad realm
of acousmaticism because the ventriloquistic sound object depends for its
success on being discovered, on its point of origin being seen, in order to
become a phenomenon. In order for the throwing of the voice into another
body, puppet, or recording device to be a successful performance, the
audience ultimately must know *where* it is being thrown from so that we
that may marvel at what is being hidden and what is being revealed. In this
way, ventriloquism is a performative extension of the action of speaking
or singing, from unseen sources inside the body: the larynx, the belly, the
stomach, the lungs.

According to Mladen Dolar, "every emission of the voice is by its
very essence ventriloquism. . . . The fact that we see the aperture does
not demystify the voice; on the contrary, it enhances the enigma."[11] The
ventriloquial voice has lost some of its unique qualities with advances in
technological transformations, as we saw earlier, beginning with radio and
leading to contemporary digital renderings of the voice, which separate
it from its bodily origins, thus "splitting the voice *from itself*, pulverizing
the vocalic body into digital granularity."[12] This digital disintegration of
voice and body, following Connor, fuels the urgency with which some
vocal performers push their "impoverished, dismembered voice-body"
into a state of stubborn survivalist action. The primacy of what they can
produce with their own voice-body alone, amid all the reproduced noise
that surrounds them, maintains a connection with an archaic and eternal
sounding out of the world.[13]

Problems of Origin: The "Art" of the Chioccolatori

What does Joseph Roach mean when he says that separating memory from invention in performance is a potentially deadly and irresponsible act? What is at risk of death? Who is responsible? He suggests that getting the right balance of memory, of history, and invention or imagination at a particular moment places performance in a precarious position, a "crux" of looking back and looking forward. Memory, invention, and death can be extracted as the essential themes at work in the spectacle of the chioc-colatori who perform and compete for the prizes in bird-whistling at the annual Festival of the Bird (*Sagra dei Osei*), which has taken place every August since 1274 in the town of Sacile in northeastern Italy. They organize schools to learn the "ancient systems" and skills, which "preserve the tradi-tions and art of imitation of bird song" known as *chioccolo*.[14] For the joint organizers—the ACET (European Association of Traditional Hunting) and l'ANNU Migratoristi (Association for the Protection and Preservation of Traditional Italian Hunting of Migratory Birds), the highlight of the festi-val is the European Championship of the chioccolatori, in which Italian, French, and Spanish singers compete for gold, silver, and bronze medals in the three main categories: thrush, redwing, and blackbird. In a curious revival of the acousmatic method of veiling the speaker/singer, the rules of the competition in Sacile state that the jury be strictly hidden from view (usually behind a panel) so that they may not identify the singers and can instead concentrate on the quality of their song. In the Sagra dei Osei of 2014, the chioccolatore Camillo Prosdocimo led the Italian team to victory, taking gold in all categories. However, in his work with artists in their installations and performances, such as the German pavilion, Prosdocimo is asked to step outside the hunting context, with its possibility of animal death, that produced his skills. Instead, he transposes these skills into the radically different territory and ideascape of an auditorium or gallery, where it is exclusively his talent as an imitator and performer that is being heard and then observed. Still, Prosdocimo and his fellow chioccolatori never depart from the "ancient art" that they embody. They are always deeply connected to the hunting fraternity they represent, which only exists as a "tradition" because of its historical connection to the hunting of migratory birds. The festival at Sacile can be traced back 750 years, but in it the hunt-ing and eating of birds, as well as adapting and imitating their acoustics for both trapping and cultural reasons, becomes conceived as a timeless

action. With the exception of Cattivelli, artists who have engaged the chioccolatori in their work appear to be more enamored of the strangeness and beauty of the singing men and have not acknowledged the complex contemporary conflicts between the Italian hunting communities and their opponents. As Roach is careful to remind us, performance comes with its own set of responsibilities. In my view, artists such as Daniella Cattivelli who observe and engage with hunting practices are being responsible in their questioning of the ambiguities involved. Following Donna Haraway, who says that while we may try to put distance between ourselves and animal killing, "there is no way of living that is not also a way of someone, not something, else dying differentially."[15] I believe these artists are taking on this "response-ability." Haraway explains contradictions of culture and killing with great clarity in this way:

> I think what my people and I need to let go of if we are to learn to stop exterminism and genocide, through either direct participation or indirect benefit and acquiescence, is the command "Thou shalt not kill." The problem is not figuring out to whom such command applies so that "other" killings can go on as usual and reach unprecedented historical proportions. The problem is to learn to live responsibly within the multiplicitous necessity and labor of killing, so as to be in the open, in quest of the capacity to respond in relentless historical, nonteleological, multispecies contingency. Perhaps the commandment should read, "Thou shalt not make killable."[16]

Returning then to Sacile: when the chioccolatori gather for their annual singing competition, they move about among the traders and bird sellers who converge in their thousands to one of Italy's oldest recorded animal markets. The support for the event is substantial, involving the hunting associations already named above, along with the Pro Sacile Chamber of Commerce, the various authorities of the Province of Pordenone and the Province of Trevisio, and under the auspices and support of the European Association of Federation for Hunting and Conservation (FACE: The Voice of European Hunters). These groups and their members also unite in their general support for Italy's complicated hunting laws, which vary from province to province and are further complicated by an ambiguity of terms.[17] It is under the canopy of these traditions, innovations, and

conservations that the individual chioccolatore stands to perform his interpretation or "rendition" or likeness of a blackbird while a jury listens from behind a veil. In the competitor's performance, we hear the first notes that will inevitably lead to another kind of "rendition" of the animal—its death and consumption by the hunter.

In what Nicole Shukin calls the "'double entendre of rendering,' . . . deeply suggestive of the complicity of representational and material economies in the production of (animal) capital," the imitation or "mimesis" of an animal is one of the labors or faculties of biopolitics.[18] A recurring rubric of Shukin's term "animal capitalization" (the production of animal bodies for sale and consumption) through rendition (killing and preparation of the meat) is a historical wonderment at mimesis, which Michael Taussig defines as "the nature culture uses to create a second nature," the faculty to copy or to imitate.[19] Moreover, Shukin finds mimesis to be constitutional in the real workings of power, not only a product of it. In the historical and theoretical genealogies of biopower, she identifies the "rubrics of rendering, which the economy of mimesis and the business of animal recycling share."[20] The history of hunting and eating animals as well as imitating them and even celebrating, worshipping, or fetishizing them is, therefore, co-constitutional with contemporary practices of animal rendition—or rather capitalist biopower has made it so. The perception that these hunting practices are ancient, universal, and common to all populations has been used to obscure the reality of some more contemporary rethinking of these relationships, while the simultaneous notion of ancient traditions is continually used to shut down discussion. In the context of the chiccolatori and their "traditions" and ancient practices, this paradigm is particularly evident when objections to the hunting of migrating birds are met with staunch defenses of the historical and archaic merits of the practice.

The statistics of contemporary songbird hunting and rendition in the Veneto province alone are staggering. During the hunting season, the individual hunter's legal daily quota of resident and migrating songbirds is twenty per day. A combination of eleven thousand legal hides, traps, nets, and lures across northern Italy ensures a large-scale annual capture that rises to six hundred and fifty thousand birds rendered in Lombardy alone. The legal hunting limit of larks, lapwings, robins, and other resident songbirds stands at twenty million per year.[21] One of the more common methods of luring the passing flocks of birds is the decoy. Birds are trapped early in the season and kept caged in dark cellars throughout the summer

months. When the migration begins, these birds are brought into the light. Deceived into thinking it is spring, the decoy birds sing and, in doing so, seal the fate of those they wish to seduce. In a double deception, this spring song lures the passing flocks into the cages and from there onto the kitchen table. Here, again, Roach's combinations of imitation, responsibility, and mortality are tested. In this complicated knot of tradition, animal acoustics, and biopower, the hiding and revealing of the animal's voice is its unstoppable undoing.

In response to these actions, another community is taking on a different set of responsibilities. Activists campaigning against these liberal hunting laws organize summer and autumn camps in which hundreds of volunteers go on camping expeditions to dismantle nets and snares and free decoy birds. For example, when CABS (Committee Against Bird Slaughter) began their campaigns in the 1980s, they estimated that three hundred thousand bow-traps targeting robins were being set every year across northern Italy. Because of their annual campaigns and dismantling expeditions, CABS now calculates that around two thousand robin bow-traps are erected. The changes brought about by legal challenges and on-the-ground activism has radically altered how songbirds and humans interrelate in this one area of Europe. CABS also focuses a great deal of energy on Greece, where traditions of snaring migrating birds through caged decoys and other poaching methods are active, and actively defended. However, the principal problem in all countries, for both CABS and for legal hunting agencies, comes in the form of the poacher.

Hunter organizations blame the poachers for all of the extra captures and kills that occur outside the legal limits of the law. For the activists, the most difficult and dangerous aspect of their dismantling expeditions is engaging with poachers, often on private land, who adamantly claim their right to ancient traditions and generations of skills. Hidden and militant, poachers argue for their traps as a connection to an even more timeless, prehistoric past. Shukin concisely interprets this argument for hunting and killing animals when she writes that "via this description of rendering, animal capital melts back into a timeless tableau of use value, appearing to be anthropologically continuous with an age-old practice of using every part of the animal."[22] In response to the poachers' claim to historical privilege, the CABS campaigners are quick to remind the poachers that when their forefathers captured thrushes and redwings in the same field for hundreds of years, their needs were entirely different, and there were

millions more birds and fewer people. The poachers claim, as do the legal hunters, that the activists, along with the government, are forcing a great cultural loss breaking an epic narrative with their ancestors and the land itself. The activists are motivated by a different sense of loss and also look to a prehistoric time when bird migration was uninterrupted by issues of tradition, memory, and cultural practice. Therefore, which actions and behaviors involving or relating to animal rendition are to be considered art and tradition, and by whom? How do some practices become barbaric and others elevated to an artform? In the sound art events involving the chioccolatori, where does their song begin and end, and what territory does it describe today? Intentions become confused in the open spaces between treasured and despised traditions. Inside these spaces, artists, activists, hunters, and animals are crossing into each other's territories in ways that produce events and raise questions about memory, invention, and animal death. In each case, the arguments are further entangled by theories and perceptions of origin.

Problems of Origin: Palaeoperformance

Stepping further back into the much-contested arena of the origins of theater and performance, the presence of animals has been central to, and indeed cannot be separated from, any history of performance, from its memory or from its invention. Creaturely acoustics are present at all origin points that travel back through the Dionysian cycles favored as cradles of drama by traditional theater historians, and back further to ritualized social events from the Upper Paleolithic or Late Stone Age era (50,000 to 10,000 years ago) and onward, as argued by Performance Studies cofounder Richard Schechner and more recently by behavioral archeologist Yann-Pierre Montelle in his book *Paleoperformance*.[23] The sound-producing artifacts that have been gathered from the hundreds of caves where evidence of prehistoric social life appears in the form of paintings are, like those paintings, exclusively animal. Whistles, flutes, and bullroarers made from the bones, antlers, horns, and tusks of the animals depicted on the walls of the deep caves in southern France and northern Spain provided scholars with enough evidence to formulate extensive theories about initiation ceremonies, prehunting rituals, and shamanistic rites of passage that have dominated speculation about what was taking place in these caves during

the relatively short "creative explosion" of the "Refuge Interval" era between the ice ages. The extraordinary paintings of charismatic megafauna such as mammoths and bison have conventionally led archaeologists to formulate elaborate theories of initiation ceremonies of the male hunter facing and killing the enormous beast. More recent (early twenty-first-century) zooarchaeological revisions of these theories point out that the middens or collected remains of animal bodies found inside and nearby the caves and other sites mostly contain the remains of much smaller prey: ducks, geese, gamebirds, songbirds, and other small fowl, in bulk, alongside pack mammals such as small deer and goats. Indeed, the predominant source of protein bird meat in the Paleolithic era was grouse. Migrating and nesting populations of waders and songbirds in the millions were the target of hunting populations from the Paleolithic to the late Mesolithic eras. How humans move with the migrations and rhythms of species is a relatively recent area of study that proposes a more integrated approach to understanding the archaeological stress of the human-animal hyphen.

Instead of focusing on the traditional theories of the emancipation of humans from the world of animals, recent archaeological studies argue for the existence of much closer human-animal relationship behavior, bound together across spatial, material, and co-evolutionary time. Rather than perceiving animals as a passive resource of raw calorific yields, some scholars propose a dynamic of interactions in human and animal social assemblies, where merging boundaries of influence begin to blur terms like "domination" and "dependence." For example, studies of swan migrations and their integrations with hunter populations in Paleolithic cultures show that the balance of influence is clearly determined by the seasonal movements and feeding behavior of the whooper swan, which is subsequently reflected in the desires of the hunter. The benefits of following and understanding the life-world of this large bird clearly impacted the social practices of the hunters in ways that went beyond a mere source of protein. The remains of swan bodies are found outside of food waste middens and appear as aestheticized and ritualized material, such as in the burial of a child on a swan's wing; also, some of the earliest known musical flutes are made of swan bones. Indeed, the larger the bird, the less likely it appears in archaeological surveys of animal-as-food bone deposits. This could be for reasons of taste (eagles are tasteless) and availability (ducks and eggs are plentiful). Bones of the aurochs and cave bears that are represented visually and unilaterally as charismatic megafauna to be revered are notably fewer

than the bones of smaller animals in the occupied caves. The bones of cave bears are almost always considered to be the remains of animals that died of natural causes. In contrast, eagles, vultures, and other less easily digestible birds consistently appear more as ritualized or aestheticized figures within funereal or musicological contexts, alongside all the other minor mammals that feature in the gastrobiography of human evolution. The archaeological swan, which was widely digested, also becomes a performance animal, its leg bone sounding a song while a dead child is delivered on its wing to the next imagined life-world. Meanwhile, the thousands of bird bodies in the prehistoric middens or food waste dugouts emerging across northwestern Europe deliver evidence of animal hunting as a social practice, presenting an alternative view to that of the lone male hunter overcoming the great beast. In the shade of these discoveries, the long-perpetuated concept of the lone, prelingual, initiated man with his spear in front of the painted animal on the cave wall, contemplating his pursuit of the bison or auroch, is weakened. Montelle's proposal is that these "galleries" must therefore have been sites of theatrical activity, or, to use his term, "palaeoperformance."[24]

Palaeoperformance expands creativity into the caves of Stone Age culture. This rethinking could be broadened even further into a more open, less gendered speculation on the decorative, domestic aspects of how the caves may have been used (for eating, sleeping, birthing, raising children, teaching, living, and dying). But what Montelle has done here is to allow for a shift away from the too-literal concept of initiatory secret rituals of boys to men—or what Jacques Derrida might call a "carnophallogocentric" assumption—and their contemplation of conquering and eating large animals in front of this enigmatic parietal iconography. While Derrida is sure that "no one will contest that in most overwhelming phenomenal form, from hunt to bullfight, from mythologies to abattoirs, except for rare exceptions it is the male that goes after the animal," his questioning of the position of the male hunter at the center of history, "establishing his dominion over the beasts," allows for new ways of thinking that suggest there were others in the cave devising more creative and diverse extensions of that dominion with the leftover remains.[25]

Acoustics and architectonics in paleoculture are always entangled with animal bodies, ingestion, fetishization, and zoomusicological instrumentation. The phenomenon of animal-based musical instruments that emerge out of the zooarchaeological histories of the Upper Paleolithic is crucial because of their specific acoustic and acousmatic qualities within

human spatial, temporal, and territorial hunting practices. Mapping of cave chambers has been inflected by their sound-producing qualities and differences in acoustics and spatiality in relation to paintings and drawings, such as the Hall of the Bison, the Chamber of the Bears at Chauvet Cave, and so on. Scholars speculate and differ over the functions of the sound-art relationships in these contexts but agree that the sounds produced in palaeoperformance are almost certainly acousmatic in nature. In the dim torchlight or darkness of the deep interior of these caves, any audible sound is altered and accentuated. Sound archaeologists have concluded that the performance of the instruments was carried out in secret, smaller chambers, hidden from "initiates" or any audience that was present. In some contemporary hunter-gatherer societies that inspire these speculations—in South America, for example—even the sight or knowledge of the instruments by the uninitiated (usually women and children) could result in punishment by death. The source of the ritual sound, especially the bullroarer, must remain hidden, and perhaps this is simply because of the power of its acousmatic effect. Power and its sources are always protected in any community, not least in these tribal contexts. We can never know whether the Paleolithic ritual/performance was deliberately and directly connected to hunting animals. We do know, however, that these people hunted some animals for food and made music with the remains.

Becoming Acoustic

Within the spectrum of findings on prehistoric sound possibilities that have been developed in diverse and interesting ways across archeological and ethnomusicological studies, the proliferation of animal matter in the production of art-sound is substantial.[26] The bullroarer alone appears in hundreds of sites. In its plain, flat, oval bone shape and the simple dynamics of its rotating string, this ancient musical instrument transcends time by consistently turning up in contemporary Indigenous and Aboriginal cultures. A wide variety of whistles and flutes made from hollowed-out bones spans all aspects of paleocultural tool production. Indeed, in Montelle's broad survey, it is the finer points of difference between a bone whistle and a bone flute that draw his attention into this paleocultural point of origin. Increasing interest in recent years in the acoustic dimension of Paleolithic cave sites has produced more analysis and appreciation for the qualities of

and differences between whistles and flutes made of animal bone that are found in large quantities in all locations across Europe. The whistles are invariably knucklebones and other short, stout bones with one perforation. With one finger covering the air hole, the whistle-blower can produce a wide, shrill sound of up to 4,000 Hertz. In Michel Dauvois's field tests with contemporary examples of bone whistles from First Nations peoples in Canada (the Mackenzie), the effect on reindeer was pronounced. Curious to find the source of the sound, the animals became entranced and approached closer, losing their defenses and even lying down in a trusting state, thus easily affording the hunter his quarry. Montelle calls this phenomenon a "rupturing of the soundscape with artificial tones," where the sounds performed with the hunting whistle are most likely intended for the animal's ears alone.[27]

The excavation of the earliest bone flutes (with two or more perforations) radically altered perception of the activities of these prehistoric people.[28] Where longer flutes appear, made from leg bones of swans, eagles, or vultures, a performing figure emerges from the perfunctory hunting-gathering milieu and begins to animate this enigmatic period in completely new ways. Flutes of bird bone produce melodic scales and artificial tones, which massively expand the sonic spectrum of the Upper Paleolithic and increase speculation about the emergence of an era of theatricality (or theater-without-words). The overall sound produced by these early instruments is clearly more abstract than a mere copying of natural sounds or an imitation of animal acoustics for hunting or even amusement. While the whistle is clearly useful to hunting, the actual purpose of the sound of the flute is only barely decipherable. We can only speculate on the meanings that the sounding-out of the bird-bone had for the musicians of the Upper Paleolithic through the sound echo we hear in living hunter-gatherer cultures today. In these environments, the connection between the instruments and the activities of the animal-hunter-artist triad are plain to understand, as they exist only alongside each other and because of each other. In these relatively recent notions of interspecies participation and significance, the ecological aesthetic at work in human-animal relationships in early societies begins with the intentional carving of a flute from a swan's bone.

Recent studies of prehistoric cultures where human-animal relations are reimagined as a coproduction of social worlds reveal porous boundaries of social action and concepts of personhood among species. These ideas have done much in archaeological research to dissolve the long-established

separation of humans from animals.[29] Precious material artifacts such as the whistle and flute, along with their acoustic artificiality, reveal a wealth of connections between the hunter, the animal, and now the performer in multiple spatial arrangements of caves, shelters, graves, and other domains. The spatio-temporal aspect of these studies now considers not only the movement of the hunter but also the simultaneous movements, rhythms, pathways, and behaviors of the hunted. For example, archeological evidence of the hunting of the whooper swan in landmark excavations of prehistoric sites around Aggersund, North Jutland, has been interpreted as a testament not only to the social value of these migratory birds but also to how their diurnal feeding rhythms, roosting sites, seasonal adaptability, and other fluctuations were profoundly synchronized with the rhythms and movements of the Mesolithic peoples who came to depend on them.[30] Archeologists Marcus Brittain and Nick Overton have observed that the whooper swan's migratory pattern to Aggersund is the same today as it was in 4000 BC; therefore, the early human practices of anticipation, journeying, preparation, hunting, and ritualization of the swan—which extends far beyond mere chase and kill—can be revealed once an interactive approach is applied to the inquiry. Using today's ornithological, biological, and geographical knowledge of whooper swan migration and behavior, Brittain and Overton now appreciate a far richer "synchronicity . . . of the hunt across paths and places, through a sensory field of varying times, light, temperatures, and weather extremes, simultaneously disclosing situated boundaries of alterity" that are also fluid, cohabitational, and, above all, interactive. This synchronicity shifts the positions of humans and animals, where "the significance of Otherness is situated against the alignment of tempo, place, and practice."[31] This interaction in human-animal participation histories emphasizes the nature of creative practices that emerge within material configurations and assemblages of human-animal engagements. Boundaries between species can be contested, embodied, transformed, and fluidly renegotiated when our approach is open to narratives that involve the dynamics of living and dying with animals.

Hunting and Acoustic Territorialization

In his anthropological accounts of English foxhunting, Garry Marvin writes about "the performance of hunting" and how a territory acquires

"a set of sensual and experiential qualities that become enriched with each hunting event. The memories are of what has or has not happened before: the present excitement is one of potential, what might occur and what experience it will generate."[32] The territory Marvin refers to is the English countryside, where generations of hunting practices (since at least medieval times), specifically the foxhunt, have "*converted* the countryside into another space . . . a sacred space of deep emotional significance and social and cultural resonance."[33] To be a good hunter means being an excellent listener. Hunting, according to Marvin, is a "fully embodied, multi-sensory and multi-sensual practice that depends on an immersion into a multi-sensory and multi-sensual world."[34] In his essays on foxhunting as "a highly complex ritual, ceremonial, performative event" he focuses on "the immediacy and the experience of hunting rather than an exploration of its social and cultural meaning."[35] In the sensorial, immersive experience of the mounted foxhunter, "presence is fundamental," where "the Hunt openly and deliberately announces itself to the countryside . . . connecting human and animal bodies . . . and dramatically enacts a set of relationships with the natural world."[36] The hounds are central to the entire event, and their cries announce their version of the landscape. Marvin describes the "voice" of the hounds in great detail as follows:

> As soon as a hound picks up the scent of the fox, it should signal this to the other members of the pack through its cries—a hound must be able to communicate. As more and more hounds find the scent, the cries intensify and are interpreted by the human partici- pants as a commentary on the developing relationship between the hounds and the fox. This cry is not merely a utilitarian signaling device; it is an important aesthetic element, and breeders hope to produce a complex set of voices and harmonious sound within the pack. Hounds are regarded as having bass, tenor, alto, or soprano voices, and these should be well represented. A mute hound—one who is unwilling or unable to use this quality of canine sound—is incomplete. The collective sound of the pack when hunting is referred to as *speaking*, and this sound is both appreciated and responded to aesthetically. Not only should the hounds' cries have content which communicates a message, but the sound, purely as sound should have a quality which is registered by referring to it as "the music of the hounds." [37] A simple set of canine sounds are

transformed in the imagination of the human listener—the natural becomes cultural.

The keenest listener here is perhaps the huntsman (and sometimes huntswoman) who must interpret this hound-music in order for the natural to become cultural and for his cultural equipment to be accepted into natural laws: he is "the catalyst of the relationship between the central animal performers."[38] The huntsman and the hounds form "an *ensemble* linked by mutual purpose, understanding and feeling . . . [the hounds] are hunting with and for the Huntsman."[39] In this fox-hunter-hound-spectator quadrangle, the hound-music and the huntsman's horn are the threads that connect all four entities across the various zones of proximity in which each "actor" follows through on his or her role or position. Marvin says: "This is performance defined as practical achievement, but it is also one that allows a more evocative accomplishment to emerge."[40] For this kind of performance to be fully realized, the engagement with the hunt must be total, and this necessitates a high degree of emotional connection between all its participants and the natural world in which they are immersed. The landscape, the lives lived on and within it, and those contained and constituted by it are the foundation for this deep connectivity upon which the cultural performance of the foxhunt depends. It is the life lived in this environment, Marvin says, that informs the "condensed, distilled, concentrated" actions of the foxhunt that are related to but distinct from everyday life.[41] Certainly, this can also be claimed for the bird hunter, who, unlike the huntsman who occasionally catches the sight or scent of a fox, is listening to his prey from first light, surrounded by the acoustic presence of the birds throughout the day, negotiating and anticipating proximities of performance and interaction in both the human world and the world of the bird.

Like the hunter and the bird catcher, who Marvin says must always "give themselves to *being* in the countryside in a more intense, aware, responsive way than they normally would," these actions suggest an understanding of the structure of experience that Martin Heidegger termed the phenomenon of *Dasein*, of being-there.[42] While his ideas have been much critiqued, from a human-animal studies point of view, as overly anthropocentric, there are some terms here that I think can be useful in understanding what I believe is happening in performance practices. Animals do understand their world, according to Heidegger, but it is limited,

encircled, "ringed," and not open to self-awareness like the human Dasein. Humans may enter an awareness of the experience of other beings, like animals, but this is not a two-way path. Animals, he says, cannot leave their sphere of awareness. This lack, or "poverty," of the animal's world means it cannot escape its own sphere of experience, a much-contested idea, not least by Derrida and Haraway. Human (and, we might now say, perhaps, also animal) experience, however, is not limited to just one's own awareness of being-there (*da-sein*) but also to being-with (*mit-sein*)—the experience of being in close, bonded relations with another of one's own kind—and also to *dabeisein*, being-there-with or being-alongside.[43] In John Macquarrie and Edward Robinson's translation of Heidegger's *Being and Time*, they explain *dabeisein* as "to be there alongside" or "to be at *that* place."[44] I would argue that it is in fact even more participatory: to be in a state-of-participation-with, to be in the mix, to say *Ich bin dabei*, meaning "I'm in with that," "I am on for that," "I am with you in that project," or simply, "I-am-being-there-with." We are both at the same event, but "we" are not an event. Most crucial, I think, is the precise perspective that Heidegger says is held in *Dabeisein*, in being-alongside, as that "which is absorbed in its world speaks not toward itself but away from itself toward the 'yonder' of something circumspectively ready-to-hand; yet it still has *itself* in view in its existential spatiality."

The experience of life is all the richer for "letting something be involved" or "being-alongside it spatially."[45] Being-alongside is always a doubling of some kind, whether spatial, visual, or experiential. It is this doubling or multiplying of perception that can be useful in determining what is at stake in the forest, or the theater, or in general for the artist. The ability to look both ways and understand multiple perspectives but stay independent of one's quarry is what sets the huntsman apart from his fellow riders, or what allows the bird hunter to get so close in song to the blackbird without losing sight of his goal. It is also what propels the artist, such as Cattivelli, to get so close to the chioccolatore, to share the same performance space with him while remaining very separate in the production of her work. Where, precisely, is the animal acoustic in her soundscapes located? Is it more a *dabeisein*, a being-alongside? When we come to her performance piece titled *UIT* (2013), which ends with the real virtuoso warbling of the chioccolatori, her curiosity with being and becoming bird is the overarching theme of the work, and it begins with the question: what does it mean to sound as a bird? What is the sound of being-alongside-bird?

UIT and Other Adventures in Acoustics

In the work of Cattivelli and the chioccolatori, a door is opened to complex, prehistorical, interspecies practices of participation in which the aesthetics and realities of hunting practices are tied to traditions and tensions of otherness and survival. The challenges that these traditional practices present, specifically when they are incorporated into contemporary performance contexts, can create echoes across disciplines, such as zooarchaeology. By both listening to the findings of others and reflecting on who or what counts as an actor in the production of historical acoustic territories, artists like Cattivelli become the hinges for this newly opened door. In *UIT*, Cattivelli stood at her laptop computer in a large blue room at the Museo d'Arte Moderna in Bologna, with a metal disc in her mouth and a variety of flutes and whistles beside her. She produced a soundscape with these tools that was insect-like, then like rain, then like techno-static-interference, then like the sustained chords of a church organ. Raising her face up, her neck pronounced, she made bird sounds through the metal object between her teeth—"UIT UITIT UITRU TITRU TITITRU TUT"—while blending and reforming the sounds from the laptop. As her performance closed, two chioccolatori, Rizzo and Prosdocimo, entered the circular arena that the standing audience had created around Cattivelli. Her actions ended as theirs began. There was a clear separation between the two, signaled by a lighting change. Cattivelli did not hide the "surprise" of the source of the sound at all. Rizzo and Prosdocimo strode into the room, faced the audience, gestured to them, and whistled and called to each other. The only acousmatic elements here were the reed instruments in the chioccolatoris' mouths. It is clear that they delight in the illusion they are creating, flapping their arms a little and making tiny quick head movements without giving away the source of their skill. In contrast to Cattivelli's open display of the instruments throughout her performance, the chioccolatori are experienced performers and sorcerers of their illusion. They know that the reeds must remain hidden in order for the magic trick to work. Concealment, acousmatics, and ventriloquism are all essential to the origins and success of their artistry.

Cattivelli devised this piece, titled *UIT*, for the 2013 Live Arts Week in Bologna and invited Prosdocimo and Rizzo to participate in her event. The chioccolatore is an illusionist on several levels. His high pitch belies his heavy human physique; his "skill" is hidden in the reed in his mouth;

and the mimicry of the bird is not for our listening pleasure but a skill of hunting. The delight in encountering this chioccolatore at a fair or in an installation lies in his animated interpretation of what a bird sounds like, of what it might be like to sound like a bird. However, his skill is motivated by a desire to know what it might be like to *eat* a bird. As I recounted earlier, Rizzo and Prosdocimo make many more appearances at hunting trade fairs and local food festivals than they do at performance art events. In the context of the local festival, the applause for the performing warbler-men is an acknowledgment of their hunting skill and its long history. In this complex cultural moment, the making of birdsong cannot be separated from making of a blackbird pie. In spite of the opposition and controversy that accompanies both practices, the chioccolatori embody the convergence of skill, potency, poetry, and timeless actions. Some artists engaging the warblers in performance installations desire these qualities to be demonstrated in their own work, borrowing the aesthetics without any of the mess of slaughter.

In Cattivelli's engagement with the tradition of chioccolo, she plumbs deeper into the subject, and her work is strengthened as a result. Cattivelli uses the term "sound capture" and interprets the chioccolo as "sound bait." In *UIT*, she says she takes the hunting skills of the chioccolatori only as a starting point to "pursue the idea of a 'sound trap' that plays with falsification and deception."[46] In these sound works, the artist is fully aware of how she is drawn to these "somehow dreadful" musical instruments and the range of sounds they can produce from the breath alone. But she also recognizes that this "blowing" is not enough. The birds may be tricked into a position in which the hunter is waiting for them, but only if the hunter knows "what every bird's song sounds like in all its nuances. Bird call players can be considered then as virtuosi, for they have to know and to be able to reproduce the different calls the birds sing in different situations: when they are eating, when they are mating, when the place is safe or dangerous."[47] It is important to note that Cattivelli understands the complexities of skill involved in chiccolo practices, and there is nothing casual about their inclusion in her performance. She has considered and understands her sound sources entirely, and she has created substantial compositions with her own interpretation and use of the chioccolo instruments. She is clear that her interest is in extracting the strategies of sound production, mimetic acoustic techniques, sound transfiguration, instrumental procedures, syllabic sequences, and the building of "a new vocabulary of sounds, a fake language, which is the fabric of an artificial soundscape open and

available to incursions that broaden the sound grid."⁴⁸ As is clear from her other compositions and explorations in sound art, she is first and foremost a musician with expertise in industrial and contemporary art-music, electro-acoustic instrumentation, improvised music, and music for theater. In her own performance section of *UIT*, she delivers the sounds from her standing position at the laptop without physical gesture or mimicry, instead allowing the sound to take the primary position in the performance. Her own performing body appears neutral: central but with minimal expressiveness. Instead she allows the bird sounds, abstract recordings, and distortions to become her "assemblage of independent blocks" of modular sound design. The compositional intention, she states, "is a rethinking of the methods and techniques" of the chioccolatori.⁴⁹

Why, then, does she involve Rizzo and Prosdocimo at all? Their inclusion seems central to the piece; indeed, in a second performance of *UIT* in the Muséum de Toulouse (October 2013) the two men traveled with the production and appeared again at the end, enchanting the unsuspecting audience with their "surprise."⁵⁰ Clearly there is something at work in the practice of the chioccolatori that only their own performance can produce and that Cattivelli wants as part of hers. As performers, the chioccolatori are certainly not what they first seem (men who can sing like birds), and the deceptions and tricks attached to both their performance and their hunting practices certainly stand in marked contrast to the context of the gallery or stage. Even though Cattivelli does not draw attention to gender differences in *UIT* and other performances she has made with chioccolatori, there is a striking contrast between the heavy men and the slight figure of the artist herself. Certainly, putting a woman-as-bird onstage has a long and diverse history, and it is tempting to project a feminist perspective onto Cattivelli's *UIT*, if only to illustrate how it departs from the trope of soprano/bird. Adriana Cavarero writes that female vocal figures, "from Sirens to muses, from Echo to opera singers," provide a crucial counter-history to the evasion of the individual embodied female voice by reconstructing what she calls a politics of the voice, reinstating the uniqueness of "who" is speaking."⁵¹ For Cavarero, "myth is full of female vocal creatures."⁵² No myth is more relevant, she writes, than that of Homer's Sirens, where "clearly, it is the feminine song that is at stake. This is precisely why it is so disturbing. It disturbs, however, in a rather curious way with respect to generic stereotypes that one finds in Western traditions. Homer in fact wants the monstrous singers to be omniscient."⁵³ Homer uses the Siren

figure to counter the narration of his epic tale, the *Odyssey*. They are there to guarantee a seductiveness and lethal pleasure, to threaten the authority of the demigods and enforce a power all of their own.

Unlike staged, operatic bird-women—such as Wagner's Woodland Bird in *Siegfried* or Walther Braunfels's Nightingale in his opera *Die Vögel*, based on Aristophanes's *Birds* (414 BC)—I position Cattivelli's persona in her performance closer to the Sirens. These in-between creatures, birds of prey with a woman's head and chest, form part of a pack or flock on their own island and are identified by the actions caused by their singing. The Sirens' function is enclosed, total—the luring of prey through singing—not in order to seduce men but simply to hunt by singing, to eat, to nourish themselves, to live. Their island is made of bones and rotting flesh, but in the description of classicist and linguist Jane Ellen Harrison, "horror is kept in the background, seduction to the fore."[54] Harrison's own early feminist reading of the myth is frank and poetic at the same time. However sweet the Sirens' singing may sound to a passing Greek demigod, "the end of that song is death."[55] For her, the song of the Siren (there were usually only between two and three sirens on the island) is closely associated with pure living and dying and has only a passing relationship with gender. Becoming-siren and singing is a means to an end, a method of survival. In ritual, in Greek drama, and in contemporary sound art, it is important to choose the right *species* for being, becoming, and becoming-alongside in order to get the artist through the struggle of production. In Deleuze and Guattari's theory of becoming-animal as another way of thinking about being, they suggest changing our anthropocentric perception of life as a stable, partial, or moralizing perspective and instead thinking of becoming as a freedom from seeing ourselves as detached from life and nature. In becoming-animal, we can begin to perceive the forces and powers of life with which we are always in zones of proximity, the vital materiality of being in and of the world. For example, Leonard Lawlor recommends becoming-rat as an excellent method of getting underneath the world of literature and creating "a new syntax of gnashing," where "writing like a rat would be a writing that struggles to escape from the dominant forms of expression."[56]

Cattivelli does this by becoming-jay. After creating *UIT* with the performance of the chioccolatori and other theatrical elements, Cattivelli stripped the work down to its core, with just her own performance, including her laptop and whistling instruments. She performed this new version (*estratto*,

BECOMING ACOUSTIC | 59

or extract) under the title *Garrulus glandarius* (2013), the Latin name for the Eurasian jay.[57] In this work, Cattivelli chooses only this bird to interpret and does not reach for the many hundreds of whistles and reeds available to her. Cattivelli breaks the rules of chioccolo by honoring the jay with a new composition. The jay is a boundary bird, a liminal acoustic creature, and hated by the hunting fraternity because it alerts other birds to their presence. The jay, or "wood watcher," is the intermediary between each chioccolatore and his quarry, or between the passerines (perching birds) and whatever is not *for* them in their world. Fanciful, shy, and loud, this observant bird is the ideal bird-becoming for the artist, Cattivelli. The jay is fundamentally interstitial, with the ability, through impersonation—losing the person—to become other-than-jay. It watches behavior on all sides and is, in its way, fair: anything unusual is reported. It is up to the woodland residents and visitors alike to negotiate how they choose to respond to the alert.

In *Garrulus glandarius*, Cattivelli creates a new soundscape for the jay with existing chioccolo instruments. In terms borrowed from Deleuze and Guattari, she has successfully transcended both oedipalized power structures (of the chioccolatori) and other perceivable carnophallogocentrisms by becoming-jay. Her attraction to/repulsion from the activities of concealment in the practice of chioccolo are crucial to her choice of bird to become-alongside. The jay is already an in-between creature, sounding warnings and listening attentively for danger in the worlds of both animal and human. By creating a new sound and a new creative event that is not imitation, one that is never the same and that changes with each performance, Cattivelli achieves an expression of the state of both becoming-animal and becoming-alongside. She fully embraces the artificiality and trickery of her techniques by "changing, damaging, falsifying syllabic sequences" to create "a fake language which is the fabric of an artificial soundscape."[58] She usurps the sound of becoming-animal by disturbing its accuracy.

As a musician working in depth with birdsong and bird behavior, Cattivelli has a tenuous connection with the practices of Messiaen and his "walk in the woods" method of becoming-bird/ becoming-artist. Her interpretations display a broader appreciation of the life of the bird and its entanglements with human society, and not just its aesthetic or musical values. But she still directly acknowledges Messiaen by calling her activity "an effort to rebuild a sound environment that reproduces the acousmatic experience of *a walk in the woods*, of the disorientation experienced due

to the perception of sounds to which one is unable to attribute a concrete physical source."[59] In *Garrulus glandarius*, Cattivelli is clearly playing with the material voice of the bird and instead merges it into her own interest in sound technology and composition, without any sentiment for the bird sound itself. She delivers a charged and confrontational sound work that reveals its ornithological sources through building and repeating sound cycles, turning itself over and over on its own vocabulary. Cattivelli uses the term "jamming" to describe her interference or manipulation of sound. For her, the word alludes to both music and resistance. She explains jamming as "the act of intentionally disrupting radio communications in such a way that decreases the signal/noise ratio. It is carried out by transmitting on the same frequency and with the same modulation of the signal you want to hide."[60] As a method of both censorship and confusion, jamming is used on all sides during conflict: to interrupt information, to warn the enemy, to sabotage communication systems. She is also making reference to "jamming" in musical terms: using improvisation, leaving the score, and departing from the canon. Alphonso Lingis surmises that "all these stammerings, exclamations, slurrings, murmurs, rumblings, cooings, and laughter, all this noise we make when we are together makes it possible to view us as struggling together, to jam the unequivocal voice of the outsider."[61] Cattivelli achieves all this in *Garrulus glandarius* without the performance of chioccolatori. For Lingis, and maybe for Cattivelli, "to live is to echo the vibrancy of things. To be, for material things, is to resonate."[62] In the simplicity of *Garrulus glandarius*, she opens up her practice as a composer and musician to a sense of play and experimentation. As spectators and listeners, we are invited into an acousmatic experience of being and becoming-alongside. We are reminded that we have always been listening and calling, hearkening and responding to creaturely becomings.

BECOMING BOTCHED

Play, Tactical Empathy, and
Neo-Shamanic Acoustic Legacies in Performance

A mighty magic comes alive as death animates things.
—MICHAEL TAUSSIG

Before taking up an artist-in-residence opportunity in Norway in 2006, the English artist Marcus Coates had already begun to stage a series of relational performance events and social interventions that were informed by his interest in shamanism and its connections with live art. He was questioning the meaning of the artist's role in a community and how it could relate to the nonhuman world. Seeking a way to combine his interests in archaic ritual practices with his extensive knowledge of ornithology and the becoming-animal theories of Gilles Deleuze and Felix Guattari, Coates attended a weekend course in shamanic practice in Notting Hill Gate in London. He found that he could apply his knowledge of British birdlife and general wildlife acoustics to attempt to access other worlds populated by animal spirits, thus giving him the means to receive and interpret any messages on his "journey to the Lower World."[1] Fully aware of the potential incongruities of positioning part-time shamanism, human-animal studies, and urban sociocultural politics alongside each other, Coates felt compelled to put himself and his art at risk in a series of community-based live art projects. These tensions and seeming incompatibilities produced a radical rethinking of how animals can be encountered in the praxis of performance. In this chapter, through a close reading of Coates's work, the tactical empathic techniques of the hunter/performer are positioned

alongside those of the shaman in circumpolar Northern communities and in the aesthetic and performative legacies of these practices. Shamanism, schizophrenia, and Deleuze and Guattari's theory of becoming-animal each explore notions and dimensions of personhood. In Coates's events, like those of his predecessor in art/shamanism, Joseph Beuys, multiplicities of selfhood, personhood, mimesis, and magical alterity are tied to the material values of creatural acoustics.

Stavanger

When the community of Stavanger in Norway invited Coates to come and stay in their city, their openness to his shamanistic practices, his incidental street performances, and his predilection for wearing stuffed animal bodies was rewarded with the complex, emotive work titled *Radio Shaman* (2006). During his artist-in-residency period in Stavanger, Coates asked certain community groups what issues or problems concerned them, in order for him to make some helpful action that might effect a positive change. More than any other issue, the people of Stavanger were concerned about the increasing presence and the welfare of immigrant Nigerian women working as sex workers in the city center. In response, Coates chose three sites where he performed a shamanic ritual action. Wearing a black suit and tie, along with a deerskin with a full head and antlers, and holding a stuffed hare with the head of another hare protruding from his chest, Coates went into a shamanic trance in Stavanger Domkirke Cathedral, in the City Mayor's Office, and on the streets where the Nigerian women worked at night. In the filmed recordings of these performances, Coates moves about calmly, pausing with his eyes closed, and then emits the sound of whatever spirit animal he is encountering in his quest down to the Lower World, the world of the animal spirits. From the deep intensity of his standing-still position he suddenly and loudly imitates the cries of a stag ("oargghh oargghh oargghh"), then a sparrowhawk ("kek kek kek kek kek kek kek kek"), and then a red grouse ("dug dug adug aduga duga dugadadadadadadug").[2] Over the course of repeated trances, the image of a young seal becomes a recurring vision for the artist. The seal pup is stranded on the rocks, and its parents are swimming nearby. If Coates goes to help it, it will bite. Coates says, "I wanted to help, but it didn't understand the complexity of

the issue."[3] Instead Coates returns from his shamanic journey and reveals his findings live on local radio. At the host's request, people telephone the show to discuss the issues with Coates following his findings. In response he suggests that, just as he found both empathy and danger with the seal pup, the community might seek a way to engage with their issues about the sex workers in a less threatened way. He does not compare the seals with the women, but he perceives their similar positions of vulnerability, danger, disorientation, and otherness and presents the image of the problem of the seal as a way of broadening the discussion.

As with other shamanic journeys he has taken on behalf of a community, the solution is not clear or literal. Instead, as Ron Broglio writes, the artist perhaps simply or naively indicates "a pathway of affect that otherwise remained hidden."[4] In a similar performance ritual for the residents of a soon-to-be demolished tower block in Liverpool, titled *Journey to the Lower World* (2003), the action takes place in the living room of one of the participants. Prior to the ritual, the residents tell him that their question relates to what will become of their community when they are forced to move to a new estate. They wish to find out if they have a protector or a guide and who or what it might be. Wearing the deerskin, playing drumming sounds on a cassette tape, and ringing of a bunch of keys instead of bells, Coates provides an answer that is perhaps even more obscure than the seal pup and involves a sparrow hawk with a broken wing.[5] But in this case, the residents themselves tease out the imagery he presents to them. The artist does not have the answer. He is the conduit. They put together a series of possible derivations that suggest a way of supporting each other as a broken-up entity and of finding ways of staying together. As in Stavanger, the image of vulnerability is strong, and it leads the residents to understand that empathy is the solution.

Coates's approach to neo-shamanism, and his loose and urbane collection of ritual objects that approximate those of a "real" or "serious" shaman, have been described by himself and others as accessible, humorous, and loaded with bathos. His whimsical forays into ritual and play, mixed with an expertise in ornithology and a developed interest in anthropology, have caused some to categorize his work as superficial and lacking the perceived depth of engagement of an artist like Joseph Beuys, whose actions also borrowed from shamanic traditions. J. J. Charlesworth summarizes these dilemmas when he writes:

This act of appropriation [of shamanism] from its original com-
munal context into our Western secular culture is already a form
of mimicry and, of course, in a social context, mimicry can be seen
as a form of deceit: What is the boundary between shamanism
and charlatanism? . . . The shaman of *Journey* may be a charlatan,
because his act, the act of making things better, seems too implau-
sible—not because he has belief, but because he has not convinced
us to believe in him. Yet this derelict form of character is one we
are nevertheless happy to maintain in the more contemporary
guise of the socially committed artist.[6]

Coates exposes his "charlatanism" first, ahead of his genuine inter-
est in the lives of others of all species, and only then reveals his genuine
understanding of what it is like to become other, to become-animal,
guided by the philosophies of Deleuze and Guattari. In this way, he can
remain superficial and lightly accessible while having a praxis of genuine
depth. At the 2013 Rutland Bird Fair, for example, the largest birding and
bird conservation event in Britain, he gave a short talk and performance
demonstration of his epic digital project *Dawn Chorus*, which turns human
singing into birdsong. In a reverse echo of the Italian bird fairs described
in the previous chapter, the Rutland Bird Fair attracts more than twenty
thousand bird enthusiasts and conservationists—an audience that Coates
addresses as readily as his peers in an art gallery. One way to respond to
Charlesworth's question of boundaries is to bring into focus the blurred
nature of these boundaries between the philosopher and the birdwatcher,
between the professional artist and the amateur shaman, between the bird
mimic and the sound artist.

Coates's accumulated work is not a casual or cynical version of sha-
manism but in fact a form of *neo*-shamanism, rooted in a deep empathy
based on zoomorphological knowledge and cultural understanding. As a
neo-shaman, Coates appropriates wildly. He has no direct social links to the
cosmologies and ritual practices of northern circumpolar peoples; instead,
he freely selects the skills and tools of their traditions to suit his purposes.
As a postmodern artist, his combination of animal acoustics, play, ritual,
and performance refers to an evolutionary perspective on what has gone
before and points toward new pathways of multiple animal-becomings
with contemporary relevance and resonance.

First Play, Then Empathy

In the triad of play, ritual, and performance that come together to form the variously established theories of the evolution of performance, human play is often associated with animals and our evolutionary ties with non-human biological continuities. Studies of animal play—in chimpanzees, for example—have resulted in some scholars suggesting that our impulse to perform, to create performance, or to observe and identify with the performances of others emerges out of this bio-evolutionary heritage. As Brian Boyd explains, "Without a biocultural perspective we cannot appreciate how deeply surprising fiction is, and how deeply natural."[7] Among most mammals, play is taken up spontaneously, or it can be intentional and self-reinforcing. Boyd's study shows how play, as an evolutionary adaptation, can reveal the advantages of flexibility of action, and how rehearsing "flight or fight" responses can playfully "refine skills, extend repertoires and sharpen sensitivities."[8] Play is compulsive, rewarding, and highly social, and, "as the foundation of all performance, the activity of play in animals already entails notions of intentionality, enjoyment and event."[9] More recent studies of animal play behavior have found that one of the most striking cognitive abilities we share with other mammals is empathy. Primatologist Franz de Waal has long campaigned for the importance of recognizing empathy in chimpanzees and large primates, and his work has altered approaches to primate research. He recalls incidents of animals sharing the grief over the loss of a newborn or assisting in a birth. His main claim is that neurological networks in the primary emotions we have in common with other mammals are vital to our understanding of the minds of animals and therefore affect our responsibility toward them. However, our capacity in other cognitive abilities is also sometimes used to demonstrate our difference from nonhuman animals and could lead to notions of exceptionalism or "uniqueism." Having a capacity for symbolic, expressive language, communication and reasoning, mental self-projection, and creating imaginary, alternative worlds is essential to the foundation of performance. McConachie phrases the distinction like this: "Many animals play, but none except Homo sapiens can play games."[10] Games rely on social knowledge and the ability to be both immersed in a game in order to compete—for example, like an athlete—but also to step outside the action to strategize or observe reactions and the play of others. Stepping

in and out of roles, separating the self, and blending concepts of self with concepts of another are at the center of both empathy and performance. This "conceptual blending" is both a conscious and unconscious activity that McConachie considers not just "an option for theatrical participants; it is a cognitive necessity."[11]

While science is still at the beginning stages of understanding the evolutionary, biological, intersubjective, and phenomenological constituents of the most basic and general forms of empathy, researchers such as Douglas Hollan are already indicating that the complexities of our cultural relations and elaborations can be reflected in a revisiting of conventional Western notions of empathy. Hollan calls for further ethnographic studies of empathy in context in order to move on from arbitrary, generalized, and biased (American-European) ideas of empathy, especially in human-animal relationships. In response to this call, some anthropologists like Rane Willerslev and Eduardo Viveiros de Castro have looked deeper into empathic patterns in populations at the borderline regions of human-animal interactions where hunting, mimicry, empathy, and performance become blended and take us further down this path of interspecies empathy in the context of performance.

Becoming Elk

When the elders of the Siberian Yukaghir community decided that their guest, a young Danish anthropology student (Willerslev) was ready to go hunting for elk, they did not prepare him for the extraordinary performance he was about to witness deep in the tundra forest. At the crucial moment of the hunt, Willerslev's guide, Old Spiridon, wearing an elk hide coat and protruding headgear complete with large elk ears, began rocking back and forth. Willerslev recalled that his skis of smooth elkskin, "so as to sound like the animal when moving in the snow, made him an elk: yet the lower part of his face below the hat, with its human eyes, nose and mouth, along with the loaded rifle in his hands, made him a man."[12] For the first time, Willerslev witnessed the complications of his research into both the concepts and practicalities of hunting, animism, and personhood among the Yukaghir and other Indigenous populations of Siberia—and their understandings of what is animal and what is human.

As he continued his transformation, Old Spiridon began to take on a "liminal" quality where "he was not an elk, and yet he was not *not* elk." Soon a female elk and calf emerged into the clearing where the hunter performed his movements and sounds. He recalled how "at first the animals stood still, the mother lifting and lowering her huge head in bewilderment, unable to solve the puzzle in front of her. But as Spiridon moved closer she was captured by his mimetic performance, suspended in her disbelief and started walking straight toward him with the calf trotting behind her. At that point he lifted his gun and shot them both dead."[13] When Willerslev discussed the event with Old Spiridon back at the camp, he learned that the elk was not alone in her visionary enchantment. As the elk approached him, Spiridon saw instead a beautiful woman and a child singing to him to come home with her. At that moment he knew he had to kill her, because, he said, "Had I gone with her, I myself would have died. She would have killed me."[14] For the Yukaghir, the capacity to first see and then take on the appearance and spirit of another being is central to their idea of what it is to be a person. Equally, animals and other nonhuman entities are capable of temporarily moving in and out of each other's bodies, changing their perspective and becoming something other than their own selves. Recognizing the empathic nature within these relationships, the hunter becomes "a hyper-reflexive pretender, who by withholding his own identity as predator maximizes the seductive force of his deceptive enactment of the animal and its associated spiritual being."[15] All this empathy has now become tactical.

For the huntsmen returning to camp, it is very important to talk about the hunt and their experience in detail among each other. In a series of transformations that define the Yukaghir hunt, this action of talking and recounting is perhaps the most important, as it reinstates the hunter back into his human social self, and all traces of the animal he became are slowly dissolved in the process of becoming human. Willerslev says that "the hunting process as a whole is, in effect, an act of temporary transformations—not only the transformation from 'me' to '*not* not me' but also back to me again."[16] Human speech and smell are the means to rehumanize oneself among the hunters in their encampment, and they remain "the tools for purging otherness from the self and reconstructing one's human identity."[17] However, the recounting of the events of the hunt is not in itself a performance of storytelling. The narrator speaking in either Yukaghir, Sakha, or Russian is only partially comprehensible and is not talking to

any particular audience but instead reintroducing their own consciousness to the human life from which they had withdrawn, reminding themselves that their personhood is now human and not elk.

Spoken language is therefore the security against total dissolution of the self or a complete or even partial metamorphosis into some mute other. For the Yukaghir, worse than death is to become a *syugusuy suroma*, or "wild one"—creatures that are human in appearance but covered in fur, living solitary lives in the forest at a distance from both animals and people. The syugusuy suroma are hunters who failed to find their way back to camp and had no one to talk with about their experience, and so they occupy this liminal state between animal and human societies. While the hunters see both animals and spirits as "cultural" beings, the syugusuy suroma are "wild" because they are in-between creatures that have lost their language. Isolation from communication with one's own kind is the great fear of the Yukaghair hunter. In the reflexive action of storytelling, the men are reconstructing their identities as human persons with the trace of elk-becomings now part of that narrative.

In Yukaghir and many other traditional cultures that involve animism, personhood is not entirely the preserve of the human. The idea of the personification of animals has, for the hunter, some delicate and crucial aspects that reveal the more performative qualities of the hunter's actions. When facing the elk mother and calf, Spiridon recognizes the shared psychological space he has entered into and is forced to see and hear the person of the elk speaking and communicating with him, or rather with his elk-hood. Equally, he sees how the elk is beginning to mimic his dancing actions and hears her inviting him closer into her world. This "situation of mutual mimicry," where the elk starts to imitate him imitating an animal, results in a version of personhood for the elk, not just a "downright metaphorical projection of human consciousness onto nonhuman entities."[18] Rather, in this highly sensitive and ambiguous—even dangerous—context, personhoods are gained and lost, ebbing and flowing in and out of each other's awareness, as both prey and killers.

It is this momentary sharing of personhood that defines the actions of the Yukaghir in particular, where necessity, skill, and tradition come together in order to produce another sharing—of meat, fur, and communal living. For the hunter, this tactical empathy is not just a matter of acquiring meat to survive but is, crucially, "a hazardous struggle to secure boundaries and to preserve his self-identity" as both a hunter and a human.[19] It is in

the precise act of empathically mimicking the other "that that other is constructed as 'other'" and where "the alterity of the other is not minimized, but rather sometimes radicalized through empathy."[20] For the Yukaghir, the concept of tactical empathy means that violence and vicariousness are faculties of survival and ambition. This ethnographic perspective deepens and enhances previous Western notions of virtuousness, mutual understanding, compassion, and social cohesion. Instead of falling back on conventional ways of seeing empathy and violence as always anathema, ethnographers like Willerslev and Vivieros de Castro illuminate instances in which deception, sociality, violence, and empathy are not opposed. Rather, linked together, they provide a new platform from which to view human life.

Siberian hunters conceive of an animist ontology and universe inside which they must "steer a difficult course between transcending difference and maintaining identity through mimetic empathy."[21] Even more fragile than the tactical empathy at work here, which strives toward identification, is the question of perspectivism and the ability to step in and out of the subjective perspective of the other. Brazilian anthropologist Viveiros de Castro calls this faculty a process of "perspectival multinaturalism."[22] In the Southern hemisphere Indigenous societies that he has extensively examined, he identifies two modes of being and of seeing the world. Perspectivism describes a world view that is defined by a relative stance—cultivated plants are seen as blood relatives by those who grow them; a prey animal can approach a hunter as an equal; and a shaman relates to a tree spirit as an associate. Multinaturalism is Viveiros de Castro's counter to universalizing Western ideologies of what is multiculturally experienced and exclusively human. In multinaturalism, "whatever possesses a soul is capable of having a point of view."[23] The perspective of, say, the leafcutter ant and its concerns have to be taken into account by the human that may cross its path. The ant's perspective, like the human's, is also multinatural, because it is "guaranteed by the objective universality of body and substance."[24] In this context, therefore, culture is universal, but nature is particular.

At the center of this Amerindian perspectival multinaturalism, where prey and predator and tribal warfare determine the lifeworlds of all species, Viveiros de Castro identifies shamanism as the major context in which "self" and "other" each develop culturally complex relations. Just as "in warfare, a human other, an 'enemy,' is used to bring the 'self' into existence," shamanism begins by negotiating the relationships of human and nonhuman entities, accepting their perspectives even if they are distorted

and distinguishing what is cultural from what is natural.[25] There are hemispherical differences in the ethnographic studies gathered together here. In Amazonian animism, all entities are subjectively "human" first, and have souls, and therefore can be said to have an anthropocentric worldview. Perspectivism implies that as predation is the universalizing fact of life, all beings are looking at their world and one another, formally, in the same way. In the Northern circumpolar traditions that the Yukaghir practice, and where the kind of shamanism that is practiced has influenced the artists under my scrutiny, "who you are and whom you perceive as prey and predator depends on the kind of body you have."[26] Personification and personhood are gained via the body and its visual and acoustic dimensions.

The person that you think you are and the person you say that you are, be it elk, rat, leafcutter ant, or human, is not assumed or automatically understood until it is performed as a means of attraction, seduction, imitation, and, perhaps, imagination. Just as the hunter thinks he can seduce the animal into believing he is something else, so the animal can distract its human predator with an impression of something the hunter desires. These ideas of how hunting performs positive, noncoercive acts of seduction in which animals offer themselves as part of a survival drama function as a screen and blur the reality of being a human predator. Old Spiridon and his fellow Yukaghir rely on the idea of play and playfulness in their hunting practices in the knowledge that this tactical empathy will draw the animal in to a close, slippery proximity of trust and understanding—but not too close to overwhelm the hunter's consciousness—where the end of the play is death.

Animals are always interested in deception. They practice camouflage and they get what they want by being playfully, tactically, even empathically mimetic. According to Roger Caillois, it is common to find "many remains of mimetic insects in the stomachs of predators," including insects that are inedible but also mimetic.[27] Caillois undoes generalized notions of the function of mimicry as solely to protect oneself or trick others and introduces new categories of biomorphology—such as defensive, offensive, direct, and indirect mimicry—and the crossover of these disguises into multinatural positions of adaptation and resemblance. Playing with identity is a risky morphological game that persists in defying the order that we crave from species when studying the natural world. Caillois and his translator, John Shepley, draw intriguing lines between praying mantises, fruit flies, Gustave Flaubert, and the paintings of Salvador Dali, in which "whatever

the artist may say, these invisible men, sleeping women, horses and lions are less the expression of ambiguities or of paranoiac 'plurivocities' than of mimetic assimilations of the animate to the inanimate."[28] In the final episode of Flaubert's *The Temptation of Saint Anthony*, the mystic visionary succumbs to a phenomenological experience of mimicry in which "plants are now no longer distinguished from animals. . . . Insects identical with rose petals adorn a bush. . . . And then plants are confused with stones. Rocks looks like brains, stalactites like breasts, veins of iron like tapestries adorned with figures," and so on until the saint wants to split himself in pieces, to be part of everything, "to penetrate each atom, to descend to the bottom of matter, to *be* matter."[29] In this passage from Flaubert, Caillois draws attention to the breakdown of the perceived strengths of the rational mind. Instead of being held together by conventional categories of reality, it opens to the wonders of weakness in a psychasthenic state of loosening logical control; of irresistible compulsions, painful sensibilities, and abnormally strong identification with the perspectives and emotions of others to the extent of irretrievable disturbance of the self. The condition is now more commonly called schizophrenia, and in what follows, concepts of play, empathy, shamanism, and schizophrenia are threaded together more tightly. An empathic understanding of animal perspectives has emerged out of hunting traditions and its rituals. This ritualization of human-animal entanglements involved in hunting produces the key figure of the shaman. Shamanism and shamanic legacies in arts and performance practices produce another enduring and problematic figure—the artist as sorcerer.

Performing Empathy: Shamanism in Praxis

When Coates wears the skin, head, and hooves of a deer in his performances, he is connecting with shamanic traditions that have evolved within hunting communities in which animal skins and heads are not simply worn as masks, to change appearance or hide the human underneath an outer layer of animal. Instead it is a method of metaphysically transforming the identity of the wearer, where the body-costume itself is a tool or apparatus akin to a diving suit or a space suit. Wearing the skin activates the power of the deer body. While hunting apparel is used to camouflage, ritual clothing is used not to deceive but to "do" something, to travel and in fact transcend appearances altogether.

The dramatic appearance of Coates in the deerskin in a small apartment in Liverpool or on the streets of Stavanger is a primary surrealist jolt on the way to a deeper engagement with the questions that arise in Coates's body of work. The first question is: How did he acquire the skin, and what had to happen in order for this surreal image to be created? When Coates began his training to practice shamanism, the first animal he met on all of his early spiritual journeys was a deer. In later works, he often uses only the head of an animal, such as a badger and even a horse, but for these first community projects he felt he needed more help. With the full deerskin, he says, "the skin would cover me, matching me physically—I couldn't imagine losing myself with a rabbit or a squirrel."[30] The two-year-old buckskin came from an annual deer cull in Cumbria. The antlers came from an older male deer, and Coates asked the taxidermist to leave the hooves on. The process of creating this costume, which usurps traditional skills such as hunting and rendering animal bodies for food and clothing, straddles two not-dissociated ideas. Firstly, Viveiros de Castro's notion that it is the shaman in deer's clothing who has the unique ability to become a "trans-specific" being, visualizing the human spirit inside every animal and living thing, where the discarded and exchangeable animal skin and body is endowed with specific affects and capacities. Secondly, Steve Baker uses the term "botched taxidermy" to describe a "loose but convenient link between botchery and butchery" in his examination of contemporary art's renditions of "the postmodern animal."[31] Baker borrows the term botching (*rater*) from Deleuze and Guattari; they claim that insufficiently imaginative (specifically Freudian) psychoanalysis can "go wrong, backfire, mess up, spoil, botch or bungle" the body. But also, Baker argues, "it can mean sticking or cobbling something together in a makeshift way," an assemblage that "holds together." Crucially, in Baker's hands, botching is creative, "precisely because of its provisional, playful, loosely experimental operation."[32] In reflecting on what he perceives as the abrasive visibility of late twentieth-century artworks that use stuffed animal bodies, Baker writes, "It was their wrongness that gave them their edge. In botching the body, in calling into question the categories and the boundaries of the human and the nonhuman, the pure, the perfect, the whole, the beautiful and the proper, they held out the promise of an art, to borrow Adam Phillips's tantalizing words, in which 'the idea of human completeness disappears,' and whose difficult effect might also offer what he calls good ways of bearing our incompleteness. Botching is a creative procedure precisely because of its openness to getting things wrong."[33]

In the performances by Coates that I am unpacking here, I perceive a purposeful botching at work. In neo-shamanism, albeit a botched version, Coates finds "good ways of bearing our incompleteness" somewhere between tragedy and comedy. As Adam Phillips continues, "tragedy is when we are ruined by our insufficiency, comedy is when we can relish it."[34] In Coates's botched becomings, key elements of historical shamanic praxis emerge through empathy, play, ritual, and performance in the contemporary figure of the artist/actor/shaman/sorcerer.

For Jean-Marie Pradier, "the highly organized performative behavior of a shaman—despite his sometime incoherent appearance in secular eyes—is a prelude to the activity of that other intermediary between imaginary worlds and the 'real' world: the actor" who can "bring into contact what is archaic in us and what is elaborated symbolically, what is animal and what is human."[35] This theory of archaic threads of connection with ancestral (and animal) points of origin also feeds theories of performance, in which many practitioners turn and return to find practical methods of bridging performer/spectator relations, as Pradier suggests, "by bringing into perception our bios, the vital flux that connects us to other species and to the cosmos."[36] Inside any sensate relationship, an active empathy is at work, creating a mirror that is as rational as it is emotional, as well as being playful and tactical. As we have seen, it is also profoundly perspectival; according to Viveiros de Castro's Amerindian studies, depending on one's position inside whatever type of body you occupy, you are in a state of being "where self and others interpenetrate, submerged in the same immanent, pre-subjective and pre-objective milieu," the result of which is played out in mythologizing contexts of art, ritual, and religion.[37]

In these counter-Western examples, spiritual universality and corporeal diversity (as opposed to human spiritual uniqueness and mere biological connection to animality) define human-animal relations in the Amazon. There are interesting inverted parallels here with how Western artists have usurped and "botched" these conventional dualisms of nature and culture. As Viveiros de Castro summarizes: "If Western multiculturalism is relativism as public policy, then Amerindian perspectivist shamanism is multinaturalism as cosmic politics."[38] Inside and in between these layers of public and cosmic politics, the figure of the shaman remains of valuable, marginal significance and has influenced many artists, including Joseph Beuys (1921–1986). Beuys's own writings and thoughts on shamanism, animal power, and social crises are well documented and anticipate the

ritualistic work of contemporary artists such as Coates, Alastair MacLennan (b. 1943), and Marina Abramović (b. 1946). Equally, Beuys's quasi-messianic healer stance and self-conferring of mandates to express the needs of the collective have been critiqued as unresolved and even resistant to conclusive interpretation. When Beuys turned to animals, they became for him a source of prelinguistic force, of natural ecologies unaffected by civilizations, and as a means of access to lost energies needed to repair the damage human society does to itself. Beuys's bestiary is a collection of appearances in performance, drawing, and sculpture by moose, hares, bees, goats, swans, foxes, coyotes, elk, horses, and stags. In well-known works such as *How to Explain Pictures to a Dead Hare* (1965) and *Coyote: I Like America and America Likes Me* (1974), Beuys presented striking images of interaction with dead and living animals that themselves are already symbolic of otherness. By enveloping archaic material into his actions, such as covering his head and body in honey, felt, and gold, Beuys stood apart from his contemporaries like Andy Warhol (1928–1987) in his deep and tactical empathy with animal experience and revealed his allegiance to nonhuman perspectives of the world. In the filmed fragments that exist of both *Dead Hare* and *Coyote*, the manner in which Beuys communicates with the animals is striking. His gold and honey mask limits any expressive explanations of pictures to the dead hare, but it is just possible to make out his muttering to the animal he reanimates in front of the gallery paintings. In *Coyote*, quietly spoken moments are shared with the canine when both artist and animal take a break from their daily rituals of felt wrapping, paper shredding, and bell ringing in the now-iconic performance at René Block Gallery in New York. These acoustic elements in Beuys's work have rarely been commented on, largely because of the fact that the only access to these pieces has been through still photographs, in which the coyote looks fierce (when it was in fact a semi-tame ranch animal, named Little John, from New Jersey, and a cooperative, communicative participant) and the hare always appears stiffly dead (while the newly available film fragments online reveal a flopping, soft creature, revived by Beuys's tender actions animating its ears, paws and head). However, it is in *Der Chef* (1964) that, I believe, the most compelling and enduring assemblage of shamanic legacies and animal voices are merged with the artist's body.

The inscrutability of *Der Chef* sustains both the power of the piece and the critical frustrations it has generated. In the film of the installation at René Block gallery in Berlin, Beuys lies on a concrete floor, his body in a felt

wrap made from hare fur. At either end of his wrapped body lie two dead hares, and this assemblage forms the central axis of Beuys's performance installation, which permits viewing but resists casual involvement. Beuys stages the piece in the context of his own biographical account of his experience in World War II: his plane crashed in Tartar territory, and the local tribal response was to wrap the body of the fallen one in animal fat and felt. Beuys's tale of his survival via these materials determined his approach to what art can do when it is informed by what a people's physical and material knowledge can achieve. For Beuys, the stag's branching antlers symbolize "a head enlivened with spiritual insight and intuition through the vitality of the blood circulating from the heart through the head and even outside the head."[39] In *Der Chef*, he invokes another dimension of animal power, the guttural voice of the deer stag. From inside the roll of felt, via a microphone and a set of amplifiers in the adjoining public space, Beuys vocalizes the bawl of the stag and other inarticulate noises, inaudible without the sound system. The acousmatics of the piece are layered between the unseen cry of the mysterious and powerful animal and the public address system of the chief, or boss, or leader of the title. This allows Beuys to blend these acoustic events in pursuit of his questioning of authority and authenticity.

Remaining unseen for the eight-hour performance, mirroring the working day of the everyday person, he also becomes that person's boss, delivering orders through the PA system of the workplace, but with the voice of an animal. He explains, "The sounds I make are taken consciously from animals. . . . I see it as a way of coming in contact with other forms of existence, beyond the human one. It's going way beyond our restricted understanding to expand the scale of producers of energy among cooperators in other species, all of whom have different abilities."[40] Even dead hares have more preserved potential, as Beuys has provocatively stated, than most stubbornly rational people. It is easier to talk with them about creativity and ecology than it is with humans, as hares both symbolize and understand the essentials of life. Beuys needs "nature and also all the animals just like he needs his heart, his liver and his lungs, so therefore one can see the hare as an external organ of the human being."[41] Thus a dialogue with an animal is a dialogue with the self.

The idea of extending the body, via the animal voice, into an experience of communication with the land, oxygen, rivers, forests, and burrows with the language of neo-shamanism and New Age practices was a very radical notion in the 1960s. If Beuys is to be critiqued for taking a healer-messiah or

leader-boss position in works like *Der Chef*, he must also be acknowledged for bringing the figure of the shaman back into the light, during a time of materialist expansion when it could not have been more incongruous. By unsettling the status quo and frustrating expectations of what an artist and a performance should be, Beuys sought to change how we look at art and how art could perform and create social change. In the figure of the shaman and an animal coming together to broaden awareness, heal trauma, and generate social reform, Beuys adopts the position, conceptually, "not to return to the past, into a time when the shaman's existence was justified," but instead to use "this old figure to express something about the future by saying that the shaman stood for something that was capable of uniting material as well as spiritual contexts into one single entity."[42] For Erika Fischer-Lichte, animal bodies in Beuys's actions "emerged as an energetic, living organism—a body-in-becoming. There was no difference between the materiality of the human body and that of the animal," which became material "only in its mortification."[43] In this way, Beuys anticipates the surge in the appearance of animals in the late twentieth century, in arts and performance practices in which animal bodies become heavily anthropomorphized images of alienation, sentiment, mourning, the uncanny, and the ironic; the parodic and the melancholic plight of the postmodern human. However, the distance between Beuys and early twenty-first century artists working with animal imagery expands and separates from these anthropomorphizations. As Baker has argued, "one characteristic of much postmodern animal art is its *refusal* of symbolism, its insistence on carving out a space in which the physical body of the animal—living or dead—can be present as itself."[44] In the context of Deleuze and Guattari's statement that when the artist becomes the animal the animal becomes something else, it only becomes something else for the human theorist. The animal in question remains the same. No one wants to fully become-animal, otherwise nothing would be written or performed as an animal becoming. As in hunting becomings, in order to become-animal one must always retain one's own consciousness and embrace the differences.

In Victoria Walters's comparative analysis of Beuys and Coates and their engagement with shamanism, she concludes that Beuys's anthropological approach to the dilemmas in art is one of "substance," while Coates's methods are less serious. Beuys becomes a "vibrant beacon" while Coates founders between bathos and pathos, and this "double aspect of Coates's work appears not only as the cathartic position of the trickster, but as a

reflection of the schizophrenia of his artistic predicament."[45] However, I believe this is what makes Coates so relevant, not only to contemporary debate about animals and performance but to the current ecological and spiritual crisis of human-animal social relations that Beuys had dreamed and proselytized about perfecting through art. The schizophrenic predicament at the core of Coates's ethos is one of deep empathic responsibility and dangerous anarchic possibility, where the shaman artist, as a foil of social dysfunctionality, is on the point of breakdown. For Beuys, art was to be the savior of social decline, but for Coates, social empathy and its ritual histories might just be able to save art from its own collapse in a time of neoliberal hyperindividualism brought about by capitalism. Coates brings his understanding of animality, myth and current crises of personhood to a destabilizing edge in performance. By opening a pathway into the connections between performance, hunting, shamanism, and now schizophrenia, his project begins and ends with and the concept of becoming-animal.

Shamanism, Schizophrenia, and Becoming

When Willerslev says "the hunting process as a whole is, in effect, an act of temporary transformations—not only the transformation from 'me' to '*not* not me,' but also back to me again," his question of identity and transformation is applicable to how Deleuze and Guattari understand schizophrenia and the links they make between psychology and shamanism.[46] In this chapter's focus on the complex contemporary terrain of creatural acoustics, we have followed pathways of empathy that are tactical, in hunting; aspirational, in shamanism; and, I think, essential, in performance. To return briefly to the Siberian Yukaghir and Amerindian peoples in the valuable and rigorous fieldwork of Willerslev and Viveiros de Castro, it is important to point out that the practices of hunting, animism, perspectivism, and shamanism are practices of contemporary living cultures in both hemispheres. This contrasts with some artists' perception of tribal cultural ritual and imagery as ancient and lost. Such artists are motivated by a nostalgic desire to resurrect the archaic in their work. Living Indigenous cultures and Western interests in the archaic converge in the dubious world of ethnotourism and organized shaman experiences for Western tourists in the Americas. The resulting newly commoditized forms of practice cater to tourists' fantasies of cultural alterity, where the

one-off shamanic experiences are privileged over traditional training as a healer within Indigenous communities. In most Native American communities, neo-shamanism is, unsurprisingly, regarded with horror. Adopting the role of a "shamanic clown" by "wannabe Indians" outside Indigenous ritual practices and communities is considered "spiritual suicide," and a further form of imperial and colonial dilution of their culture.[47] The discursive complexities that are rampant in the shifting shamanic identities created as commodities (and often by the shamans themselves) in these cross-cultural encounters is a study in itself and outside the scope of this book. But it is important to acknowledge these issues here as a reminder of the continually changing presence, meaning, and problematics of the legitimacy of the shaman in every era up to and including the present. As the figure and function of the shaman has been in discussion for several decades of thought, there is no need to add to any generalizations of such a complex phenomenon. Instead, Stanley Krippner's advice is to pay attention to the perspective in which "Western interpretations of shamanism often reveal more about the observer than they do about the observed."[48] My focus has been on one event in the 1960s that I believe describes something of the elusive understanding of what shamanism can be and its influence on artists and writers of that time, and in turn on contemporary legacies that begin in this formative period.

In the mid-1960s, when Beuys was devising and performing his live art rituals involving dead hares, felt wraps, honey, and gold head masks, and declaring himself a shaman and a healer, the concept of the shaman across scholarship ranged from trickster, magician, witch-doctor, priest, and entertainer. In 1963 Claude Lévi-Strauss wrote, "The modern version of shamanistic technique called psychoanalysis thus derives its specific characteristics from the fact that in industrial civilization there is no longer any room for mythical time, except within man himself. From this observation, psychoanalysis can draw confirmation of its validity, as well as hope of strengthening its theoretical foundations and understanding better the reasons for its effectiveness, by comparing its methods and goals with those of its precursors, the shamans and sorcerers."[49]

The mental health professionals that Lévi-Strauss wishes to enfold into shamanic history were in turn pushing shamanism out to the fringes of neurosis, postulating that shamanism was in fact a type of acute schizophrenia and that both states share "grossly non-reality-oriented ideation, abnormal perceptual experiences, profound emotional upheavals and bizarre

mannerisms."[50] In psychologist Julian Silverman's landmark study, he estimated that the only difference between the contemporary understanding of schizophrenia and what is known of shamanic states, in a modern Western context, is "the degree of cultural acceptance of the individual's psychological resolution of a life crisis."[51] It must also be acknowledged that these links were made following the publication of Mircea Eliade's epic and influential study, *Shamanism: Archaic Techniques of Ecstasy* (1964), which remains a key reference. Eliade's definition of what a shaman can be runs the gamut of liminal practices, from the trickster-magician and hoaxer to cultural hero and reconciler of opposites, often displaying a kind of tactical empathy for the communal well-being of a people through the use of legerdemain, deception, and magic. But it is the figure of the fragmented healer-hoaxer that featured predominantly in the early years of refining the diagnosis of schizophrenia. In time, as both shamanism and schizophrenia became more deeply understood, psychiatrists would counter Silverman's theories, and the connections at least in psychopathology became untenable. Shamans emerged as the members of their community with the most knowledge and the healthiest constitutions, and as the keepers of order within vulnerable societies. It is along these lines that in the 1980s and 1990s the origins of psychotherapy were traced back to shamanism. However, once the connection had been made, shamanism and schizophrenia became tangled together in ways that ensured that their influence leaked into other disciplines, namely art, performance, and philosophy.

At La Borde, a psychiatric clinic in France that opened in 1953, Félix Guattari proposed that schizophrenic psychosis was a fundamentally different way of facing the world and a kind of breakthrough, rather than a breakdown. Guattari's system of organization at La Borde directed patients and staff to share all duties and swap positions at regular intervals. Into this environment, he regularly brought artists in for residencies, to produce work with the patients and staff. Performance proved an enduring method of including people of every position, and Guattari encouraged regular performances of devised dramas and vignettes with writers and other visiting artists. He pushed the boundaries of art, empathy, and psychosis even further by inviting Japanese "Butoh" dance artists to work at the clinic. This was a relatively new form of dance performance in the 1980s; one of its notable practitioners, Tanaka Min (b. 1946), performed there in 1986.[52] For Butoh specialist Sondra Fraleigh, the shamanic aspects of the dance form are seldom discussed, even though for both Butoh dancers and

for shamans, everything is always alive and always changing. She writes: "Metamorphosis is the metaphysical method of Butoh, its alchemical aspect, and its shamanist basis."[53] This series of close connections between Guattari, La Borde, Butoh, schizophrenia, Deleuze and becoming-animal makes tangible the context in which Deleuze and Guattari developed their philosophy of what they termed schizoanalysis in both *Anti-Oedipus: Capitalism and Schizophrenia* (1983) and "becoming-intense, becoming-animal, becoming-imperceptible" in *A Thousand Plateaus* (1987).

For Deleuze and Guattari, the clinical diagnosis of schizophrenia is a misreading of "the pure, lived experience" of schizophrenics, whose actions and ideas are always interpreted as representational, as opposed to real. Instead, they argue that schizophrenic states of consciousness produce experiences of "intense quantities in their pure state, to the point that is almost unbearable . . . like a cry suspended between life and death, an intense feeling of transition, states of pure naked intensity, stripped of all shape and form."[54] Deleuze and Guattari view the experience as a profoundly empathic encounter, a becoming, an intense, nervous, even frightening event and, most importantly, as Laura Cull phrases it, something "through which the subject passes, but which cannot be said to belong to that subject."[55] Deleuze and Guattari blur the distinctions of the clinical and philosophical use of the term, as they explain in *What Is Philosophy?* in this direct way: "Philosophy and schizophrenia have often been associated with each other. But in one case the schizophrenic is a conceptual persona who lives intensely within the thinker and forces him to think, whereas in the other the schizophrenic is a psychosocial type who represses the living being and robs him of his thought. Sometimes the two are combined, clasped together as if an event that is too intense corresponds to a lived condition that is too hard to bear."[56]

As both philosophers and clinicians, Deleuze and Guattari worked together to produce new assemblages of thought. They had no difficulty in understanding how "conceptual personae and psychosocial types refer to each other and combine without ever merging."[57] Combining without merging is a key aspect of becoming when the emphasis presses for a coexistence of planes of thought and experience, not a top-down or hierarchical succession of systems. Becoming is an infinity of possible mergings, combinations, and transferences in which these writers' understanding of schizophrenia has a role to play. Putting all conventional diagnoses, labels, and categories of this contested and distressing condition aside, Deleuze and

Guattari espouse a radical recontextualizing of the disturbance of perception at work in the concept of schizophrenia, bringing us into a becoming where "nothing is representative; rather it is all life and lived experience, . . . nothing but bands of intensity, potentials, thresholds and gradients," bringing us "as close as possible to the matter, to a burning, living center of matter," where we can reach "that unbearable point where the mind touches matter and lives its very intensity."[58] While Deleuze and Guattari have been criticized as having a naive or idealized view of this highly complex condition, by "elevating the figure of their 'schizo' to that of a metaphysically privileged visionary,"[59] as Cull says, they are equally scathing of the practice of psychoanalysis that reduces a person to an "autistic rag—separated from the real and cut off from life" with a diagnosis of schizophrenia, which they distinguish from neurosis.[60] Instead, they are drawn to the extra-human faculties of the unfixed or emancipated mind, as they perceive it to be. Central to the theory of becoming-animal and becoming-imperceptible is the notion of escape, of "lines of flight," where I find echoes of both shamanic transcendence and schizophrenic terror. In ethnographic studies of play, performance, and then ritual and religion, the deeper root of this laterally expanding, cross-disciplinary rhizome that Deleuze and Guattari planted and fostered is difficult to locate. Extracting this root and applying it to the animal-sound performance practices of Coates and his peers can create points of departure from the strictures of definition and categorization. These practices can instead push thinking through performance into a novel arena of play, deep empathy, hypersensitivity, and provocative renegotiations of interspecificity. How is this achieved? One approach is first by becoming-animal and then by botching it.

Becoming Seal

Becoming-animal is a gauntlet thrown down on concepts of human identity that both privilege human subjectivity and bind it to power systems and processes of exclusionism, exceptionalism, alienation, and alterity. Giovanni Aloi even suggests that becoming-animal as a means "to replace human identity with an interspecific performativity is to go some way towards destabilizing the autonomous Cartesian subject and mobilizing an ex-centric subject always in process."[61] The concept of becoming-animal can be difficult to grasp because there is very little to gauge or measure

whether a becoming is taking place. It can be directly identified as neither a resemblance nor an analogy, nor an experience of recognition. Deleuze and Guattari use these terms in a literal sense in order to force the idea of becoming as a total rejection of all previous references to animality in psychoanalysis. Becoming is defined more than anything by what it is not. In this complex passage they insist that becoming-animal has nothing to do with imitation, resemblances, metaphors, analogies, or personifications: "Becoming is certainly not imitating or identifying with something; neither is it regressing-progressing; neither is it corresponding, establishing corresponding relations; neither is it producing, producing a filiation or producing through filiation. Becoming is a verb with a consistency all its own; it does not reduce to, or lead back to, 'appearing,' 'being,' 'equaling,' or 'producing.'"[62]

In becoming, therefore, I do not become a representation of what I am becoming, or a manifestation of this relationship. For Leonard Lawlor, there is no distance of difference between entities, as "it is *not* a relation in which the subject and the object remain outside of one another . . . and it is not a representative relation of one thing standing in *for* another."[63] In stating what becoming is not, and by listing all of the familiar and historical tropes of imitation and anthropomorphization of animal othering, Deleuze and Guattari point to the liminal spaces in between all of these states, finding "zones of proximity, indiscernibility or indifferentiation . . . neither imprecise nor general, but unforeseen."[64] Deleuze and Guattari look squarely at what is uncertain and indeterminate, where the territorial boundaries are blurred, or even removed altogether:

> A becoming is not a correspondence between relations. But neither is it a resemblance, an imitation, or, a limit, an identification. . . . To become is not to progress or regress along a series. Above all becoming does not occur in the imagination, or even when the imagination reaches the highest cosmic dreams or dynamic level. . . . Becomings-animal are neither dreams nor fantasies. They are perfectly real. But which reality is at issue here? For if becoming animal does not consist in playing animal or imitating an animal, it is clear that the human being does not "really" become an animal any more that the animal "really" becomes something else. Becoming produces nothing more than itself. . . . The becoming-animal of the human being is real, even if the animal the human being

becomes is not; and the becoming-other of the animal is real, even if that something other it becomes is not.[65]

In spite of this extensive catalogue of negative definitions, like Lawlor, I think that becoming is only possible if something creative emerges from the becoming, some evidence of the experience. Otherwise, how are we to know if a becoming has occurred? Lawlor says that for artists and writers "a becoming is only successful if writing results."[66] While the aspiration to transcend and resist representations of a becoming experience is central to Deleuze's theory, Claire Colebrook also rightly asserts that the artist and writer must simply conclude that "we do not actually want to be a molecule or animal, for this would mean not writing at all."[67] The kind of freedom that becoming brings with it requires moving beyond the human. For Deleuze, literature and all creative practices are essential to this process. Becoming is a complete overthrow of the obstacles to the continuous flow of life, which for him are humanism and subjectivism. It is also important not to replace the privileged image of "man" with another cultural or historical model but to think without models, axioms, or grounds. Philosophy, art, and science are the powers of becoming, where affects can be created that in turn change our perception of what we take experience to be. In literature, as in all art forms, the potentialities of "things," the experience of sensibilities, possibilities, imperceptibilities, variations, mutations and singularities that are presented, allow perception to be opened to the virtual.

In Franz Kafka's work, for example, Deleuze and Guattari focus on the moments when he imagined being an insect, a machine, or a burrowing animal and show how we can recognize ourselves "as nothing more than a flow of images, the brain being one image among others, one possible perception and not *the origin of perceptions*."[68] In these actions, Claire Colebrook observes, "the human becomes more than itself, or expands to its highest power, not by affirming its humanity, nor by returning to animal state, but by becoming-hybrid with what is not itself . . . using the human power of imagination to overcome the human" and moving away completely from a moralizing perspective.[69] It is this gesture of overcoming the human, and all of its psychological difficulties, that Deleuze finds fascinating in Kafka and that I find finely developed in Coates. Beginning early in a film performance titled *Finfolk* (2003), before he acquired the deerskin and took a course in shamanism, Coates was already practicing becoming-animal at a primary and experimental level, without any of

the accoutrements that would identify his later major projects. Here, he describes his understanding of becoming and how he adopts the idea:

> Becoming animal suggests a progression from one state of being to another, from one's consciousness to another's—specifically that of different species. The attempted leap between these is of interest to me. One skill I have developed, and it is probably the reason why I chose to be an artist, is the conscious study and practice of moving between personas and positions of identification. This, along with an interest in natural history has led me to adopt "becoming animal" as an investigative device. More recently I have looked at the historical use for becoming animal particularly shamanism and have started to employ this "skill" in society as a direct benefit for communities.[70]

In this succinct description, there is an emphasis on physical and conceptual movement, progression, and development that is central to the dynamics of performance and becoming. Movement between entities forms a sequence of alliances and involutions that are by their nature creative, and they occur through "transversal communications between heterogeneous populations."[71] In the creation of new alliances and assemblages, actions involve "perpetual relations of transformation, conversion, jumping, falling, and rising," which all the time run the risk of being botched or blocked. Interrupting the immanent flow of becoming by botching it can, Baker says, become "a creative procedure precisely because of its provisional, playful, loosely experimental operation."[72] As we have seen in the major pieces *Journey* and *Radio Shaman*, which Coates developed into further stage performances and festival residencies, he plays fast and loose with botched taxidermy in his costumes that use the skins of badgers and hares as well as the spectacular deerskin with antlers. He also botches the neo-shamanic ritual skills of drumming (on a cassette tape), cleaning (using vacuum cleaner), and bells (shaking car keys). What he does not botch is his repertoire of animal calls and voices, which takes the performance away from kitsch and claims an authenticity and seriousness for the action. The trance he enters at least appears genuine, as the artist is lost to us, eyes closed and emitting strangely moving barks and squawks with a clear, knowing, empathic quality. As he returns from the journey, his description of the communication he found with the animal spirits is profoundly empathic

and sincere. In a simultaneous act of contradicting and embroiling himself in the definitions of a Deleuzean becoming, he strikes a new position in an assemblage of representation, mimicry, empathy, and schizoid behavior. In the authenticity of his animal acoustics, he abandons human language (which is "majoritarian," or powerful) in favor of the language of creaturely vocalizations (which is "minoritarian," or marginal). This creatural repertoire fulfils Deleuze and Guattari's criterion for "minor" interventions in culture, namely "the deterritorialization of language, the connection of the individual to a political immediacy, and the collective assemblage of enunciation."[73]

Prior to this culmination of behaviors, botchings, and sophistication of his repertoire, Coates created *Finfolk* in 2003. This short performance (7 minutes, 38 seconds) takes place on the icy shore of the North Sea, where Coates emerges from the water fully clothed in an athlete's tracksuit, climbs the boat ladder up the pier wall, and stands before us, grinning. Soaked through, he begins to amble about muttering and spitting in a casual manner. He walks to the shoreline between sea and land and makes some ungainly, almost slapstick dance movements. As we get closer we hear the strange sounds he is making, which I have transcribed here as "Fin Fin Fok Fok Fuk FOFOFO Fin Flak Flak Splak FOFOFO," and which he spits out with the urgency of a curse. His mouth is spit-flecked and frothing, his teeth and tongue snap out the syllabic nonsense, and for a moment this intense communication is all we are asked to focus on. Then he sees a family group approaching him; he clambers back into the water and disappears. In the film of the piece, the last frames show a seal, its head bobbing out in the water looking to shore. In this experiment with mythology and animal-becoming, *Finfolk* draws directly from the Icelandic-Scottish-Irish narrative of the "selkie," a seal that can become human and a human that can become a seal. The selkie is never half human or a physical hybrid, but either one physical manifestation or the other. As a human, the selkie must always keep and bury on the shore his or her sealskin in order to return to the water. Coates is selecting this imagined moment of transition to perform the figure of the shapeshifter, where he is not fully one thing or another. In appearance he is human, but his tongue is still tied to the sea. Only by disentangling one language from the other will the selkie achieve its full becoming one way or the other. Ron Broglio writes that "Coates looks like an idiot; his words as a finfolk do not make sense," but he deduces that "it is precisely this nonsense that is the fulcrum by which Coates leverages and

jostles the human and animal worlds."[74] Everything becomes botched—the myth, the metamorphosis, the human voice and the seal voice, folklore, film, and performance itself—but the piece holds together in its assemblage of intensities. Coates disrupts speech in a manner similar to how Deleuze and Guattari see the ways in which Kafka:

> ... deliberately kills all metaphor, all symbolism, all signification. ... There is no longer any proper sense or figurative sense, but only a distribution of states that is part of the range of the word. . . . It is no longer a question of a resemblance between the comportment of an animal and that of a man; it is even less a question of simple wordplay. There is no longer man or animal, since each deterritorializes the other , in a conjunction of flux, in a continuum of reversible intensities. Instead it is now a question of a becoming that includes the maximum of difference as a difference of intensity, the crossing of a barrier, a rising or a falling, a bending or an erecting, an accent on the word.[75]

Instead Kafka's, and Coates's, botched becomings are mutually dispensing with language restrictions and creating a new intensity of enunciation.

In the doomed figures of the shaman clown, the lay philosopher artist, and the hoaxer trickster that we see in the performance work of Coates, he activates a disturbance of myth, a schizoid relationship to language and acoustics, and a desire to escape and to fall over in a slapstick tragedy. In *Finfolk*, this slipping in and out of the water and in and out of human skin and human language is also the slipping away from the rational and into the splitting of the person, like Flaubert's saint wanting to split himself in pieces, to be part of everything, "to penetrate each atom, to descend to the bottom of matter, to *be* matter."[76] This overly empathic, hypersensitive, and gruff human seal is losing himself in the fringes of Deleuze and Guattari's schizoanalysis. Perspectives are skewed, appearances are breaking down, and the ambitions of becoming-animal are botched into a track-suited, sea-soaked savant trying to become a human man, perhaps the most botched becoming of all.

BECOMING CANINE
The Scandal of the Singing Animal Body

Although I was profoundly confused by the sounds that accompanied
them . . . they were dogs nevertheless, dogs like you and me.
—FRANZ KAFKA, *INVESTIGATIONS OF A DOG*

I am the dog. No, the dog is himself and I am the Dog.
O, the dog is me and I am myself.
—WILLIAM SHAKESPEARE, *TWO GENTLEMEN OF VERONA*

At the end of Alexander Raskatov's opera *A Dog's Heart* (2010), the dog
is lying at the feet of his master in front of a warm fire in a salubrious
drawing-room stage set. In his short onstage life, this stray dog has been
homeless, starving, scalded with boiling water, and left for dead. He has
been rescued by a famous eugenics surgeon, Professor Preobrazhensky, who
replaces the dog's pituitary gland and testicles with those of a dead alcoholic
balalaika-player with a criminal record. Following the surgery, the dog,
named Sharik, mutates into a man, becoming Comrade Sharikov. While
he continues to live with his surgeon-father, Sharikov gets a job as head
of the Sub-Department of Moscow Pest Control. His anarchic vandalism,
womanizing, and vodka drinking quickly become a serious problem for
the surgeon, whose bourgeois status in a newly emerging Soviet Russia is
precarious enough. The surgeon and his assistant soon decide to reverse
the surgery. The operation is a success. In this last scene of the opera,
Sharik, now reverted to a mongrel dog, considers his fortune at the feet of
the kind, sausage-providing master and decides that, in the end, being in

the drawing room with the human is better than being out in the Moscow cold. He sings, "I'm so lucky, simply incredibly lucky."[1]

Raskatov's opera is an adaptation of Mikhail Bulgakov's novella *A Dog's Heart* (1924), a short satire of the growing pains of Bolshevik society. After Bulgakov first read the work in his Moscow flat for his friends, it was immediately confiscated and banned, remaining unpublished in Russia until 1987. The story was never published anywhere in Bulgakov's lifetime. De Nederlandse Opera in Amsterdam originally commissioned an opera of the story from Raskatov, and the English National Opera's production, which I write about here, was performed in London in 2010. The dog puppet created for this ENO/Complicitè production by Blind Summit Theatre was inspired by an Alberto Giacometti bronze of an emaciated, almost skeletal dog (1957; Museum of Modern Art, New York). So as the puppet lies there onstage, in the beginning (in agony) and at the end (in ecstasy), it is already twice removed from any direct sense of dog-ness. Instead it is a puppeteer's translation of an artist's impression of a dog in another time and for a different purpose. Giacometti's sculpture is a complete work of visual art in its understanding of what it might be like to be a dog. The gray puppet from Blind Summit's studio lacks substance with its barely-there bony body. It is difficult to see onstage. A gang of puppeteers is in constant attendance as they manipulate the puppet's every move. Unlike that of a strung marionette or a type of independently moving animatron, the gray dog's stage presence is very much diffused by its design. Physically, this puppet version of Sharik weakens the potential for presence on the stage. But acoustically, he is a revelation.

From Sharik's very first appearance, he claims the stage with his voice. In Act One, the composer has given the dog's character a double voice—soprano and countertenor. As the puppet growls in anger and cries in pain in equal measure, these two singers circle around him and establish the complex persona that is to become Sharikov the dog-man anarchist. From the outset, Raskatov goes against the grain of the conventions of the opera house. In this work, the main character is a scalded, feral street dog; the prima donna is wandering around in a trench coat and galoshes barking into a megaphone; and the only reprieve is a sweet voiced countertenor whimpering about sausages as the snow falls on a back street in 1920s Moscow.

In the finale, writes Edward Seckerson, "man and beast become indistinguishable and images of Soviet workers are superimposed with those of dogs like Sharik and a whole clutch of megaphones turn the chanting into

a bestial wailing."[2] The animal acoustics at work here are entirely human in their creation and interpretation. In this chapter, a close reading of Raskatov's radical work contextualizes this composer's intense reimagining of Bulgakov's creature within the long history and narrative of the onstage canine, both musical and silent. The opera becomes, for me, a precarious hybridization of canine stage biographies and performing dog histories, Victorian and Soviet romanticization of stray dogs and their autobiographies, eugenics, and vivisection, and how the medium of the opera is uniquely able to bear the risk of placing, at its center, the scandal of a singing dog.

In a musicological context, Raskatov's opera tests the boundaries of the stage where silent and singing animals are, in general, stereotypical familiars (as we have seen with birds). In his treatment of animal suffering and social upheaval, Raskatov stands apart from a generation of composers like Jonathan Harvey and R. Murray Shafer, who have carved out some space for musical events that reflect their intense interest in eco-musicology, where (recorded) animal acoustics play a literal, re-sounding part. Their work is in many ways indebted to Thomas Sebeok's influential scientific writings on animal communication, and on "bio-acoustics" in particular.[3] Theirs is a concern for the diminishing ecological status of the sound world by which animals identify their environment, as renowned musician and naturalist Bernie Krause's writings have so thoroughly investigated.[4] In contrast, Raskatov shows no particular fondness or support for his singing animal subject. Indeed, Sharik's marked indifference to the conventions and concerns of human life radicalize him within the history of onstage dog figures, and this indifference also ensures his survival. In a further twisting of the traditional characterizations of dramatized dogs, it is the human's disregard for the dog's voice when he does speak, and the rejection of his position and his needs, that thwart our expectations. Ultimately the animal finds a home, in spite of all that happens to him and the almost total lack of sympathy for his plight. Raskatov's operatic version of Bulgakov's satire on Soviet social reordering explodes narrow readings of animal-as-symbol. As a trainee medic and the nephew of an esteemed progressive surgeon, Bulgakov strayed from the conventional scientific milieu that surrounded him in his critique of scientific experimentation on animals even while exploiting its symbolic value in his criticism of the emerging new Soviet state. Both works (opera and novella) position the social and scientific horror of the dog's life as a real, feeling member of a

society that is in revolution. Sharik's vocal persona and what he has to say separate him from his canine onstage brethren and their mute appearances. He is a usurper of both traditional and contemporary artistic interpretations of the stray dog, where convention repeats narratives of rescue, domestication, and contractual rewards for good behavior. In this chapter I reposition this singing dog-man creature alongside the irreverent dogs of the Elizabethan stage—and by tracing his departure from the stereotypes of the well-behaved, faithful dog of stage and screen that have survived as a trope since the late eighteenth century—Sharik bucks the trend of obedience and becomes a channel for anarchy.

Life of Its Own, Regardless

In the many written accounts of dogs onstage and in performative contexts in general, silence and reliability are the traits most treasured in the canine actor. Most animals in performance practices, including circuses, share this trait of convenient muteness while becoming spectacularly symbolic. This also holds, I believe, for living, literary, and artificial animals. In this chapter, I move freely from one to the other in order to deepen this investigation into representations of acoustic animality in a variety of performance contexts.

Onstage animals rarely raise vocal objections to their roles in the performance because they have been well trained for the task. Live dogs are especially prized and spectacularized because they are at once both fully "animal" and familiar "companions"—real and imagined, domestic and theatrical. Erica Fudge reminds us that for the canine onstage performing as a representation of friendship, "it is the reality of the animal that *is* his meaning." [5] This reality, says Fudge, is most explicitly tested in Shakespeare's play *Two Gentlemen of Verona* (ca. 1590) with the character of a dog called Crab. This particular Elizabethan animal player emerges in a period when dogs were popular contributors to elaborate theatrical treatments of historical events, romantic tales, and the occasional Greek tragedy. Whole packs of hounds were included to demonstrate a hunting scene (in *Palaemon and Arcyte*, 1566) or to perform as an individual living prop accompanying a shepherdess as a symbol of fidelity (in *Il Pastor Fido*, ca. 1586). By the time Crab wanders onto a piazza in *Verona*, the persona, and indeed dramatic duty, of the onstage dog was well established and well sought after—not for the skill of its performance but for the total absence of one.

Elizabethan audiences preferred their stage dogs to be uncomplicated living beings, wholly themselves and behaving as they wished while onstage. Performing tricks or enacting clever deeds was both unwelcome and unheard of. Dogs and hounds were to be themselves, not to play themselves, and especially not to play dead. In Ben Jonson's *Every Man Out of His Humour* (at both the Globe and at Court in 1599), the knight Puntarvolo's greyhound is given a fatal poison, but it is led offstage by a string before it "dies" in the text and thus remains, as Michael Dobson describes, "strictly an accessory, a mute externalization of Puntravolo's folly."[6] Dobson brilliantly outlines how dogs in this period were mostly paraded and displayed but were also expected to bring the scene "to life" through their material bodies, silent and nonperforming. This was the intellectual frisson that audiences of the period were exercised about, and dog owners were very well paid for keeping their animals ignorant of the follies of the theater. The onstage canine's principal task was to remain an unutterable fact within the spoken fiction of the spectacle.

In *Verona*, Shakespeare makes it clear that the dog is not even housetrained, and his human companion Launce's monologues draw attention to the dog's total lack of performance skills. Crab is given nothing to do except appear beside Launce, who describes his dog's misbehavior, his troublemaking, and not least his disregard for Launce's emotional state in two long speeches. Fudge focuses with precision on the one point where Launce castigates Crab for having urinated against the underskirts of a woman with whom Launce wishes to consort. Launce recounts the incident, because we, crucially, do not see Crab perform this action. Fudge interprets the scene of Launce's castigation and lamenting as the key that increases the farcical progressions of the play, and of the play within the play. Crab, via the text, appears ever more mystified as to his function in the drama. The more Launce castigates the dog for his inaction, the more Crab as an actual living animal reveals that, for Shakespeare, his function is just to exist, to play against the play, and, as best he can, to hold off from doing anything he might be inclined to do (such as relieve himself or fall asleep) or, crucially, anything that might actually qualify as performing. The presence of the live dog in *Verona*, and his unruly behavior, "signals in the most explicit way" what Fudge calls "the very real danger of incivility that hangs over the drama."[7] For Fudge, the silent, hapless dog is Shakespeare's way of reminding us that we are fragile, barely domesticated creatures ourselves who may not know what we are doing in general any more than the dog knows what he is doing in this play.

The creation of Crab occurs at the beginning of a long line of Shakespearean dog references that connect human and animal species and in turn illustrate the difficulty of what it is to be a human. Shakespeare begins his menagerie of animals with the actual living dog in *Verona*. By the time we get to the heath scene in *King Lear*, animals, humans, climactic forces, and their qualities have become completely ensnared in the language Shakespeare uses to describe his human protagonists, and especially their condition. But rather than just reading this zoography as a cache of anthropomorphic insults, using animal natures and appearances to degrade the human character, perhaps, as Fudge suggests, Shakespeare is revealing his exemption of the animal from the torment of humanity. The playwright grabs at animal characteristics and the perceived foibles of other species as a means of rebellion against changing perceptions of humanity, namely emerging and messy enlightenment philosophies, that surround him. He positions the human as the abject exception to the rule of nature, one who has no command, who contradicts and confounds instinct and psychologically and physically violates the body and its politic. With Shakespeare, the universal human, in all its situations, ultimately becomes a creature without the capacity to become an animal.

In a zoographic reading of *King Lear*, Laurie Shannon exposes a cross-species platform in which the human, the declaimed exception, becomes a negativized, prostrate creature, far removed from the perceived vertical directionality of the newly emerging conscious human body in this period and its "ontological movement towards divinity."[8] For Shannon, in the abject status of Lear, Edgar, the Fool, and others in this play, it is their humanity that is exposed as unspeakably impoverished. King Lear, she writes, "calculates man's pathetic condition when unsubsidized by animal debt: 'Thou owes't the worm no silk, the beast no hide, the sheep no wool, the cat no perfume. Thou art the thing itself. Unaccommodated man is no more but such a poor, bare, forked animal as thou art.'"[9] In this stripping away of what little protection animal body parts can give the human, "in its flagrant insufficiency, [it] is barely an animal at all."[10] In Launce's more comedic declaration, he expresses these confused identifications when he worries if "I am the dog. No, the dog is himself and I am the dog. O, the dog is me, and I am myself." For poor Launce, however, the "flagrant insufficiency" here is that "the dog all this while sheds not a tear, nor speaks a word" of comfort to Launce, while he himself "lays the dust" with his tears. Shakespeare makes it clear that it is imperative in both action and

word that the dog remains a silent, indifferent observer to the trials of his human companion.

In a production of *King Lear* at the Abbey Theatre, Dublin, in 2013, a pair of Irish wolfhounds were led through the set at various points during scene changes and then lounged around onstage with their cloaked handler for both of the twenty-minute intervals. These huge animals were mesmerizing in their hairy physicality, their toenails clacking across the stage and their tongues panting and drooling under the heat of the lights, making the interval non-act a truly Shakespearean experience. Those of us who sat riveted by the dogs during the intervals secretly knew that each dog was yawning and wagging his tale in the fullest dog-knowledge that he was still himself alive—be it onstage, in the street, in his living room, in a kennel, or in another theater. For Bert O. States, the thrill in seeing the onstage Elizabethan dog, like these hounds in the Abbey or like Crab in the Globe, is how liveness in performance plays with illusion. States suggests that the theater may think it has stolen something from the real world to show how remarkably it can cope with these levels of risk. However, the audience is more excited by how "the theatre has, so to speak, met its match: the dog is 'blissfully' above, or beneath, the business of playing and we find ourselves cheering its performance precisely because there isn't one."[11] For States, this phenomenological question centers on the theatrical experience itself and what is at stake for the spectators as co-contributors to this life-world fabulation onstage. Turning to Crab in *Verona*, he finds the "intersection of two independent and self-contained phenomenal chains, natural animal behavior and culturally programmed human behavior."[12] Crucial for this kind of premise to succeed is that the dog behaves with complete, silent indifference to what is going on around him, remaining somehow pure, as the human performers turn themselves inside out to try to reach their target.

For Dobson, "nothing gives a more convincing impression of having a life of its own regardless of the demands of dramatic convention than an untrained dog brought onto a stage."[13] This idea of "having a life of its own *regardless*" locates a unique autonomy in the character of Crab in *Verona* and, in my view, is also at the center of the portrayal of Sharik the stray in Bulgakov's novella and Raskatov's opera. There is a vital connection between Crab and Sharik across a broad historical period, but perhaps not such a wide human-animal gap. In both live and imagined characters, their disregard for what is going on around them is what will get them through this ordeal with the chaotic human, whose unpredictable

circumstances and disastrous approach to social life is continued into literature and onto the stage. Voicing the animal's intentionality in these dramas becomes the unruly spark that ignites tensions of and about species hierarchies, wisdom, the politics of sharing territories, and the living dynamics of otherness.

With Shakespeare's Crab, it appears that the secret to getting through this strange situation is to do nothing and say nothing and therefore remain blissfully unaffected by the drama. For Launce "'tis a foul thing when a cur cannot keep himself in all companies" by being both unhygienic and unaffected by social niceties. Launce says Crab fails to comply properly with his position as servant to his master by not speaking a word of condolence or shedding a tear. While Crab's onstage moment depends on his presence signifying the absence of a performance, Launce's admonishment of his companion animal could well be applied to Bulgakov's Sharik, who goes through such extreme physical trauma and torture with a certain degree of indifference. Sharik should be listening to Launce, who advises his dog to be someone who "takes upon him, as one should say, one that takes upon him to be a Dog indeed, to be as it were, a Dog at all Things" (*Verona*, 4.4). When his ordeal is over, Sharik decides that his best option, in spite of his humanized experience, is in fact to behave more like a dog at all things and less like the frustrated New Soviet human citizen conflicted with concepts of freedom, standardization of social living, and learning political opinion from a manual.

The Rise of the Dog Stars and Their Biographers

The potential for canine indifference to the activities and desires of the human players in any performance context, be it the Crufts dog championship or the Globe theater, is a crucial element of the success or failure of the event. For the early modern audience, playing against the stereotypical subservient dog further fueled the delight of any dog owners who knew full well that this animal is capable of mischief, heedlessness, and bias in real time. In Crab, Shakespeare's canine actor is made to *do* nothing but must *be* something exquisitely spectacular for its audience—that is, to be really, convincingly alive, which in itself is so desirable and so difficult in any performance context. In the transformation from animal to actor, dogs did not become performers until after 1760.What Dobson calls the

"rise of the dog star" initiated legislation of labor laws for theatrical animal workers.[14] By 1784, a poodle named Moustache was earning £7,000 profit a year for Sadler's Wells Theatre in London as principal performer of an entire troupe of uniformed retrievers who nightly attacked a fort in Charles Dibdin's play *The Deserter*. Moustache's career was followed by an even more astounding performance by a dog called Carlo and the introduction of a new genre of dog drama in a play called *The Caravan* (1803), written for Carlo by Federick Reynolds. At the climax of the play, set in the outskirts of Barcelona, Carlo dives into a vat of water to rescue the daughter of the Marquis of Calatrava. According to Richard Brinsley Sheridan, the commercial success of this dog drama saved the theater from ruin, and Carlo became "the author and preserver of Drury Lane," ensuring his celebrated status as actor and savior of theater and celebrated for his commitment to his vocation to the stage.[15]

The newly celebrated onstage dog star became a popular subject for an emerging genre of animal "autobiography." The imagined vocations and theatrical adventures of the dog actor and the scale of his adoring audience were inevitably going to be exaggerated. Elizabeth Fenwick's 1804 book, *The Life of The Famous Dog Carlo*, differs from many of the sentimental biographies of faithful dogs that were beginning to be published in this period. Fenwick's first-person narrative of Carlo's life is not a work of great literature by any means, and it was written as a potboiler—Fenwick had no connection to Carlo but was struggling to find ways to live independently as a teacher, librarian, and eventually an actor in the West Indies. But what marks her book as unique is the way in which Carlo discusses his experience of life, from puppyhood to his early adventures, as preparation for this feted performance in *The Caravan*. In Fenwick's story, we have the vocational intention of the dog artist; everything in his life made sense when he was finally cast in the play to save the Marquis's daughter from drowning. Carlo's career continued, with many more shows developed especially for him and, no doubt, his many "Carlo" replacements. Carlo's franchise had a long stage life, performing all over Britain. There was a "Carlo" still saving children onstage in Birmingham until at least 1827.[16] Only because of the shift in the function of the onstage dog—from spectacular "liveness" to acting animality—did the animal "autobiography" become possible in literature. These nineteenth-century dog actors were no longer admired for being dogs of the everyday but for how wonderfully close to mindful humans, as actors, they had become.

From Carlo through to René de Pixérécourt's popular 1814 play *The Dog Of Montargis*, in which a silent dog defends a mute man wrongly accused of murdering a knight, and even up to Uggie, the dog star who saves the main character from a burning building in Michel Hazanavicius's (2011) silent film *The Artist*, dogs have been working long and hard onstage and onscreen as lively allegories of fidelity to humans and, by extension, a living testament to the human's benign but exceptional understanding of and control over the animal other. Silence is less of a feature of dogs in literature, where talking-dog stories became classics for Miguel de Cervantes, E. T. A. Hoffmann, Nikolai Gogol, and Franz Kafka. The comedic values that a dog might speak are secondary to the perspectives these literary dogs have given on moral attitudes, scientific taxonomies, social systems, and how we humans may or may not adapt to modernity. In Hoffman's story, Berganza, the wandering stray, ends up on the stage. Other literary talking dogs find various employments but invariably lose hope for humankind and return to a life on the streets. They are united in their experience of the world, and the wisdom they gain from interaction with human life informs how they determine their next move. However, for Franz Kafka, any retreat from a moment of enlightenment is something that his dog narrator is unable to bear.

In Kafka's short story *The Investigations of a Dog*, an inquisitive young pup lives an ordinary life until he encounters seven artistic dogs in a woodland clearing performing mysterious ritual movements while producing musical sounds that overwhelm the young dog. The experience changes him forever. Written in 1922, two years before Kafka died, this canine autobiography is one of the writer's longest short stories and certainly one of the strangest, even by Kafka's standards. It is also a moving tale of frustration, education, art, and freedom. The story is entirely narrated in the first person by the nameless dog, who, from the outset, describes in detailed long paragraphs how his encounter with the musical performing dogs was a contradiction in itself, because "they did not speak, they did not sing, they remained generally silent, almost determinedly silent: but from the empty air they conjured music."[17] From the beginning we are in a territory of dualistic complexities: silent voices, animal cultures, physical transcendences, and, not least, the vocalized performance of canine autobiographies.

In the pup's investigations, the source of the music is unknown. There are no visible mouths singing or any evidence of musical instruments in

the description of the physical performances of the seven dogs. Their voices and music emerge out of nothing. This event determines the pup's agenda as he sets out on his epistemological quest to find the source of this mystical canine acoustic world. He has little interest in the ritual spectacle itself or the artistry of the pack of seven dogs, in whose performance "everything was music, the lifting and setting down of their feet, certain turns of the head . . . the positions they took up in relation to one another, the symmetrical patterns they produced."[18] The experience of the sound was so physically overwhelming for the hapless young dog that its immersive impact changed the course of his life, and certainly the course of his thinking. He describes how his mind "could attend to nothing but this blast of music which seemed to come from all sides, from the heights, from the depths, from everywhere, surrounding the listener, overwhelming him, crushing him, and over his swooning body still blowing fanfares so near that they seemed far away and almost inaudible . . . the music 'robbed me of my wits.'"[19] What impresses the dog is not so much that the Mysterious Seven are able to make such powerful music, and make it invisibly, but more the demonstration of their "courage in facing so openly the music of their own making, and their power to endure it calmly without collapsing."[20] Their performance resonates with him deeply and can, in turn, resonate with a reader who understands what it means to be physically impacted and enmeshed in live acoustic performance events.

The dog in *Investigations* becomes acutely aware of the strength of spirit in the performers. They have physical control over the phenomena of their actions and they can bear the consequences of their display, which, he now knows, flies in the face of the common good; not against society, but maybe in spite of it. In the last line of the story, Kafka suggests that their intention may have something to do with the idea of freedom—but not before the dog has thoroughly tested his research at great length against other questions, such as where food comes from, and is there any relationship between the origins of food and music. Mladen Dolar suggests that for Kafka's dog, "food, pure materiality and immanence, will suddenly point to the transcendence" of the musical performance and that the voice, maybe even his own musical voice, "is the source of food he has been seeking. There is an overlapping, an intersection between nourishment and voice."[21] The dog also mentions leaving his childish concerns behind after the Mysterious Seven Dogs event. Concerning oneself about food sources might indeed be an infantile preoccupation, and "there are more important things than

childhood."²² For Dolar, this is one of Kafka's greatest sentences "in our time of a general infantilization of social life . . . a time which loves to take the despicable line that we are all children in our hearts." ²³ Dolar is on the side of the young dog who decides to grow up and to begin his investigations. He pursues his quest as an aware adult dog. This, Dolar observes, is also the slogan of Lacanian psychoanalysis, which seeks to leave infant histories behind and fully enter into the problematics of the conscious adult world. But Kafka's story suggests that this will not be easily achieved, and certainly not without a significant degree of alteration and great personal sacrifice. The relentless noise of the chattering voices of the innocent, uninitiated dogs affects this dog to such an extent that he abandons his investigations. He is reconciled that he must limit his ambitions within his social circumstances in spite of his new canine consciousness. However, he has one final comment about possessing at least some knowledge of freedom. For Kafka and for the reader, there is the slight hope that maybe an experience of music, ritualization, starvation, bloodletting, and psychological interrogation of selfhood was not all in vain. The dog exclaims that, "Freedom! Certainly, such freedom as is possible today is a wretched business. But nevertheless freedom, nevertheless a possession."²⁴ In this important sentence at the end of *The Investigations*, the dog hints that even the awareness of a more expanded consciousness, beyond immediate basic existence might be a route to liberation. The physical trauma, the dancing, and the psychological expansion of mind go beyond observation and investigation, because in the end one does "possess" something—a knowledge through art—that cannot be taken away in spite of a social regime that is barely tolerable.

Kafka's dog's tone of voice changes in the course of the story from young, naive pup to mature, almost world-weary adult animal. There is also a nuance of resignation in his voice and in the acknowledgment that he came close to something "other," perhaps to a sense of becoming-with the Mysterious Seven and moving beyond the everyday experience of his species. Kafka's obscure tale of evolution and transformation of self has an important place in animal narrative literature. As Kafka's story of dog-pack becomings was added to his posthumous archive, Bulgakov was simultaneously creating another canine autobiography with *A Dog's Heart*, not knowing that its destiny was to be scandalized into silence. Both stories are so unusual that they cannot be included easily in the catalogue of Victorian dog "autobiographies" that had become so popular prior to the publication of these two eccentric dog tales. The fantasy of the narrating canine

contradicts the reality of a dog's life in this rather brutal period, when strays were beaten or shot on sight on the streets of nineteenth-century England. In the conclusion to her essay *Dog Years, Human Fears*, Theresa Magnum is not surprised "that when mute or muted creatures speak, they speak in the voices of sentiment," expressing their fictional frailty after a lifetime of usefulness and obligation "and a grim reminder that old age, like animal life, is a tableau that our culture prefers to see blind, silent and bathed in sentiment." While these faithful dogs are given a voice, and "sensation, often pain, forms its language," it is at this point that the animal also becomes a "companion" and is willing to suffer for the sake of its human companion's needs. Carlo's autobiography is a particular example of the quality that defines the genre, namely canine fidelity to the human.[25] While the "autobiographies" continued to be popular and maintained the narrative of the devoted dog, the realities of the street dog's experience as a laborer, or as an experimental animal in the science lab, were as prevalent as the activism against these practices that grew alongside the politicized action of women's suffrage. The women's suffrage movement and the establishment of the British Union for the Abolition of Vivisection (BUAV) collide in historical time and continue to be linked. Frances Power Cobbe (1822–1904) epitomizes these complexities as a member of the executive council of the London National Society for Women's Suffrage as well as being the founder of the BUAV in 1898. Feminism was part of an expanding movement that saw animal cruelty as a reflection of the patriarchy's general mistreatment of people and animals. Activists like Edith Goode (1882–1970) were among the first to talk about animals as citizens. These initiatives eventually led to the antivivisection Old Brown Dog Riots in Battersea Park in 1907, when student surgeons, suffragettes, animal rights campaigners, liberals, Marxists, police, trade unionists, and members of Battersea Council engaged in a series of violent encounters. The reason for this anarchy was the installation of a memorial sculpture of a dog whose vivisection and death in the veterinary college of University of London instigated scandalous court cases; the protests resulted in the removal and melting down of the metal sculpture. In the court cases against Ernest Starling (1866–1927), Professor of Physiology at University College, London, and his brother-in-law, William Bayliss (1860–1924), who were using vivisection on dogs to determine whether the nervous system controls pancreatic secretions, as postulated by Ivan Pavlov (1849–1936), the widely reported testimonies of witnesses to the experiments on the nameless Old Brown Dog are indeed gruesome.

This short detour through this potent period in written animal biographies shows that the literary genre of the benign, reminiscing, aging dog continued, regardless of the riots, the links to the women's suffrage movement, and the establishment of several new animal welfare movements that continue to be active today. For example, Virginia Woolf's *Flush* (1933), an "autobiography" of Elizabeth Barrett Browning's spaniel, is, in effect, an homage to the poet and her trouble with her father and her illnesses. Flush, after a lifetime of devotion, is content to die of old age in the sun in a piazza in Tuscany, knowing his mistress is safe and well. The hounds unleashed by Kafka and Bulgakov would be horrified by this kind of obsequiousness, given that they have physically and psychologically torn their own identities apart.

Homo Sovieticus

In *A Dog's Heart*, the animal's identity unexpectedly expands with his pivotal role in the Professor's developing experimental practice of replacing his human patients' organs with animal organs in a process of so-called rejuvenation. Eugenics is at the center of concern for Bulgakov, a writer with an interest in medicine who witnessed the emergence of eugenics practices in post-revolutionary Russia, an era full of the promise of biological rejuvenation for a healthy new society. At the birth of this ideology, according to Yvonne Howell's essay "Biology is Destiny," is the ability of the dog (and perhaps by inference, the peasant underclass) to speak for itself. There is a problem, however, that ultimately becomes the undoing of everybody: the surgeon, his assistant, the dog Sharikov himself, and especially the new bureaucracy that tries and fails to integrate him into its socially standardizing administration system. Howell describes how "the problem is that Sharikov, as a particular example of the miraculous leap from animal to man, opens his mouth initially and primarily to spew out obscenities."[26] Historically, it is the fundamental fact of language acquisition that declares the human and, in turn, reveals how language-less animals have been uniquely useful in establishing strata and schemes of human exceptionalism.

When Sharikov the dog-man usurps the miracle of language granted to him by science by speaking only in profanities, he scandalizes the whole project. The broader question occupying the minds of Russian intellectuals

and eugenicists in this period, about cultural programming and biological determining of human social behavior, now hinges on speech and language. Howell explains that "the problem of language proves to be a powerful illustration of the futility of applying existing eugenic solutions to create the New Soviet Man. . . . Any class based eugenics program designed to promote the proletariat will dissolve in a fatal paradox. . . . Bad stock will most likely produce bad offspring."[27] And here, in this moment, Sharikov is born. In both the novella and the opera, no one is surprised that the dog can speak, especially as he becomes more human-like. The new concern is more a question of what he is going to say and do, now that his social status has risen. Howell concludes that for these Russian surgeons, speech is universal, but language is class-based, and "linguistic backwardness" is never going to be overcome by eugenics, no matter how strong the will to position the peasant and "the vanguard of national identity."[28] For Professor Preobrazhenksy, the experiment is a further failure because of the very individual natures and traits that are fighting each other in the body of Sharikov. Preobrazhensky's goal was to improve humanity as a whole, not one peasant at a time. An individual can be transformed, but changing a society will take more than surgical rejuvenation experiments involving animals and their vocal opinions.

Language and its origins quickly become less of an enigma for the surgeon and his assistant, Dr. Bormenthal, and more of an ethical nuisance. The urgent issue now is not how to teach their dog-man any more words but to find ways of shutting him up. For Bormenthal, the drive of the project was rooted in their bioscientific speculations about what, genetically, makes a genius like, say, Spinoza. What are the biological constituents that produce exceptional human thinking? However, Bormenthal has little time to ponder these matters. The reality of the physical horror and chaotic nature of their laboratory creation overtakes his philosophical meanderings. Bormenthal goes so far as to say that Spinoza was just a human man and no amount of eugenic manipulation can guarantee genius. This dog-man Sharikov is therefore an unknown philosophical entity. Even though we have heard the dog's own rather rough view of the world at the beginning of both opera and novella, Sharikov has clearly inherited his foul tongue from his biological donor, the criminal drunk Chugunov, whose pituitary gland is now active in the dog-man's brain. There is no option left but to abandon the whole enterprise before Sharikov says anything more that will threaten the surgeon's reputation as well as the new social order. There is no

room to accommodate or domesticate this kind of human-animal under the Housing Laws of the new administration, nor is there any bureaucratic system in place for anyone to be entrusted with the concerns and ambitions of a talking dog.

When the dog-man Sharikov announces that he is engaged to his secretary at the Sub-Department of Pest Control and intends to start a family, the surgeon wastes no more time. Sharikov is violently cornered, captured, and then accepts his fate. In a tender turn, it seems the burden of humanity has been weighing too heavily on him, too, in spite of his efforts to be a good citizen and comrade. The surgical procedures carried out on Sharikov's brain and testicles are a frenzy of white-coated chorus men and women, descending on the animal's body. Soon the stage floor becomes saturated with blood, seeping forward into the musicians' pit. In the novella, it is even more chilling and uncomfortable when the professor and his assistant begin "tearing Sharik's body apart with hooks, scissors and some kind of clamps. Out slipped the pink and yellow tissues, weeping bloody dew. Fillip Filippovich twisted the knife in the body and then cried 'Scissors!'"[29] By giving the screaming animal the voice of a countertenor (with its own testicular history), Raskatov shows that he is well aware of these uses and abuses of both the human and animal body for creative purposes. Following even more bloody surgery, he reverse-mutates into being a dog, in a remarkable ten days. The last trace of his human self is his human voice. Soon this, too, will be lost to the growls and whimpers of Sharik the stray, only to be beautifully interpreted by the soprano and the countertenor.

Opera has historically been considered either a dangerous social practice (by religious institutions) or as a frustratingly beguiling nonsense (by philosophers such as Rousseau and Nietzsche, and, more recently, Žižek and Dolar), mainly because of the threatened loss of intelligibility of the text and the casual regard of composers for the absolute power of the spoken word. This threat is most in evidence when representations of animals start singing onstage. The project becomes even more precarious when the singing animal starts making sense. Operatic animals and human-animal hybrids are usually to be found outside the human world—for example, in Wagner (*Siegfried*), in Mozart (*Die Zauberflöte*), and, spectacularly, in Braunfels (*Die Vögel*). In what is generally considered to be the first opera, Monteverdi's *L'Orfeo* places the singer-poet Orpheus, who charms animals and even stones with his music, as the central figure of this new form of

performance. In keeping with opera's classical or Greek origins, animals function very effectively as non-Greek or "barbarian" voices within the drama or crisis onstage. In Delibes's *Lakmé*, for example, the girl goes out to the forest to calm the beasts with her infamous "Bell Song." The female, human voice quells the barbarous multitudes. "Barbarous" is an echoic word reflective of strange tongues. Being a barbarian is different than being just an outsider. Walter J. Ong's term "the barbarian within" is focused on speech and language ability, where "the barbarian is defined not in extra-human geometrical terms," such as who is and who is not inside the city walls, "but in terms derived from human life itself, from the eminently human activity of verbal communication."[30] In this context, the medium of opera could be considered as an exciting and controversial practice in which human speech and language are both distorted and detached from meaning through singing—especially as baroque audiences seeking extraordinary vocal virtuosity came to prize the vocal high note, or what Michel Poizat calls "the angel's cry." The rapid development in early opera of foregrounding the soprano and castrato voices usurped the original ambitions of the Florentine renaissance intellectuals who sought to rein-vent the Greek theatrical art form of sung speech. Instead, Poizat says, "the distinction between humanity and animality collapses. The prelapsarian indifferentiation of the human and the animal comes at the cost of the renunciation of speech: Orpheus communicates with animals through his singing and the angels communicate among themselves without the intermediary of the spoken word."[31] By giving the stray dog, Sharik, both a soprano and countertenor double-voice, Raskatov is making his crucial point. The animal only becomes a monster when he begins singing with the voice of a human. The chief character of his monstrous humanity is to lie about almost everything: his history, his name, his movements, his job at the Sub-Department of Pest Control, his identity papers, his love interests, his drinking, and especially his future intentions. When Sharikov claims social status but behaves like an anarchist, his physical actions constantly undo his verbal promises to be a good human animal.

The Scandal of the Singing Animal Body

In Judith Butler's afterword for the 1994 publication of Shoshana Felman's book *The Scandal of the Speaking Body*, she decribes how "the body is not

'outside' the speech act." The body is an organism recognized by Butler and Felman as being within the actions and activities of speech. Butler expands the idea by declaring that since the body is "at once the organ of speech, the very organic condition of speech, and the vehicle of speech, the body signifies the organic conditions of verbalization. If there is no speech act without speech, and no speech without the organic, there is surely no speech act without the organic. But what does the organic dimension of speech do to the claims made in speech, and on behalf of speech?"[32] It is an essential question, and, by extension, I ask what the organic dimension of speech does to the claims made in speech when the organic dimension, the organ of speech, is an animal body? What is different about the question of broken promises made with speech acts onstage when the exchange is between species, about species, or abandons the concept of species? Perhaps it is not so unlike an exchange between different sexes, if we follow Butler's line of inquiry into modes of gender identification. If the performance of gender creates gender, can the performance of species also create species? Could playing a dog, for that while, for whatever purpose, be classified as "dog"? How could such a concept, as played out by artists becoming creaturely, bring us any closer to understanding what it might be like to perform a version of one's own species, or another species, whether one is human or not human?

At the core of the scandal in the performative act of speech lie the spoken promises that are made by speech and then broken by the body. Felman uses Molière's *Don Juan* to illustrate her interpretation of J. L. Austin's theory of the promising, speaking body and how the body is made profane by its own actions, by promising one action and doing another. The "I will say" and "I will do" of the speaking body, which can so easily break these promises through silent physical action, usurps the human dependency on the authority of the spoken word. Felman reveals the fragility of speech-acts by placing them in an erotic or sensual context, such as Don Juan's mouth. She explains how "one might say that the Don Juan myth of the mouth is the precise place of mediation between language and the body. Don Juan's mouth is not simply an organ of pleasure and appropriation, it is also the speech organ *par excellence*, even the organ of seduction."[33] We know we cannot trust Don Juan, as he repeatedly breaks every promise right up until the end of the performance and his own demise. In this context of mistrusting voices, we can question whether we can trust our creative interpretations of animal acoustics as being anything other than

a projection of human desire onto other species and an appropriation of their vocal worlds. In the final scenes of *A Dog's Heart*, the libretto presents a challenge to this notion of the dog as trustworthy, a further troubling of the veracity and value of speech.

What is unique to the particular animal in *A Dog's Heart* is that he remains unchanged by the trauma of his experiences at the hands of the doctor. The last trace of his human self is his voice. In a moving scene in which Sharik is recovering from his last surgical procedure, graphically stitched and bandaged together, he rises up on his hind legs for one last time and "barks suddenly" at the Household Inspectors, saying, "Don't use rude words" when they aggressively come looking for the unregistered resident of the surgeon's apartment.[34] These are the last human words he declares aloud—his final instruction on how to speak, on how to behave vocally. As a dog giving advice, his final act of defiance is closer to his social awareness of how to survive as a stray underdog than anything he pronounced in his desperate struggle to be a good human comrade. This is the remarkable aspect of this character. The social drama, death threats, love interests, and species-altering surgical procedures do not change the speaking subject of these traumas. There is a transformation, but it is a futile one. There is only *this* individual dog, with his own principles from beginning to end. Sharik/Sharikov is the ultimate "barbarian within"—a creature that is both sensible and disruptive but one who has little interest in human affairs. He wishes either to be left alone or to die. His relationship with Professor Preobrazhensky is entirely opportunistic. If it ended tomorrow, Sharik would most likely shrug it off as a waste of time.

The composer's lack of sentimentality in the musical double-voice of the creature and his determined allegiance to the original text ensures that even the most fervent dog welfare activist might struggle to find political support for this animal. When Sharikov the man-dog-tenor starts to assert his needs and his will, the mood is high for some animal-as-victim payback. It does not arrive. As soon as Comrade Sharikov starts assaulting the doctor's maid and terrorizing the cats of Moscow by rounding them up and making fur coats out of them, any remaining sympathy—or even empathy—is lost (with hilarious effect). Even though Sharikov must pay for his social chaos and rampant sexualizing of the boring civic job he was assigned to do, by being surgically reversed to "animal," another promise of operatic tragedy is broken. Nobody dies. When Sharik awakens from the anesthetic he is singularly indifferent to his renewed canine status. He

as much as says, to paraphrase, "If there's a sausage in it, I might as well stay here in the professor's library for now." Perhaps what remains constant for Sharik throughout both the drama and the novella is, ultimately, the sausage that he desires so much (he has already learned to read shop signs so that he can recognize sausage shops), and it is the sausage that gets everything in motion. The dog is homeless and starving; the professor has the sausage and a home.

In Donna Haraway's assessment, this is what humans have been exploiting ever since we discovered that some animals are good to eat and other animals are good to domesticate (and then eat), and the most companionable of animals are those that are good to eat with. Since dogs discovered that humans have the same palate as they do and will provide a calorific bonanza of food waste and potential reward systems that can benefit a pack of hungry dogs, the notion of the companion species, the *cum-panis* or bread-sharer, was born. Breeding other animals to be eaten is a human activity that, throughout recorded history, has uniquely benefited canines. For Haraway, the alliance does not simply end there. Humans benefit enormously from the companionship of a pack of wolf-dogs in their own struggle for survival. It is because of such apparent ease of companionship that dogs have been straying into people's missions—and not always to their benefit. The figure of the stray dog in arts and performance practices comes with layers of romance, heroism, domination, and domestication that have both been directly influenced by experiences with actual canines and, in turn, shaped the lives of some particular dogs. For example, in live art performances involving feral, stray, and domestic dogs, the canine figure is almost always loaded with a romantic agony by artists; examples include Joseph Beuys's coyote, Oleg Kulik's violent dog impressions, and, most controversially, Guillermo Vargas's installation with a dying street dog in Nicaragua in 2007. The fetishizing of the angry or silent canine martyr extends beyond the gallery and the theater and into social scientific spheres where similar iconographies occur. A famous example is Laika, a stray Russian terrier who became the first living creature to orbit the earth—but not to survive the mission. She was soon followed on subsequent Sputnik rockets by two more strays, Pchyolka and Mushka. The mission programmers reckoned that if a young dog could survive two or three freezing Moscow winters on the streets, it was more than prepared for outer space. Laika quickly became an idol of the new

Soviet nationalism that the space program sought to generate, not least because of her many radio appearances, barking her enthusiasm to play her part in the great Soviet project. In her imposed fidelity to the human effort, Laika was seen as a kind of sacrifice in the name of science. Indeed, the word "sacrifice" is used by experimental biologists in laboratories today as the technical term to describe animals that are fatal specimens. The term carries with it some metaphorical references to ritual transformation and the "making sacred" of repeated physical actions.[35] Therefore, Laika is precisely the type of found stray dog that became an immortalized and capitalized commodity, part of an emerging animal social history that Haraway describes as the "instrumental relations between laboratory animals and their people."[36] In the context of considering dogs as workers in all kinds of situations—not just in art or theater but also in the field, as herders, in airports, as rescue workers, in rehabilitation, guiding the blind, anticipating epileptic seizures, and as psychotherapeutic assistants for trauma victims—Haraway considers the laboratory dog as perhaps the most hardworking social animal of all.

In Haraway's example of laboratory animal labor, the scientific race to be the first to clone a dog culminated in 2005 at the center for embryonic stem cell research at Seoul National University (SNU), where more than one thousand dog embryos were implanted into one hundred and twenty-three bitches. The resulting three pregnancies produced one living pup, "SNUppy," an Afghan Hound clone, who has since sired several litters of pups out of cloned dams, all of whom are being trained to work for the Korean state as sheep herders and in various positions of national security. In Haraway's estimation, SNUppy's dubious past and uncertain future reveal "the thick cross-species travel between agribusiness research and human biomedicine often obscured in the US 'ethical' debates over human stem cell technologies and imagined therapies or reproductive marvels."[37] SNUppy, and Haraway's controversial readings of her biography, joins a long list of stray and domesticated dogs that have made both dubious and remarkable contributions to bioscientific events like cloning, which, in turn, have become entangled in human sociocultural expressions such as literature and art. It is under the canopy of these historical narratives and cross-species circumstances that the operatic Russian dog-man and his contemporary onstage surgical moments become relevant to this undisciplined straying in and out of laboratory-literary dog discourse.

Broken Promises

The lesson in *A Dog's Heart* is not that the dog Sharik suffered, but that his suffering is of no consequence to him. He breaks with the history of the onstage canine promise of stereotypical, silent obedience and the potential for martyrdom by singing about it accompanied by an orchestra on the operatic stage. Raskatov's opera ultimately declares, with characteristic irreverence—as the medium has regularly done from the outset—that there is no hierarchy in speech, that the phenomenon of the voice emanating from the body can override or even dissolve the meaning of the words that are being sung, and that this crying out is angelic, empathetic, and animal at the same time. The acoustic exclamation is what matters: the vocalized, carnal, emotive interior becoming exterior, airborne, and being heard, even if the vocalizer is the only one listening. Singing is an acoustic statement of being, and the human and animal phenomenological moment is held there in that moment, in the aestheticized sounding-out of the self. This is what Walter Benjamin calls the "creaturely voice" that emerges "from the mysterious interior of the organic," and which, he maintains, is the foundation structure of the genre, the opera. In *The Origin of German Tragic Drama*, Benjamin writes, "The 'passion for the organic,' which has long had a place in the discussion of the visual art of the baroque, is not so easy to describe in literary terms. And it must always be borne in mind that such words refer not so much to the external form as to the mysterious interiors of the organic. The voice emerges out of these interiors, and properly speaking, its dominion extends in fact to what might be called an organic impulse in poetry."[38] In *A Dog's Heart*, what is most challenging about the animal victim is how he expresses his casual regard for what is happening to him. He is more aligned with Shakespeare's nonchalant Crab than any of the celebrated dog heroes of the stage or the sentimental Victorian and contemporary biographies of the faithful hound. The opera is more in tune with Nicholas Ridout's notion that "theater's greatest ethical potential may be found precisely at the moment when theater abandons ethics."[39] The ethics in relation to animal vivisection as an allegory for human political struggle in *A Dog's Heart* are certainly murky. No one seems to be on anyone's side. But the break with the theatrical history of the silent onstage canine, and its multiple, biographically embodied promises of fidelity to the human project, mark this performance as unique in the context of interpreted animal acoustics.

Bulgakov's story similarly separates itself from conventional allegorical animal tales by making the animal body and its experience too present, too physical, and too vocal to be just a symbol of human crisis reused time and again. The narrative technique in this novella and the opera is so complex that to read the story as merely an allegory is to ignore something crucial. In Erica Fudge's critique of the novella, she finds something unsettling in Bulgakov's text that ultimately reveals the human to be an "impotent, priapic, monstrous construction engaged in using animals as objects while acknowledging the closeness of humans and nonhumans," especially dogs.[40] In Raskatov's opera, these imbalances of voices, silences, allegory, and human monsters form the precarious core around which the opera is built. The horror of vivisection is elaborately aestheticized onstage, with rousing Russian choruses, puppetry, stunning video projections, high-tensile virtuoso singing, and dark humor, while at its troubled center remains what Fudge calls "the most dislocated thing of all: the human. And sitting by its side, playing with it is as ever, the animal."[41] At the end of the opera, the bandaged dog finds himself sitting in front of the fire beside his master-surgeon-father's armchair and counting his blessings. He is so grateful to be a dog again, a dog at all things, having experienced something of the chaos of what it is like to become a human.

BECOMING LINGUAL
Primate Trouble in the Academy of Speech

> The act of Becoming is a capturing, a possession.
> —GILLES DELEUZE AND FÉLIX GUATTARI

> Death and life are in the power of the tongue.
> —PROVERBS 18:21

This chapter examines living human and animal vocal bodies in perfor-
mance for gestures of communication that are ambiguous, fluid, primal,
muscular, interior, and fascinating. In the many shared biological similari-
ties of species, especially between humans and apes, the means of communi-
cation—the larynx, the lungs, the lips, and the tongue—become emphasized
in a culture in which, as Roland Barthes stated, "the larynx is the mediating
muscle."[1] Voices can appear to carry truths but can just as easily be decep-
tive. Speech, voice, gesture, and meaning can become entangled concep-
tually, and this entanglement is delivered or, for Barthes, "expelled from a
body that remains motionless" while the muscle itself remains materially
unchanged, or even pure.[2] When David B. Dillard-Wright thinks across
species boundaries, he concludes that to become fully human is to find
one's voice in the broad general world of animal acoustic communication:

> Becoming human, then, requires acknowledging this already-ex-
> isting continuity with the non-human who prevents the error
> of imagining a self-sustaining, self-enclosed human world. The
> production of human cultural meaning cannot happen without
> the dense, interconnecting layers of signs that constitute it; nor

can an individual consciousness exist without the general soci-
ality that gives rise to it. . . . Thinking of meaning-production as
an interstitial phenomenon more honestly embeds 'human' cul-
tural production within larger processes of interrelation, marking
within language, within writing, an opening to other modes of
signification.³

The concept of humanity therefore has only ever existed as an "articu-
lation" inside the general milieu of "world," where nothing is neutral, and
everything is already meaningful and "teeming with other minds, other
lives."⁴ Selfhood, be it human or animal, is only constituted within sight
of the currents of meaning that swirl through this milieu, this world. This
phenomenological understanding of embodied meaning arises from shifts
that have occurred in scientific knowledge of animal communication behav-
ior. It implies that we can no longer say animals are only reactive, mute,
and have no bearing on human life and language. Instead we now know
that human communication emerges out of a historically shared acoustic
world, however distanced we have become from that original place of
exchange. For Dillard-Wright, human meaning and language are infused
with content "from the swarming, crawling, leafy world," and, just as human
beings are impossibilities without air and earth through respiration and
digestion, "human culture as a whole cannot function without the nonhu-
man actors who co-constitute it."⁵ Alongside biological co-evolution, the
once-autonomous human cultural distinctions and dichotomies of nature
and culture, body and mind, behavior and language can now be examined
in a much wider territory. Co-constitutionality in the border regions of
linguistic and biological signification produces not a defacement of the
human order but an enrichment of it. Inside this newly opened territory, the
phenomenon of speech has been rethought in terms of gesture and not just
as a product of the mind. For example, Maurice Merleau-Ponty reconnects
speech and flesh in a chain of becoming in this way: "The spoken word
is a genuine gesture, and it contains meaning in the same way as gesture
contains it. This is what makes communication possible. . . . The spoken
word is a gesture, and its meaning, a world."⁶ Failing to recognize the role
that nonverbal gesture plays in speech and language, and schematically
creating divisions of meaning between what can be said and what can
be signaled, only creates further problems and pulls language away from
the body. Just as gestures can be ambiguous, so too can speech, and it can

remain open to interpretation. Therefore, Dillard-Wright suggests, "all communication is gestural" and "studies of human communication should begin with extra-human communication."[7]

The becoming-human that Dillard-Wright describes exists within the continuum of larger processes of multispecies becomings, including the shared space of acoustic communication. Humanity has long been defined as having an exceptional status among species through the distinguishing achievements of language and communication, abstraction and creativity—capacities that are considered absent in, say, an insect or a plant. But certain animals such as chimpanzees and other great apes have consistently undermined these distinctions since their importation to Europe in the early modern period. Even though their unique physical and anatomical closeness to the human body was seen as threatening, their communication behavior kept them safely apart. Because of the apes' inability to speak as humans do, the human "miracle" of language was thought to be secure. In the long and messy struggle for enlightenment, speech, song, and prayer were the exclusive acoustics of the human. However, after Charles Darwin's radical declarations of species evolution, maintaining the status of human exceptionalism became more difficult. Pushing back against scientific and religious insistence on difference, writers and artists began to question notions of species, now newly troubled by the enigmatic presence of apes. The artistic and literary works that shape this chapter interrogate hierarchies of vocalization in human-simian cultural co-evolution, beginning in the post-Darwinian period of the early twentieth century. The legacies of what Erica Rundle has termed the "primate drama" of this era continue to influence interpretations of human-simian cultural relations in film, such as the Planet of the Apes series, and in contemporary performance and drama, beginning with the triadic tropes of humans, apes, and cages in the work of Eugene O'Neill and Franz Kafka.[8]

Opening and Closing Cages of Identity

In the final scene of O'Neill's drama *The Hairy Ape* (1921), the lights fall on the primate houses at the Bronx zoo, where "Yank," the colossal laborer at the play's center, enters the arena of cages and starts a chorus of angry chattering among the chimpanzee and gorilla residents. Since coming ashore from the coal-stoking bowels of an ocean liner to the streets of New York,

Yank has failed to fit into this urban milieu, and at the end of almost every scene he is set upon by a mob or policemen, finding himself in a prison cell or thrown out of a trade union club. He cannot join in anywhere, and, failing to fit in with these architectures of civilization, he is told to "go to hell" and wanders up to the zoo to meet his fate.[9] He is drawn to the cage of a gorilla and begins a dialogue with the animal, first identifying with him and then aggravating him as the gorilla growls back and rattles the cage in frustration, driving the other apes into a vocal frenzy. When Yank, in an act of solidarity with the animal, opens the cage and offers the gorilla his hand in friendship—the "secret grip of our order"—the gorilla pulls him into a crushing embrace, snaps the man's body, and throws him into the empty cage, slamming the door shut. Yank, still alive, realizes the irony of the reversal, pulls his broken body upright on the bars, and calls out "in the strident tones of a circus barker," declaring "Ladies and gents, step forward and take a slant at de one and only . . . one and original . . . Hairy Ape from de wilds of . . . ," and then he slips to the floor and dies. Yank's physical appearance in O'Neill's production notes is specified as "Neanderthal"; he should be "hairy chested, with long arms of tremendous power, and low, receding brows" above "small, fierce, resentful eyes." Alongside his fellow shipmen, black from coal dust and stripped to the waist, "he seems broader, fiercer, more truculent, more powerful, more sure of himself than the rest."[10] By the time he has gone through his reverse-Darwinian devolution into a marginalized creature, weakened by the travails of becoming a social man, seeking refuge in the zoo, he meets his animal mirror in the form of the gorilla. The strength that drove him through the drama is gone when he extends his hand to shake the hairy hand of the very animal that gave him his pejorative moniker.

The character of Yank is further isolated within the drama in the specifics of his heavily accented speech—a distinct New York drawl that O'Neill writes phonetically to pinpoint the class and even neighborhood of this outsider. In Yank's long speech to the gorilla, who pounds his chest in response to Yank's questions, he says; "Sure, I get yuh. Yuh challenge de whole woild, huh? Yuh got what I was sayin' even if yuh muffed de woids. . . . Ain't we both members of de same club—de Hairy Apes?"[11] In Erika Rundle's expansive and leading study of *The Hairy Ape*, she begins with a survey of early twentieth-century theatrical conversations between men and apes onstage, most notably with a 1921 Broadway adaptation of Edgar Rice-Burroughs's *Tarzan of the Apes* (1912). O'Neill's play was itself an

adaptation of his own 1917 short story "The Hairy Ape," which emerged in the company of numerous stories of primate and animal kinship from Rudyard Kipling and Jack London, among others. In recounting these stories or fables, Rundle observes that the beginning of the twentieth century was a curiously productive period for the emergence of these primate dramas, which she defines as "a twentieth-century American hybrid of classical and modernist structures that treat the subject of evolution, both explicitly and implicitly, through the disciplines of performance."[12] While monkeys and their metaphors had populated Western stories and playhouses for some four centuries, the gorilla had been only a rumor until its arrival in London as a stuffed exhibit in 1861. Coinciding with the consequences of Darwin's theory of the origin of species a mere two years earlier, the spectacle of the gorilla's remarkable body was fully exploited to a public still reeling from the discovery of their closest relatives, the primate family. In a post-Darwinian world, as Marian Scholtmeijer has pointed out, ape stories were newly loaded with hazardous comparisons and questions of identity, where suddenly "*all* stories are stories about apes told by other apes—or at least primates."[13]

In Rundle's study of O'Neill's expressionistic play, she shows how the combined allegories of race, slavery, class, and struggle are very much of their time and are further complicated because of O'Neill's awareness of the general post-Darwinian confusion of what it means to be human. This new speaking, swearing, philosophical human-animal differs crucially from the standard man-in-a-monkey-suit of vaudeville, who was already active onstage as a comic folly. For Rundle, this speaking, apish man is a figure of resistance in devolution of human privilege, breaking the paranoid hyper-anthropocentricism that was produced in response to Darwin's theory of human history. Inside these broad themes, I am drawn to how Yank is expressing himself and how his articulation anticipates his crumbling into what Rundle calls his "humanist hell."[14] Yank's tragic state is highlighted in his exclamations that his life is for industry and for steel: "I'm de ting in coal dat makes it boin; I'm steam and oil for de engine. I'm da ting in noise dat makes you hear it. I'm smoke and express trains and steamers and factory whistles; And I'm what makes iron into steel! Steel, dat stands for de whole ting! . . . I'm de muscles in steel, de punch behind it."[15] When his fellow shipmen tell him he is just a slave, a man-machine with no voice and no power, the seed of doubt is planted in Yank, and he can no longer believe in his man-of-steel mantra. It is knowledge itself (t'inkin'

and dreamin') that drives Yank into confusion, rage, and then despair. He begins to dissolve, physically and linguistically; his train of thought becomes scrappy and random as he clearly breaks down into a nervous and delusional state. In reaching out to shake the hand of the gorilla, he enters into a contract of otherness, divesting him of the human social milieu that has rejected him and embracing the liminal zoo-world of the captive ape. However, the gorilla pulls him in too quickly and destroys him in a physical welcome embrace. The stage gorilla (another man in a monkey suit) lopes off into the dark night, a dangerous, voiceless power with a long career ahead as a metaphorical animal, from which it will never escape. To borrow from Gilles Deleuze and Felix Guattari, when the human becomes an animal, the animal becomes something else.[16] Yank closes down, death stealing his voice and reducing him to the status of a dead human primate, incarcerated and alone. Yank's body has been emptied of its identity and silenced in the crush of the animal.

If the figure of Yank is coded with categories of species, race, class, and gender in search of a distinct identity, he also signifies, for Rundle, how "American drama had now begun to reflect an understanding of human identity as a series of transformations played out across the vast scale of evolutionary time rather than the static discrete forms authorized by divine creation."[17] O'Neill was producing a new kind of theater among the ruins of the "quickly receding myth of the Enlightenment subject" and into a mental and emotional confusion of science and of the "spiritual chaos" it produced in early twentieth-century American culture.[18] After O'Neill, the figure of the ape is no longer just a para-human, a stand-in vaudeville joke, and a pejorative jibe, but a newly liminal creature that can carry prejudices of Irishness, Blackness, and the laborer through the character of Yank and his fellow workers. While becoming a symbol for these outcasts, the ape is positioned as "a paragon of liminality" in all senses.[19] For Annalisa Brugnoli "the ape comes to embody the psychopomp, a mythical figure of passage who appears in different cultures with the function of mediator between irreconcilable worlds."[20] As we have seen from Mircea Eliade and others, the psychopomp is more commonly known as a shaman—a trickster or medicine man—and a go-between, generating ecstatic transformation and escape. In stories from both O'Neill and Kafka, the psychopompic nature of the ape-man as an in-between figure becomes "the primary engine of theatrical action," in which he can cross freely over the many boundaries and borders put in front of him—in the ship's belly and stokehole, on Fifth

Avenue, in the theater, in the academy, and in the cages of the prison and the zoo. He provides an intermediate presence and an "element of transition in otherwise irreconcilable dimensions" and zones of conflict.[21] Primate drama is also, I believe, the place to begin to locate a turn toward the speaking animal, which can be identified in the fables that dominate this post-Darwinian period of Rice-Boroughs, London, O'Neill, Kafka, and then Disney. It is a postwar world, regenerating itself from the horrors of the dehumanizing trenches and struggling with the birth of twentieth-century modernity. In these dramaturgical contexts, the ape speaks directly to us and communicates its experience to us, as interpreted by these writers. By breaking the language taboo in literature and performance, the creature we are beginning to call "cousin" has much to say about human life and what it means to become-human, or to become, in Gustave Flaubert's description of his man-ape, Djalioh, "a marvelous monster of civilization outfitted with all its symbols, great intelligence and shriveled soul."[22]

Franz Kafka wrote his short story A Report for an Academy in 1919. In the ninety years before its adaptation for the stage in the form of Colin Teevan's play Kafka's Monkey (2009), it has had several interpretations. The misnomer of "monkey" (monkeys have tails; apes do not) in Teevan's title is a further slur to the tragic great ape of this fable, who is called "Red Peter"—a title he acquired in captivity because of a facial scar and bullet wounds on his cheek and hip at the moment of his capture. Far from his origins as a captured ape on Africa's Gold Coast, Red Peter stands before the academy to deliver an account of his evolution from ape to man in the highly stylized formal language of an erudite "gentleman of society." Red Peter's story, similar to Yank's, begins aboard a ship, heading both for the civilized world and for trouble. Yank's identity is strongest out at sea, where the constraints of social life are at a safe distance. In Red Peter's case, his captivity ends only when he learns to speak and enters human social life. The door of his cage is opened, and he begins his new identity as a man of the urban world.

Red Peter was offered two choices when he arrived in Europe: the zoological gardens or vaudeville. He didn't hesitate: "I said to myself: do your utmost to get onto the variety stage; the Zoological Gardens means only a new cage; once there, you are done for."[23] He makes it clear that learning to speak and acquiring the disposition of a middle-class professional theater actor is far from what could be called freedom from his cruel and extended captivity. Learning to speak was only an escape from one set of

awful conditions to a marginally more acceptable set of circumstances for any performance artist, which includes a nice apartment, a rocking chair, and an agent. Almost as a footnote, at the end of Red Peter's report, he describes his new domestic companion, a half-trained female chimpanzee whom he barely tolerates. The majority of his lecture details his experience in the cage aboard ship. The cage had three sides, the fourth side being the wooden wall of the vessel. The space was so tight the bars pressed into his back. He couldn't lie or sit, but only squat and tremble. Over the long months at sea, he slowly realized that, as he was never going to return to his community on the Gold Coast, he was no longer free to be himself, which is the only freedom. He came to understand that he had to turn around somehow, learn to speak, and get the men to open the cage so that he could escape its confines, while knowing full well that he would do so only to enter another set of revolting restrictions.

Both of these primate dramas, *The Hairy Ape* and *Kafka's Monkey*, begin on board a ship, heading for new lands that will also be their characters' undoing. For Yank, the cage door slams shut once he has lost his strength and his voice in his violent death at the hands of the powerful gorilla. In Kafka's tale, it is only when the ape finds his voice that his animal freedom ends and his escape into human life begins. He clarifies that "freedom was not what I wanted, only a way out."[24] The images of opening and closing cages hinge on the theme of capture and release; of speech, of freedom, of humanity, of animality. Speech becomes a way out. By losing it in death and finding it in captivity, it unlocks a route to another kind of life. These human-ape voices now turn inward, away from listening to the echoes of nature and acousmatic phenomena and toward voices and desires corporeally and imaginatively demanding to be heard from inside the body. The tongue, the fetishized organ of *logos*, Barthes's mediating muscle, now articulates the carnal machinations of being and becoming human.

The Miracle of the Lingual

Both O'Neill's and Kafka's fables describe arrivals that echo the arrival in Europe of the first great apes from Africa in the seventeenth and eighteenth centuries. Chimpanzees from Angola and orangutans from Southeast Asia were a shocking spectacle to an early modern European world that had already created an elaborate cache of tropes for the mimicking monkey

since the classical era. Knowledge of smaller and more common monkeys appear as far back as the Pharaohs, in both domestic and divine contexts, as a trickster, a hoaxer, a fool, and a menace—but always animal, and not to be confused with humankind. Never larger than a baboon, the medieval monkey was a mischievous and playful sidekick in the human drama, earning its place as an exceptional mimic.

Because of their great size and their striking likeness to humans, the great apes threw everything into ambiguity. As the scale of the animal body increased, so did its capacity to be filled further with a stock of new identities that the figure of the ape still bears on its skin. In particular, character traits and moral flaws that were previously the sole preserve of humanity could now be projected onto these fascinating animals, who seemed to absorb every physical gesture from their human hosts and corrupt it. They quickly became living icons of sexual deviance, degeneracy, and hypocrisy, and they were considered ugly and an affront to the divine creation of the human. In becoming a grotesque caricature with remarkable mimetic abilities, the apes of this period are so heavily laden as tropes for human failure that they could never return to their original free status and the freedom of being themselves alone. Even when viewed more benignly in paintings and dioramas that began in this period, where ape families are depicted living peacefully together, their violence is stolen from them, and their complex social worlds are pacified into a zootopian idyll. Alongside this symbolizing process, from primate to the most anthropomorphized of creatures, science in its exactitude tried to keep the alignment of apes with humans in check. With ongoing Enlightenment theories as a backdrop, scientists examined apes from the earliest days of their appearance in Europe and published the subtle but crucial anatomical differences of species that these baffling creatures presented to them. The anatomical studies by the famous Dutch surgeon Nicolaes Tulp (1593–1674) are well documented as being the first to name and describe the orangutan in 1641. His contemporary in London, Edward Tyson (1651–1708), had dissected humans but never a chimpanzee, and his findings from his first primate specimen were to secure the status of the ape as not man, but not *not*-man, confounded by the many uncanny resemblances.

In Tyson's detailed and careful report to the academy in 1699, he could categorically confirm that the vocal chords of the chimpanzee were "mere pipes and vessels" and "never intended by the Creator to enhance rational speech."[25] In this crucial distinction between what is seen (the exterior

body) and what is unseen (its internal constitution), the metaphysics of human-ape relations became established in a manner that would not change and indeed would be regularly reiterated as far as the mid-twentieth century. Tyson could not deny the creature its many similarities to human biology, including brain size, an upright gait, and the general structure and size of the larynx. However, he was adamant that these striking discoveries bore visual equivalences only, and that he could claim this as a certainty because of the absence of speech. As a follower of Cartesian thinking and definitions, Tyson agreed that speech was the signal of the presence of a soul. Even by proving the physiological impossibility of speech in apes, their newfound position as the "link" between the animal world and humankind (a role held by pygmy peoples until this alteration) was still dangerous, but manageable with diligence. As the influx of apes to Europe in the new eighteenth century grew steadily and spectacularly in private menageries and public circuses, the philosophers and thinkers of the period were provided with plenty of evidence to redefine their classifications of "original" or "natural," brutish or civilized, higher and lower. In his *Systema naturae* (1735), Carolus Linnaeus bravely ranked *Homo sapiens* in the same class as the orangutan, or *Homo Sylvestris*, and alongside several other monkeys and apes as members of the zoological order of primates. This new biological affiliation caused uproar. The question of human dignity arose, and Linnaeus was quick to assure his critics that this was the concern of the theologian, not the natural historian, who only observed what was visible and stayed clear of abstractions such as reason and spirituality.

Making humans part of natural history not only was a dangerous challenge to the divine actions of a Christian god who had already named all the animals; it also undercut the trouble he had taken to make humans in his own image. As the debates raged around these classifications, apes were already finding their way onto the stage and holding positions in the finest menageries of French noblemen, including the royal gardens at Versailles. Their capacity for mimicry, wearing clothes, drinking tea, and walking upright began to draw attention and expand the possibilities of what figures the ape could become—satyr, rapist, savant, satirist, artist—and, in turn, threatened to unsettle the order of species privilege that the Judeo-Christian powers of influence treasured so deeply. In the opinions of the naturalists and biologists of the period who supported Linnaeus's view, although these extraordinary, ambiguous creatures might be the intermediaries between human and animal beings, there was no question that humans were different

from other primates. It was essential that apes must remain "in truth . . . a pure animal wearing a human mask."[26] Nonetheless, further proof was needed to affirm the impossibility of one of these animals crossing over the divide of species and to clear up the mounting confusion about God's real intentions. A second Dutch anatomist and university professor, Petrus Camper, made a series of dissections that confirmed differences in human and orangutan material bodies, and the most important of these anatomical differences, he argued, were the muscles that enabled speech in humans and disabled it in the apes. This, in turn, diffused the threat of violating the uniqueness of the human, who alone could pray to the Creator.

In the Jardin du Roi in Paris, where an orangutan lived long enough to be stuffed after a life of spectacle, the Bishop of Polignac is reputed to have demanded of the ape, "Speak and I shall baptize thee" in front of a gathering of people who were reassured that the ape's silence guaranteed it "would never be admitted to the community of rational, God-like persons by the ritual of baptism and naming."[27] Speech at this moment became more sacred than it ever had been before the arrival of the great apes to Europe, becoming urgently reritualized in the form of prayer. According to Richard Allestree in 1674, good "government of the tongue" maintains a clean, disciplined organ and a devoted larynx: "And to this purpose the infinite wisdom of God ordained Speech; which as it is a sound resulting from the modulation of the Air, has most affinity to the spirit, but as it is uttered by the tongue, has immediate cognition with the body, and so is the fittest instrument to manage commerce between the rational yet invisible powers of human souls clothed in flesh."[28]

Managing soul powers with the tongue separated human from animal because in every other way, both tongues could be mistaken for each other. The anatomists of the seventeenth and eighteenth centuries were in fact correct in their comparative dissections of the ape and human larynx and in disclosing the differences they found there. What Tulp, Tyson, and Camper visualized as physiological difference has more recently become known as the defining evolutionary development in the Darwinian, broadly imagined arrival of the human, and it is located in the very visceral descent of the human tongue and larynx. The reduction in size of the mouth and face in *Homo sapiens* and the changes in cranial shape and increase in size resulted in the descent of the larynx to a lower position in the throat and the increased function of the tongue, thus expanding the range of vowel sounds that can be made and the degree of laryngeal control available to

the rapidly developing brain. The descent of the larynx is not only the beginning of speech but also the origin of human singing as the "art" of laryngeal control and the governing of the tongue.

Lingual Iconography and the Drama of the Tongue

In the basilica of St. Antony of Padua (1195–1231) in Northern Italy, the centerpiece of the main altar is not the saint's bodily remains, which lie in a white marble tomb in the side aisle, but instead the holy relic of his uncorrupted tongue. For the 750th anniversary of the exhumation of the tongue, in 2013, a great number of pilgrims gathered to venerate the relic. After his body was exhumed in 1263, it was revealed that his tongue was still "beautiful, fresh and ruby red," and so began his enshrinement as an Orphic deity. Like Orpheus, when St. Anthony spoke, not only could his voice unify the multilingual world of humans, but he could converse with all creatures (fish in particular) in a phenomenon of universal communication, not unlike his peer St. Francis of Assisi (d. 1226). The cult of the miraculous organ grew to a high pitch in the eighteenth century, with a revival of interest in the works of Ovid and the story of Orpheus in the eleventh book of the *Metamorphoses*. Composers such as Vivaldi and especially Tartini were commissioned to write concertos to be performed for the Feast of the Tongue. The success of the relatively new musical theater genre of opera, which is usually credited as beginning with Monteverdi's *L'Orfeo* (1607), produced a generation of singers and composers for the stage who moved freely between church and opera house, where the work was seasonal and popular in both institutions. The baroque phenomenon of both the virtuoso opera singer and the virtuoso violinist meant that the musical veneration of the miraculous tongue in Padua was amply provided for with a cache of singers and musicians eager to demonstrate their own lingual prowess. For Pierpaolo Polzonetti, these links "between the Saint's *lingua* (meaning both tongue and language) and the violinist's music without words stems from the utopian goal of equating instrumental music with language in order to overcome idiomatic boundaries."[29] With the violin in particular, and particularly in the concertos of Vivaldi, the veneration of the tongue through sound soared to new heights. Here, Polzonetti notes, the solo violin episodes in the music "dramatize the superhuman aspects of the Saint's tongue by exploring idiomatically instrumental techniques and

extended excursions to the extreme high register that are unapproachable to the human voice."[30]

It is against these extraordinarily unapproachable heights of veneration of the human tongue that the surgeons and biologists of the late eighteenth century could make their rightful assertions that the new ape cousins remain less than human. However convincing in their likeness, they would never be part of the dialogue of lingual-specific separation of species that was deemed so essential to human progress. The human tongue had been a wonder for centuries, and in the exhumation of St. Anthony's remains, the "beautiful, fresh" tongue became miraculous, enshrined, and venerated. Allestree's manual on how good governance of the tongue can quash these unruly traits could not have been more timely in a period of extravagant meaning for this singular organ. It still needed to be controlled, as it was both flesh and part of the body but also could have a mind of its own, nourished as it was on food, sex, and other pleasures. Some of its suspect nature lay in its being partially hidden and occasionally protruding from the body in all manner of lewd gestures. The tongue, at the interface of body and mind, can become independent of the carnalities of the flesh by the beauty of its divine speech, while at the same time it betrays the mind by always being attached to the corporeal. As a weapon, it can be poisonous, sharp, and deadly. As an organ of great power and officialdom, it can decide, deceive, flatter, seduce, and speak unjustly. This brief history of the iconography of the tongue is the foundational ground for some artists working today, for whom tongues can carry a sacramental and sacrificial consciousness in their performative actions of display and association.

In artist Alice Maher's Portrait series (2003) and in her performance film *Cassandra's Necklace* (2012), she strings together collars of lamb's tongues to be worn either against her own bare skin, for the portraits, or around the neck of the actress, in the film. In the latter, the tongues also appear, in glistening detail, on silver platters presented by a young girl to the camera.[31] For Maher, the tongue is not only the silenced organ of the Cassandra myth but also the arrested and silenced speech organ of women's voices. In a visceral allegory employing the bodies of sacrificial animals in the Judeo-Christian tradition, the display of the necklace around the throat of the artist is weighed down with fleshed-out symbolism. Unlike stuffed animal bodies, these fresh lamb's tongues (acquired at a butcher's counter) retain their slippery aliveness and connect the (digital) capture of the image to the killing and rendering of the lamb. Maher also associates the extracted

tongue with the loss of native language through colonization in her own country, Ireland, where she says, "the mouth is a site of troubled identity."[32] As a punishment for speaking the Irish language, schoolchildren under late nineteenth-century colonial rule wore a "tally stick" around their necks, which was notched every time they spoke Irish, and they were punished accordingly. Out of this, Maher says, comes "a mythopoeic and deformed vernacular" in the form of Hiberno-English—the kind of manipulation of language that emerges in the work of James Joyce and Flann O'Brien, for example. Where English was the language of the colonial government and the law, Irish becomes occulted into English as an act of subversion and revenge on behalf of the mother tongue.

Subversion is also central to the practice of Korean American artist Doo-Sung Yoo, who reanimates cows' tongues in a series of robotic wall sculptures as part of his *Organ-machine hybrid* series in 2007, developed further in the cyborg performance series *Vishtauroborg version 3.1—"Incompatibility"* in 2012. The slapping, jeering, and very long tongues protrude from the gallery wall in disturbing, visceral, animatronic surrealism. In the live performances, the tongues are operated by an elaborate post-punk robotic costume worn by a quasi-Butoh dancer.[33] For Doo-Sung, this biological detritus coming from the butcher's waste bucket is repurposed as a prosthetic signal to warn a hyper-consumerist society about the consequences of forsaking the individuality of the mass-produced animal.

In a further sensational lingual moment that had none of the biopolitical conscientiousness of the works by Maher or Doo-Sung, a synthetic giraffe's tongue was wielded in front of a wilting soprano onstage at the London theater The Coliseum in ENO's 2012 production of Handel's opera *Julius Caesar* (1724). As a warning to Pompey's widow, Cornelia, who is sworn to silence after the assassination of her husband, Ptolemy drags the head of a prop giraffe across the stage and, with great effort, pulls out the huge, rubbery muscle and brandishes it in front of her mouth in a dreadful display of power. The whole body of the "dead" giraffe was previously seen lying onstage as a gift from Caesar in Act One. Cornelia is so revolted by this action with the tongue that she is ushered away, holding her retching mouth closed. Ptolemy flings the tongue into a bucket and sings a long aria of revenge. The audience, including myself, waited for the bucket to be removed and the splashes of tongue blood to be mopped from our collective experience. Slowly, as my own tongue felt less present and distressed in my own mouth, I understood the metaphors in the violence of the scene,

but the violations done to the virtual animal body were more difficult to overcome. Was this, like everything else that had happened on the operatic stage, an augmentation of the real, in a fantasy of multisensory experience, or a gratuitous exploitation of virtual animal bodies in a grand narrative of supremacy and hierarchical exclusion? Before the beheading of the giraffe in this production, Cleopatra had already disemboweled an eighteen-foot dead crocodile (another gift from Caesar) and removed its eggs, which remained positioned about the stage for the whole of Act Two. The gory exposure of these animal figures contextualizes some of my specific interests in the corporeal materiality of the vocalic body inside the more general subject of animals in performance. Since the general disappearance of live animals from opera performances, new and spectacular virtual or puppet animals are subjected to innumerable violent actions and distortions in a manner that would be inconceivable for a traditional production of, say, Verdi's *Aida*, where a pair of hired camels—or, if circumstances and finance permit, an elephant—simply increase the exoticism and extravagance of the mise en scène. The contemporary trend for presenting these exceptionally realistic animal bodies in productions, and also the symbolic puppets themselves (of Complicité, for example), allow for a new interpretation of what the animal body can achieve in material-semiotic, visceral, but sanitized fantasies: an oversized leopard corpse pierced with spears and suspended above the action in ENO's *Radamisto* (2010); a beheaded giraffe whose mangled body lies at the back of the stage while its tongue is brandished above the orchestra pit.

In one final example of contemporary tongue iconography, artist Anselmo Fox's series of portraits *La lingua della lingua* (1999) pushes the proximities of human and animal lingual identities into a closeness that threatens a number of boundaries at once. Yet the method of photographing these low-key, high-impact actions keeps the physical revulsion at a remove. For this project, Fox acquired the tongues of a leopard, a wolf, a python, a kingfisher, a sheep, a flamingo, and an ape, and inserted them in his own mouth, and the mouth of a female friend, to make his portraits. He was able to readily collect his cache of tongues through his butcher, a gourmet food store, and the pathology section of the Berlin Zoo. In some sidelong views, the larger tongues, like the ape's, are seen to be held and supported by the humans' own tongues. The tongue-to-tongue contact is sensual, bestial, and sacramental all at once; this is reflected in the title, which is open to translation as "the tongue of the language," "the language

of the tongue," "the language of language," or "the tongue of the tongue."
But literal translations of the images are wasted in place of the tactile
viscerality of imagining holding a serpent's forked tongue between your
lips, or holding your mouth open so as not to swallow the fat tongue of
a leopard. In a further sacramentalization of the action, each tongue was
purified by being dipped in grappa before being accepted into the human
body, hosted by the resident tongue, and beginning a partial hybridiza-
tion. Alongside these botched lingual becomings, Fox created a series of
mouth-to-mouth kissing sculptures by preserving the intimate actions in
dental silicone and casting the negative impressions in metal. The images
of the tongue in these diverse examples draw from historical, religious,
and sociocultural contexts. By detaching the tongue from the throat, each
piece relies on the empathy of the viewer to be affected physically by the
violent image of the muscle being extracted out of the safety of the mouth
and into a visual confrontation as a disembodied object with a sensual
history. The physical interior-becoming-exterior in these works suggests
a mirroring of the metaphysical thought-becoming-word via the tongue.
In these narratives of human-animal encounters, in opera and drama, the
phenomenological sensations of being and becoming a vocalic body are
experienced in the muscles of the tongue.

Fabulizing the Creatural Voice and Its Materials

In Fox's assemblage of portraits, he achieves a kind of "symposium of the
tongue" in which actions of speaking and eating are interrogated, conviv-
ially, in what Chris Danta might call the "orification of philosophy."[34] The
mouth is the place of the appropriation and assimilation of the animal
other—through eating, conversation, and storytelling. For Danta, this
mouth-as-site is not just the preserve of the human storyteller, who tells
stories about talking animals while eating them, but it is further compli-
cated in the speaking animals of fables—and fables are often about talking
animals. For example, in an early scene from the (anonymous) biography
of Aesop, the creator of fabulous beasts, he is working as a slave in the
house of Xanthus. When asked to cook a meal for Xanthus and his students
with the finest ingredients, Aesop goes to the butcher and collects all the
discarded tongues of the pigs that have been slaughtered that day. After a
series of courses of tongue, Xanthus asks Aesop if he could not have found

any other meat more fitting for a banquet. Aesop replies that there could be no finer an organ, on which all of education and philosophy depends. The students suffer that night from their feasting, and the next day Xanthus asks Aesop to make a plain meal for them, nothing rich, and with poor, even inferior ingredients. When Aesop serves up a second night of pig's tongue dishes, to the disgust of his master and to the revulsion of the students, he defends his actions by claiming that, at his master's request, he sourced the most abominable organ, the source of all lies, enmity, plots, battles, and cruelty. The tongue epitomizes all that is both good and bad about being human. For Danta, "Aesop thinks with the mouth. He shows the mouth to be a site of thought . . . by rerouting various concepts through the mouth," and in turn he uses "both his own (once muted) slave tongue and the slaughtered tongues of animals . . . to deprive the masters of their power over discourse."[35] For Xanthus and his students, their desire to transcend the materiality of eating and speaking at the same time is arrested by Aesop's "beastly strategy," in which he undermines lofty ambitions with bodily realities by corrupting their meal into what Danta calls "a grotesque symposium of tongues."[36]

In *The Animal that Therefore I Am*, Jacques Derrida advises that "above all" it is necessary to avoid fables, because "we know the history of fabulization and how it remains an anthropomorphic taming, a moralizing subjection, a domestication. Always a discourse *of* man, on man, indeed on the animality of man, but for and in man."[37] However, he also can see the value of fables (as he does with the fables of La Fontaine in *The Beast and the Sovereign*, 2009), where, for him, the tongue banquet illustrates perfectly his theory that "the place of devourment is also the place of what carries the voice," where the fable "more than any other genre depends for its meaning on the double function of the mouth-as-site for both speaking and eating and troubled intersection of the beast and the sovereign."[38] All of the discourse "of man, on man" that troubles Derrida is a product of "the anthropological machine" that turns everything into service for the human project. In human-animal interactions in fables, however, Derrida can see that the limits of reason are exceeded by a truth contained in the moral force of the tale, and so the fable itself becomes a kind of speech act, an oral gesture, repeated and performed, perfected and refined, in which speaking animals moralize about the foibles of humans. In the post-Darwinian context that created the fables of O'Neill and Kafka, the fabulized animal, especially the ape, can no longer be so easily used as a caricature "of man,

on man," nor is the ape so readily made to fit into a project of "anthropo-morphic taming,"[39] in which "whoever refuses to recognize himself in the ape, becomes one."[40] As the shockwaves from Darwinism were to reach far into every corner of early twentieth-century Western consciousness, the ontological uncertainties and complications of primate life became captured in the genre of the fable: in literature, with Flaubert's *Quidquid Voleuris* (1837) his dark tale of the biological hybrid ape-child, Djalioh; and aboard the H.M.S *Beagle*, where Charles Darwin first surmises in his notebook that species may not be as isolated from each other as previously assumed. On returning to London, Darwin had his first encounter with an orangutan in the London Zoo. From this point on, as Scholtmeijer wrote, "*all* stories are stories about apes told by other apes."[41]

Becoming Lingual, Becoming Humanesque

It is an established fact that apes will not speak or, to be clear, learn to speak as humans do. Aside from some aberrations of primate vocal research in the 1950s and 1960s, and the ongoing experiments with sign language—along with the ebbing of chimpocentrism in favor of a broader field of primate research, which has a conservation bias—we can be grateful that captive great apes will no longer be subjects for this tedious and fruitless anthropocentric obsession. Instead, apes in both research centers and in the field today are continuing to challenge and advance our understand-ing of what language and communication can be; what it might mean for them. In light of these studies, my aim here is to locate creative moments and events when the knowledge and skill of the lingual, the almost sacred attachment to speech and human uniqueness, is no longer sufficiently expressive. Instead, the artist/performer, across disciplines, turns to what is devolutionary, counterlingual, guttural, unintelligible, and even banal by reinstating the spittle, the chatter, and "the yell, the stutter, the stammer, the groan, the cough, the laugh, the hemming and hawing, the umming and erring" in an attempt to broaden what Simon Bayly terms "the pas-sionless category of 'speech' that strips out the scream from the voice."[42] Alongside the enormous volume of sound and words and music already available, these expressions of human-ape relations become the sound of this "paragon of liminality," the human-ape, contesting the government of the tongue and opening the cages of speech itself.[43]

In Kathryn Hunter's interpretation of Kafka's Red Peter story, she appears onstage in a man's suit, a white tie, patent leather shoes, and a bowler hat. She carries a suitcase and a walking stick. From her appearance, her gender is as unclear as her species, and when she begins her monologue, her voice confounds her strange figure even further. In the slightly rasping, heavily enunciated accent of a Victorian gentleman, she announces to the "*esteemed* members of the academy," which we the audience automatically become, that the small man she is portraying is happy to give his account of his former life as an ape.[44] From the outset, the tale of Red Peter, who we know acquired his name from his capture wounds, is one of violence. His anthropomorphosis is a kind of corporeal sacrifice in which he relinquishes his ape-ness in order to satisfy the needs of others, his captors, and find a way to survive. He mourns the loss of his ape nature before turning around in his tiny cage and facing the challenge of becoming human, a familiar scene in the long and violent tradition of simian narratives at the intersection of literature and science. In Hunter's performance of Red Peter, she brings this violence and frustration through in the vocal complexities of her ape-man character, who swerves from grand gentleman to emotional wreck and holds himself together just long enough to deliver his report as he explains politely, "You see, I am still overcome with such an aversion to human beings, I can barely stop myself from retching. . . . It's nothing to do with the person in question, Least of all your good selves, Ladies and Gentlemen of the academy, It's *all* humanity."[45] What Red Peter finds unbearable is not the smell of human beings, per se, but how "the smell of humanity" clings to his own body and "mingles with the smell of my native land."[46] Along with learning how to drink alcohol, spit, laugh, and perform his transformation from ape to human with a humiliating impression of a vaudeville chimpanzee, it is with the voice that both Hunter and Red Peter cross the threshold of anthropomorphosis and their reluctant becomings. At the center of the play and the short story is Red Peter's explosive breakthrough into the human world. After weeks of rehearsal with one of the sailors, he performs the trick of drinking a whole bottle of schnapps, and then, in Kafka's words, "I threw the bottle away, not this time in despair, but as an artistic performer; forgot indeed to rub my belly; but instead of that, because I could not help it, because my senses were reeling, called a brief and unmistakable 'Hallo!' breaking into human speech, and with this outburst broke into the human community, and felt its echo; 'Listen, he's talking!' like a caress over the whole of my sweat-drenched body."[47]

Exhausted from this effort, Hunter brings a deep pathos to the next scene, where having found his voice, Red Peter loses it again immediately, and it does not return for months. Departing from the text, Hunter steps toward the audience, and with frustrated emotion she delivers an extended "soliloquy" of botched becoming-ape:

Uh Hoo hoo hey. Hey ellouu?
Egay hoo hoo egay? Egeg ooo. Uh hoo Gu. Eh guh Gu eh.
Eh he beh. Oh he beh uh Gu. Inn Nee. Uh Hoo hoon Nee.
Ee zee eezee Low. Eezee Lum Eezee.[48]

Red Peter's anthropomorphosis also begins with taste and oral retraining from his sailor captors, who "hardly spoke but grunted at each other," but whom Red Peter says were "good creatures, in spite of everything."[49] Smoking cigars and drinking schnapps, and laughing like barking dogs, "they always had something in their mouths to spit out and did not care where they spat."[50] Before Red Peter turned around in his cage he used his voice and his mouth differently, he recalls, "I am supposed to have made uncommonly little noise. . . . Hopelessly sobbing, painfully hunting for fleas, apathetically licking a coconut . . . sticking out my tongue at anyone who came near me—that was how I filled in time at first in my new life."[51] Once Red Peter decides that this new life could have another dimension outside the cage, he begins his transformation by imitation and via the mouth. He says, "it was so easy to imitate these people. I learned to spit in the first few days. We used to spit in each other's faces; the only difference was that I licked my face clean afterwards and they did not."[52] Reorientating the body toward this new, though revolting, human world comes through the bottle of schnapps, of which the smell alone of an empty bottle causes him to reel in "disgust, utter disgust." It is only after taking the men's vile liquid down his throat into his body, in a "becoming by ingestion,"[53] that he is rewarded with his first word, "Hallo!"[54] For Red Peter, as with the other human-animal metamorphoses in Kafka's work, the mouth becomes the primary point of transformation and the crucial first contact of becoming other.

Animal voices in Kafka's fables always go through a process of lingual transformation before becoming fully human or fully animal. In *The Metamorphosis*, in which Gregor Samsa progresses into fully becoming-insect, it is the deterioration of his ability to communicate with his family using human speech that becomes the hinge on which the story turns. The

physical transformation has already taken place as the story opens. When Gregor wakes up he has already morphed into a gigantic insect, and this is his (and our) first astonishment. It is when he tries to speak from behind the closed bedroom door that the scale of his predicament is revealed. In responding to his mother's wake-up call, Gregor can still hear his own voice, but "with a persistent horrible twittering squeak behind it like an undertone, that left the words in their clear shape only for the first moment and then rose up reverberating round them to destroy their sense, so that one could not be sure one had heard them rightly."[55] Once Gregor loses his speech, he becomes less interested in everything else to do with the human world and begins to explore the possibilities of his new insect body by walking on the ceiling. In order to complete the zoomorphosis, Gregor must willingly sacrifice his sense of human consciousness and human language. When he abandons his efforts to communicate as a human, as Akira Lippit explains, "the entire world is thrown into an animated state of disarray," and so he is "forced to reconstruct every relation between his body and the environment anew," which is the very essence of a Deleuzean becoming.[56] All doors and windows are constantly locked and unlocked and opened and closed and furniture is repositioned as Gregor's world undergoes a radical re-territorialization of his insect body. His environment becomes an exclusively acoustic domain where he listens to the politics of the household and the ritualized pattern of secrets that accommodate his trauma. Crucially, however, it is an oral renegotiation of food, of survival, that replaces speech in his communication with his sister, who brings him his favorite vegetables and milk. Gregor is repulsed by the produce but finds something rotten to chew in the garbage, which his sister understands will supply his digestive needs from then on. Even without speech, he finds a way to renegotiate his relationships not by visual signals, but with oral signs. When Deleuze and Guattari consider metamorphosis in Kafka's animal stories, they succinctly define its core elements to be "a sort of conjunction of two deterritorializations, that which the human imposes on the animal by forcing it to flee or serve the human, but also that which the animal proposes to the human by indicating ways-out or means of escape that the human would never have thought of by himself (schizo-escape)."[57] While the deterritorializations of Kafka's spaces—such as burrows, castle keeps, the Gold Coast, and the theater—offer different routes to freedom for his human and animal creatures, each renegotiation with territory and with the transformed body begins in the mouth.

Recalling the screaming, laughing, sobbing mouth in Samuel Beckett's *Not I* (1972), Simon Bayly follows a line of thinking about the mouth as the preeminent organ of surrealist, sacrificial exposition of the body in a dismantling of the face, where "the face is all mouths, a concentration of openings into a labyrinth of interior cavities, each with its own potential for violent and essentially formless emissions, whether spittle or laughter, phlegm or speech. All of these take on a fluid excretory quality in which the humid wetness of the oral cavity plays a generative part. Vocal emissions of any kind become inseparable from accompanying fluid substance, the very stuff of life and death, opposed to the disembodied, silent odourless, dry and ethereal voice of immortality."[58] In the primate dramas framing this chapter, renegotiating the territories of human-animal becomings generates a metalinguistic shift in which animal acoustics test the boundaries of acceptable speech.

When Kathryn Hunter steps forward into a single light that focuses on her distressed face, she is not chimp but *not* not-chimp, in a Beckettian not I but *not* not-I. Instead, with her garbled speech she creates a new, questioning voice that fills the chasm between the ape-man and the academy of spectators: "Inn Nee. Uh Hoo hoon Nee. Ee zee eezee Low. Eezee Lum Eezee." Hunter departs from the texts of both Kafka and Teevan in this astonishing schizolingual performance. She is not attempting to speak words here, but her vocal expression is full of empathy for the crisis of the splitting person she is inhabiting in the terrible humanimalian condition of Red Peter. Bayly uses the term "humanesque" to describe a similar sound spectrum that can contain "what is sacred and the raucous cacophony of what is profane, but also of the infra-human, the sub-human and the inhuman."[59] The humanesque departs from the strictures of humanism to become something more elaborate and precarious, stretching the phenomenon of the voice back to its origins and forward into unknown territories of perception. In the multiple vocal resonances of Hunter's Red Peter, her capturing of the humanesque—human, ape, not ape but *not* not-ape—stretches our understanding of how we articulate ourselves in the academy of speech.

René Spitz's influential essay on the genesis of perception locates the mouth, sound, and hearing before sight as the birthplace of all future understanding of the world: "The mouth as the primal cavity is the bridge between inner reception and outer perception; it is the cradle of all external perception and its basic model; it is the place of transition for the

development of intentional activity and for the emergence of volition from passivity. . . . [T]he activity of the mind retraces its way toward the primal process, and the primal cavity then becomes the cavernous home of the dreams."[60] Mediating muscles and mammalian physiologies of larynx, tongue, lungs, and mouth struggle against the anthropological machine to retain the acoustic qualities of their own species. But when nonhuman primate animal bodies are brought into human culture, they are put to work long and hard to find escape routes for human fantasies of being and becoming nonhuman and humanesque. In primate drama, an often Artaudian cruel theater of fables and dreams, humans and animals swap spittle, liquor, songs, words, and terrible emotion. The tongue, in the cavity of the mouth, articulates the action of dangerous dreaming and botched lingual becomings.

BECOMING RESONANT

Sounding the Creatural Through Performance

Becoming does not produce, it resonates.
—JENNIFER PARKER-STARBUCK

Feeling sound comes before speaking, singing, screaming, laughing, and all other vocal soundings. The voice is a phenomenon that is first felt. In the womb, the unborn infant creature resonates with sounds coming through the parent's vocalic body. Chanting, crying, soothing, and snoring all reverberate through both bodies—as do pregnant silences. In order to learn the language of your species, you must feel it first. Before birth, whale calves listen and sense the deep, long songs of the whale mother. Sounds move through both their bodies into larger bodies of water. Bat infants learn to keenly negotiate their world through echoes and reverberations in their cave or attic. Their whole body becomes a listening device inside the larger soundspace cavities of their world. Bodies become chambers for sound to move around. Chambers resonate with sonic knowledge. Resonance, then, is primary to the phenomenology of creaturely sound.

This chapter examines the connections between creative acts of listening, sounding, and, specifically, resonating across species boundaries. The focus is on the physical and phenomenological challenges these actions present. According to Don Idhe, both artists and phenomenologists share a practice of looking at variations of things in order to explore and create new variations in their search for meaning. "Each new variation" he writes, "each new metaphor, holds exploratory significance—but with a

qualification, it must be seen to be only a variation, for the phenomenon itself doubtless hides more yet to be found."[1] By exploring all the variations of their subject, the artists in this inquiry, in general, do not wish to produce finite objects but instead to open up new cosmologies and ways of experiencing the world. They are producing unknowns that they present to be explored and expanded by other thinkers and makers. The artists that interest me are those who challenge their subject and the context of their presentations and move their concerns beyond the sum of its parts into new assemblages of being and becoming. In the gallery, in the nightclub, and in the opera house, these practitioners move freely between the cosmic and the microcosmic, creating assemblages of things and ideas that in turn drive perception further.

For example, in her questioning of the nature of the cosmos, artist Amy Youngs looks to the world of the worm. For her installation titled *Intraterrestrial Soundings* (2004), Youngs put eight custom microphones into a box filled with soil, newspaper, food waste, and a colony of live worms. The microphones were connected to an eight-channel fire wire interface (MOTU 896) and a Macintosh laptop, which filtered the noises of the worms and fed the live sounds to a custom-upholstered chaise longue, which was embedded with eight amplified speakers. The speakers were positioned in the chaise to mirror the location of the microphones in the worm box, which was only visible from the outside, in the dimly lit room of the gallery. When a visitor lay on the chaise, listening to the worms move about, making compost, a screen positioned overhead projected a live infrared video relay of the action inside the worm box, in the actual vermiculture. Everything in Youngs's installation was amplified: sound and image, furniture, participation, interior and exterior, light and darkness. The movements of the worms generated gentle vibrations in the chaise, which you could feel pulsating through you, a strange sensation bringing you into perception of their small, moving bodies. These reverberations produced a kind of sensory awareness, opening receptors or nerves in the body—specifically in the ear, the muscles, and the joints. This awareness of both internal and external influences is also how a worm proceeds through its own intra-terrestrial environment.

In the many subsequent biological, bio-techno-cultural, and ecocritical interactive works that Youngs has made using soil, live plants, and worms, the worm box is one of the few that uses live sound. For Youngs, the purpose of the sound is to listen in on the survival work of the worms

and to amplify the underground, unseen world that she feels is broadly underexamined and underappreciated. "Humans continue to be interested in detecting signals of extra-terrestrial life in outer space," she says, "but have overlooked the intra-terrestrial signals of life—the worms and insects that sustain our own terrestrial existence."[2] It is important to her that her work, which is always interactive, has a palpable as well as visual connection in which "the human experiences self as a mutually dependent being, intermeshing and intermingling with the non-human."[3] Compared with the experience of only watching the video image, the sense of having comingled with the vermicultural world of the worms physically and sonically (a kind of worm-becoming-alongside, perhaps) is what sustains the encounter long after the image of the busy worms fades. Lying on the reverberating chaise, there is an uncanny sense of closeness to the worms' movements and the influence of their material bodies, living and breathing and interacting with each other, that would be impossible to experience without this technology. As with the other amplified human-animal entangled sounds that have been addressed in this book, worm worldings and vermiculture appear both acoustically and acousmatically. The soundwaves and reverberations coming from the box stretch our perception of the creatural away from the charismatic macro-fauna, such as whales, and into the more unfamiliar territory of the worm and our deterritorialized, listening, reverberating bodies.

In the deterritorializing processes of extending the self through musical instrumentalization (of bird to flute to music to recording, for example), Gilles Deleuze and Felix Guattari see evidence of "a new threshold" of creativity, where they identify vital values of insects and microbial, even molecular, life. "Birds," they write, "are still just as important, yet the reign of birds seems to have been replaced by the age of insects, with its much more molecular vibrations, chirring, rustling, buzzing, clicking, scratching, and scraping [in electronic new music, for example]. . . . The insect is closer, better able to make audible the truth that all becomings are molecular."[4] When considering microcosms of sound in insect life (which could also include worm life) Deleuze and Guattari discover that "the molecular has the capacity to make the *elementary* communicate with the *cosmic*: precisely because it effects a dissolution of form that connects the most diverse longitudes and latitudes, the most varied speeds and slownesses, which guarantees a continuum by stretching variation far beyond its formal limits. . . . The same thing that leads a musician to discover the birds also leads him

to discover the elementary and the cosmic. Both combine to form a block, a universe fiber, a diagonal or complex space. Music dispatches molecular flows."[5] Creating an exchange between the cosmic and the microcosmic, or at least positioning oneself to being open to listening to these exchanges, requires an epistemic shift, becoming both subject and object of sonic forces and perhaps being affected by them; this is the challenge of what I call *becoming resonant*. In describing this state of openness to resonance "far beyond its formal limits," Michelle Duncan considers how "the position requires us to open both mind and body to the wonder of resonance and to postpone analysis: to postpone translating voice into the predetermined cognitive categories the mind has at its disposal and to simply wait and listen, to experience what the voice does."[6] Asking the listener to be open in this way, particularly to operatic voices, Duncan suggests that we, as listeners, would be well served by taking leave of our "absolute sovereignty" and acknowledge that we can be subject to material forces that have more control over the mind and body.[7]

When composer John Cage availed himself of the opportunity to spend time in an anechoic chamber at Harvard University, it was just this kind of experience he was seeking, in the hope of hearing total silence. However, his time in the chamber, which is sealed and structured to eliminate reverberation and to have no other sound whatsoever, was slightly disappointing to Cage. Instead of hearing silence, he clearly heard two sounds of an upper and lower register. On emerging from the chamber, he was told that the higher sound was his nervous system whirring, and the lower sound was the noise of his blood circulating through his body. Eliciting a profound sensational awareness of his own molecular bodily interior, Cage's experiment also illustrates an insight into the third sonic event, which is the listening organ itself: "the hole in the head"; that is, the ear.[8] In the anechoic chamber where there is nothing external to hear, the ear turns inward, listening to the machinations of the body and its labyrinthine network of resonances. What I learn from Cage's story is that my ear becomes the conduit for an exchange of acoustics in which soundwaves travel into my body, through the network of passages of the inner ear, along the "bony labyrinth" (or osseous labyrinth), to the vestibule where tympanic membranes push the waves through canals into the cochlea.[9] There, the auditory nerves, the neurons, pass on the external soundwaves to the brain and mix them with the barely perceptible internal sounds of my other cavities, muscles, blood vessels, larynx, lungs, nerves, and bone joints in a continuous flow of aural

intensities and looped exchanges. In these structures of the ear, the anechoic chamber, and the chamber of the worms, I find acoustic routes—corporeal, instrumental, architectural—that guide the exploration of resonance deeper inside the human-animal acoustic exchanges that shape this chapter. In the assembled works discussed here, from the molecular (worms) to the monumental (Covent Garden), all sound must find its way through the bony labyrinth of the ear, in reverberations throughout the body, and through body parts, as both receptors and instruments, and in the process become meaningful by becoming resonant.

Body as Instrument

In Don Ihde's speculations on different types of human musical production, he identifies two phenomenological types: voice, which is directly, physically expressive; and instrumentation, which embodies relations between humans and sound technology. As discussed earlier, the genesis of music performance is closely aligned with the development of hunting techniques in prehistoric cultures. The material animal body is just as present today in the orchestra as it was then, in the form of bone, leather, hair, and gut and, transitionally, keratin in the form of horn. The horn section of the orchestra—English horn, French horn, oboe, clarinet, and so on—are all developments of the animal horns of rams, deer, antelope, and bulls. As with the previous examples of objects of ritualized play, these instruments have origins in hunting and religion and, in their combination, the ritual animal sacrifice. Like other instrument families, the horn section has its origin in hunting practices, but as a byproduct of animal rendering and as a communication device between hunters and then herders across large territories—as it is still used today in some traditional farming communities. With the horn, the call that emerges holds a trace of the animal's voice within its resonating tones.

Sometimes, sound crosses species. The ancient Jewish ritual instrument called the *shofar* is made of a ram's horn, and the blowing of the horn at the close of Yom Kippur sounds something like the roar of a bull. The sound of the trumpet is meant to echo the original blast across the desert of Mount Sinai, where Moses received the Tablets of the Law and put an end to the bull-calf worship of the trembling people below. Sounding the shofar is a numinous phenomenon through which the listener and player can come

into communion with a "wholly Other" in an experience that is sacred, transcendent, or even supernatural—what Donald Tuzin has called "the magicality of sound."[10] In the broad stretch "from the shaman's rattle to the Mormon Tabernacle Choir," Tuzin and his ethnomusicologist colleagues find that it is not the instruments that hold the magicality of the numinous sound object but the voice.[11] He suggests that sounds created from the body interior through wind/breath instrumentation and "human voices, especially when they are augmented and distorted in a resonant chamber such as a basilica" (or a synagogue), become the conduits for the uncanny and the preternatural and all other enthralling experiences of ritual.[12] What is curious to me is that the shofar, and other ancient instruments such as the bullroarer, described earlier, are not entirely musical per se but produce abstract, sonic events that go to the core of the body physically and psychodynamically. These instruments do not try to imitate or reproduce natural sounds, but their sustained, disturbing, arresting strangeness instead manifests the presence of an aural otherness (which can quickly become the voice of a cult spirit). The reverberations that these instruments produce, alongside their aesthetic qualities, find unstoppable routes into the listening body and resonate there. At this infrasonic level, Tuzin explains, "sonic vibrations assail the entire body; but because the sensation is vibration—as is normal sound—the feelings we report, and the idioms we employ in describing it, are recruited from the realm of audition."[13] In turn, ritual and religion have found myriad methods of exploiting this sensation of being visited by a presence through the use of sound. Elaborate and numinous sound objects have been created and developed in order to repeat and sustain these sensations. This is spectacularly evidenced in the pipe organ, which has its humble origin in animal horns and bone flutes. In the contact of human mouth and animal body, when the performer takes the hollowed horn of the animal to her mouth and breathes sound through this bony projection taken from the animal's head, what is being amplified? I think that for both the performer, who is also a listener, and the listener who enables the performance, the exchange amplifies the phenomenon of Dasein, of being-there, in a way that overcomes the specificity of being. To listen, to receive sound, and to make sound is to extend the self beyond the material body. To hear and feel another's presence through sound is to fully become aware of being there, where you are, right now. Idhe phrases it like this: "Sound permeates and penetrates my bodily being. It is implicated from the highest reaches of my intelligence that embodies

itself in language to the most primitive needs of standing upright through the sense of balance that I indirectly know lies in the inner ear. Its bodily involvement comprises the range from soothing pleasure to the point of insanity in the continuum of possible sound in music and noise. Listening begins by being bodily global in its effects."[14]

Sensations of waves of meaningful and abstract sound coursing through the wind instruments featured above, reaching deep in through the ear and the layers of the body, alter the experience and awareness of being embodied. This alteration is so sensational that we are compelled to repeat and reinvent the experience in an endless cycle of navigation and manipulation of the sonic. Where animals and their bodies have provided the material means of amplifying and distorting human breath and voice through instrumentation, the development of the voice itself—and specifically the singing human voice and the attendant, internal mechanomorphisms that classical training demands—are a further facet of the rubric that shapes the resonant vocalic body.

Voice as Instrument

Contemporary trained singers discuss their own voice and singing muscles as "a tool to produce sound . . . a vehicle of power we exert upon the world, trained and disciplined as if it were a well-organized machine."[15] Phenomenologist and classical singer Päivi Järviö wrestles with the vocal educational theory of the machining of the body, in which she should consider her body "as a thing" where "the singing body consists of lungs, the larynx, and the resonance chambers." However, as a living being, she says that when she wakes up, "I am immediately a singing body, whether I begin my day by singing or not. This is my body singing. It is something that experiences itself, supports itself, rejoices in itself. It is flesh that does not consist of atoms or any other divisible parts, but of pleasure and suffering, hunger and thirst, desire and tiredness, power and joy . . . the flesh is knowing—and knowing is acting. Flesh is an absolute and uninterrupted knowing."[16]

The enthusiasm in Järviö's waking awareness is infectious, but as her tutors know, the process of becoming this singing body involves taking it apart, muscle by muscle, breath by breath, and then rebuilding it with discipline, then intelligence, then emotion. This mechanomorphization of

the singer's body places this machine for singing in a strange position both inside and outside the body and the person. In classical definitions of what can be considered a musical instrument, the voice is not included, as it is largely respiratory and "lacks an external agent" (unless the hands are used to shape and extend the vocal sound—then perhaps the hand can be considered instrumental).[17] Singers and their academies further mechanized the human throat, larynx, glottis, and vocal chords as something newly visible through live video laryngoscopy, which allows the singer to view the movement of the vocal folds on a monitor as she is singing. The throat interior is at once intensely intimate, being felt vibrating in the body, and visually detached, being viewed on a screen. Jennifer Parker-Starbuck has coined the term *becoming-animate* to encapsulate phenomena in which the performed limits of the human are expanded and "expose a becoming animate, a condition of sensory attunement—palpable and vibrant—that reveals the interrelationships and traces left between animal, human and machine."[18] Parker-Starbuck interrogates the mediatized encounter with the animal in theatrical performance events where, through projection, recorded film, and animation, a becoming "emerges from the inside-out, from within the machine," where we can see it "for just what it is; an interrelated component of the world we share."[19] In the study and training of the newly instrumented voice, the singer watching her vocal folds on a monitor is prompting a type of becoming-animate that could be included in the "corporeal intersections with multimedia" performance that are at the center of Parker-Starbuck's theory.[20] The image and action of the visual singing machine is a becoming-animate for the singer. In this way, it further fleshes out the sound that originates within the confines of the body or the box—much like the Dodo, nightingale, worms, or other sopranos already discussed in these pages.

The singing voices in the theater-as-box of the opera house, the classically trained voices that strive to resonate in that immense chamber, are experts at understanding frequencies and carving out sonic space in order to be heard, unamplified, above the orchestra. They achieve this by controlling and shaping the vocal tract, opening the mouth wide, enlarging the pharynx, and lowering the vocal cords (glottis), thus boosting the energy of the frequency and using "loudness," but with remarkable control. Phillip Ball describes how the effectiveness of their technique can depend on the enunciation of the vowel sounds, which are the principal carriers of vocal energy. Therefore "singers have to balance intelligibility—the extent to

which a vowel sound can be identified—and audibility, and this explains why, at the very highest frequencies of female soprano singing (2,000 to 3,000 Hz), all vowels tend to sound like an 'a' as in 'ah.'" [21] Ball suggests that this is why operatic singing can sound artificial or, at least, unrelated to everyday spoken emotion. However, for the student of the operatic voice, it is this subversion of the rules of language, using this machining of the voice, that presents a dilemma. Because of its tendency toward unintelligibility and the flourishing of the voice at the expense of the text, the genre of opera has generated a certain amount of philosophical mistrust. In early western sacred music, such as plainchant and polyphony, which preceded and produced the operatic voice, all effort is tied to the text and in service to the word, and this is its special achievement. With the operatic voice, the concreteness of the word is pummeled into submission and is also liberated into a new world of complexities and tensions that produce Orphic and Dionysian resonances, as evidenced by the history of opera from Monteverdi to Birtwhistle. The dilemma of the operatic troubling of voice, Mladen Dolar writes, is in the creation of "expression beyond language," which "is another highly sophisticated language; its acquisition demands a long technical training. . . . Singing, by focusing on the voice, actually runs the risk of losing the very thing it tries to worship and revere: it turns it into a fetish object—we could say the highest rampart, the most formidable wall against the voice."[22]

This fetishization of singing runs into trouble because it is an illusion of transcendence, carrying as it does its long history of sacred agency, linking the natural and the divine and promising "an elevation above the empirical, the mediated, the limited, worldly human concerns."[23] Instead, Dolar advises, we should be mindful that only through language does voice exists and also that music only exists for speaking beings. We should be wary of imposing onto the voice the character of being the bearer of profound messages, which he says is "the core of a fantasy that the singing voice might cure the wound inflicted by culture, restore the loss that we suffered by the assumption of the symbolic order."[24] This contentious topic is troublesome for musicologists, philosophers, and linguists and is the basis for an enormous body of questions and argument all of its own. I appreciate Dolar's reservations about the vocal fetish and what it is doing and undoing to language. He is correct that it is, or can be, illusory, misleading, and full of false promises. When the voice strays outside the linguistic structure, then it joins all the other nonlinguistic voices—coughing, babbling, hissing,

screaming—at the zero point of meaning and the base level of phonology. However, it is precisely at the zero point of meaning that the singing voice can begin to create a new meaning for itself and to develop its own language, a new acoustic creatural language that includes all of the screaming and babbling as the core structure on which it will be built. By turning to listen to more creaturely voices, we can discover contemporary sounds that are extraordinarily inventive and voices that might offer a bridge between the saying and the screaming, the rational and the liberational, in performance.

When the eminent post-humanist Rosi Braidotti looks into creative futures, she does not see a meaningful role for sopranos and basses and their vocal shifting and shaping of the nature of human language. Classical music, she says, is banal and flat and has depended on a stagnant, mimetic method of imitating birds and animal sounds, which it has completely used up to produce a mockery of itself. She has already moved on to a techno-cultural acoustic world, where new aesthetics "undo not only the priority of the human voice in music making, but also the centrality of the human as a sensible means of achieving rhythms and sounds that reflect our era."[25] For Braidotti, this new era is rich in becoming-animal, and specifically becoming-insect, aesthetics and revolutions. Postindustrial urban creativity, for her, develops in an "over-crowded, noisy, highly resonant urban environment where silence and stillness are practically unknown" and where music and sound production can then capture this intense sonority without complications of representation.[26] The urban sounds of popular music and sound art installations that Braidotti highlights have the double purpose, she claims, of mapping "the acoustic environments of here and now, while undoing the classical function of music as the incarnation of the most sublime ideals of the humanist project."[27] Instead, new music in technoculture rips through time in a nomadic push and pitch of resonances that are often inaudible, imperceptible, or overwhelmingly speedy and massively Deleuzean in a swirl of becomings: insect, animal, molecular, electric, territorial, and deterritorializing. In Braidotti's new era, "technologically mediated music de-naturalizes and de-humanizes the time-sequence" of music and deterritorializes "our acoustic habits, making us aware that the human is not the ruling principle in the harmony of the spheres."[28]

This acoustic environment certainly finds echoes in the music of urban culture that is thrilling and pushes all of its boundaries all the time. But that is all that it does. The music of technoculture is an elaborate sound mirror the likes of which we have never heard before, but it is still a mirror.

Braidotti's claim of the dehumanizing of music in technoculture is unclear, because the human experience is inevitably prioritized at the center of any human cultural, or even countercultural, expression. There is more confusion, I think, in her persuasive enthusiasm for the liberated music of technoculture when she cites the work of Diamanda Galas, Laurie Anderson, Meredith Monk, and Carmelo Bene as examples of the new post-humanist order. She describes these artists' projects as occasions in which the "sheer materiality of the human body and its fleshy contents (lungs, nerves, brains, intestines, etc.) are as many sound-making acoustic chambers. . . . [They] confront the listener with as shocking a sensation of unfamiliarity as the external rumbles of the cosmos."[29] Braidotti is being selective with the choice of chambers she highlights here, as these artists and their peers have built their careers on the virtuosity of their trained voices and live performances. Perhaps in the intervening years since the publication of her influential *Metamorphoses*, the novelty of electronic music and sonic insect-media approaches that emerged from technoculture have lost some of their bite. The aestheticized urban sound continues to grind and match its environment in seductive and powerful ways that fuel the soundtrack for each fast-developing generation. Indeed, the digital revolution has exploded the availability of new music, and the outlay of layer upon layer of globalized sampling and mass production of volumes of digital sound has in many ways adhered to and stretched Braidotti's vision of a newly non-anthropocentric acoustic world. But it cannot be called countercultural anymore. In my search for the anarchic, the revolutionary, and the countercultural, I turn to the voice outside of technology that contests the very language in which it must narrate its passions. In the contemporary live music of singers and performers such as Christian Zehnder and John Tomlinson, I find the energy of serious artists who plumb the depths of their sonic and vocalic bodies and find their own becomings—animal, insect, imperceptible, and molecular.

Singing and Sounding the Animal Body

Bearing in mind Dolar's serious concerns about the illusory nature of singing, along with its historical promises of divine access and its fetishization of itself, I turn toward artists who seek to bring out something creatural in their voices in order to usurp these promises and the anthropocentricity

that Braidotti correctly seeks to end in our time. Growing up in the Swiss Alps and listening to the cow horn communication of herders across vast tracts of pasture, Christian Zehnder trained his own vocal range to access this cultural memory while learning the skill of the yodel as well as its pastoral echo in Mongolian throat singing, wherein the doubling of the pitch of the voice produces two pitches at once.[30] His pursuit of a culturally meaningful acoustic envelope resulted in a performance sequence with the wind instrumentalist Balthasar Strieff under the title *Stimmhorn*. In the late 1990s and early 2000s, they expanded this performance into a half-folk, half-jazz clown cabaret. In more serious contexts of monastic settings and spiritual buildings, the raw depth of the nonverbal throat song consumed the air around it. Strieff's collection of horn instruments—including the alphorn, double alphorn, alpofon (his own invention), büchel, cornet, baroque trumpet, cornetto and tuba along with a collection of herder's cow horns—leave the listener-spectator in little doubt as to the focus of the duo's authentic concerns. Air itself is the primary material of their performance, and they treat it with a seriousness that forces its material presence to define the experience. Inside the virtuosity of their vocal control remain the traces of the cattle herder, the mountain herder, and the spatiotemporal environments that generate this remarkable sonic event in the throat. Zehnder has since broadened his three-octave vocal repertoire and practice with collaborations, notably with the Aka people in Central Africa, and in 2010 he sang the main part in a new opera by German composer Klaus Schedl titled *Amazonas*, based on the diaries of Sir Walter Raleigh. This slide from mountain to grassland to opera house is also my route to another work that challenges the stereotypical categorization of the trained voice of the classical singer.

In bass singer John Tomlinson's interpretation of *The Minotaur*, composer Harrison Birtwhistle's opera for Covent Garden, I hear the "sublime ideals of the humanist project" that Braidotti found antiquated now being viscerally challenged rather than just repeated. In turn, I believe this opera presents a complex proposal, in scale and originality, that does not simply hold up a mirror to contemporary culture for it to gaze on itself and its past. Instead, in the voice of Tomlinson's bull-man hybrid, the edifice of language comes crashing down to Dolar's zero point of meaning and base of phonology in the screaming and babbling of the chorus and the resounding bawl of the bull. For the human-monster figure of the Minotaur, the librettist and poet David Harsent created three voices and three

conscious states of being. In the first voice, we hear the bawl of the bull-man in his labyrinth who cannot speak when awake. His first written line in the libretto is "NUAAAAARGH!"[31] Only when he is sleeping do we hear his second voice, as a human, in which he questions his multiple personas and his terrible condition:

> the beast's hide and horn,
> the man's flesh and bone, no telling one from the other . . .
> Except for this lust, all too human
> This rage, all too human
> This hard heart, all too human . . .
> This inescapable sorrow, all too human.[32]

In these night scenes, while dreaming, the third voice is heard coming from a large screen projection of the Minotaur. This is the interior voice of the creature's conscience, which berates his bull-man persona for his violence to the young Athenians being sacrificed to him in the labyrinth. This projected figure also behaves like a mirror, reminding the Minotaur of who and what he is and how he can never be free because of his phys-ical contradiction, a "half-and-half" for which there is "no telling one from the other."[33] The Minotaur is a figure of ostracism, born in secret to his mother Pasiphae and given the name Asterios; then committed to live eternally in the labyrinth with no way out. He is not bull but not *not* bull. The mirrored walls of the labyrinth add to his torture, as he is constantly reminded of his difference to the beautiful youths that are flung into his pit. Harsent considers that, unlike the other characters of Ariadne and Theseus in the opera, the Minotaur does not change. His predicament is constant until Theseus kills him in the final scene of the opera. Harsent has empathy for the monster because "he is a tragic figure and, although he does rape and slaughter his victims, it's almost as if he's under an obligation to do so. DNA dictates: that aspect of his nature has taken over. It is duality."[34] In order to describe this tortured life, Harsent creates this multiplicity of voices that allows Asterios to articulate his abject state. Harsent explains, "I had this notion of continual struggle in him, evidenced by his struggle with speech; 'When I sleep does the man sleep first? When I wake does the beast wake first?' The human part of him wants to have the ability, the virtue, of language and the abilities that language provides to communicate, explain, apologize, justify. All those

things he cannot do. So he is left with this inchoate rage."[35] In these sleep sequences where, alone onstage, the bull-man triangulates his image and voice through live sound, recorded voiceover, and projected images, he is integrated into a becoming-animate.

Using Parker-Starbuck's definition, the staged body of the creature is "a site within which the three terms, human, animal, and technology, interrelate imaginatively and rehearse some of the ethical, practical, and philosophical possibilities of their integration."[36] In manifesting Asterios's inchoate rage, Tomlinson wrestles with these torments that are thrust upon the Minotaur and tries to find its voice within these multiplicities of persona and physical doublings. The performance of the three voices is a complex orchestration of live, amplified, recorded, and improvised sound. In the sleep scenes, and heavy with the weight of his massive hypermasculinity, which is doubly enlarged in a screen projection of his body wearing the hairy body suit of the mythic bull-man, he is sensitive and tender. In the arena of the sacrifice, when Theseus appears, Asterios wears a kind of cage head, complete with horns, through which Tomlinson can be heard, and the audience can sometimes see the "man" inside the "bull." The literalness of the treatment can be critiqued for its stereotypical interpretation of the myth, but we must keep in mind there is no standard or so-called correct way to portray a mythic monster. Reading the performance through the concept of becoming-animate, however, allows for what Parker-Starbuck calls "catalysts for reformulations of humanity's relationship with the non-human."[37] Inside the struggle to speak, in the throat and body of Asterios, there are multiple becomings at work. Along with the enunciation of the words through the music, which is Tomlinson's great expertise, he also finds a method of pulling the bellows and bawls of the minotaur away from a banal imitation, or even potential pantomime, and instead he creates a new voice—part human, part animal, and part machine—in the instrument of his voice. While the spoken and sung libretto reach around the auditorium in Birtwhistle's discordant contemporary sound, the bawl of the bull threatens us, the audience, sitting passively in our red velvet opera seats, because it pushes the limits of our acoustic experience into a new realm of perception and into our receptive bodies.

The priority and the risk in the operatic voice in this moment, according to Michelle Duncan, now "hinges on the performativity of voice: its effect rather than its meaning. What is sung is neither representational nor a process tied to cognition as we generally understand it, but a tangible

physical effect."[38] Because of its multiplicity of potential resonances, first, and its meanings, second, it is, like many operatic voices, often excessive and suggestive of "a slippage to something other or something more than what is first evident, a potential scandal waiting to unfold."[39] As a counterweight to this massive, excessive bull-man bawl of Asterios, another voice in *The Minotaur* arrives with its own legacies, mechanomorphisms and complexities that I think are worth diverting to here, because this voice is no less brilliant and tragic in how it mirrors the monstrosity of the beastly man. In the second act, Ariadne visits the temple of the Snake Goddess oracle to make a sacrificial offering of a dove and to hear the oracle's prediction for the fate of Theseus's fight against her brother, Asterios, in the labyrinth. When Ariadne summons the oracle in this production, a hole in the floor opens and a head appears. Then a body rises up, bare-breasted, corseted, and skirted, and soars into a column that towers over Ariadne and the attendant priest. The priest instructs Ariadne to sacrifice the bird, which she does, and then she may ask her question. The Snake Goddess speak-sings "in tongues" and in an unintelligible, shrieking falsetto that is excessively theatrical and marvelously operatic.

This shrill voice comes not from a female singer but from the countertenor Andrew Watts. In his arresting performance of outstretched arms holding two snakes and in his epileptic, manic head movements accentuating his babble, he heightens the deranged excess of his voice, which is not soprano but not not-soprano. Watts is one of a generation of countertenors whose developing voice coincided with a revival of interest in baroque opera, in the early 1990s, and a new trend of casting men in the both male and female roles that have been sung by sopranos and mezzos since the demise of the castrato. A new generation of European composers have created contemporary operas particularly for Watts's voice, appreciating his daring performance style that has seen him cross-dress, appear naked, and deliver commanding interpretations to the most avant-garde compositions in current art-music. The training of the countertenor voice is especially difficult because there is so much at stake. Without the right control, the voice can be ruined in every register. Before and after the arrival of the castrato, falsetto male singers sometimes sang women's roles, even though there was no ban on women performing onstage outside the Vatican. Opera was barely in its infancy when the boy sopranos of the Vatican were the first to undergo the barbarous act of castration to produce the voice so desired by the church: the high range of the child with the vocal strength of the male

tenor. The castrato was never a replacement for the female soprano, and they rarely played female roles in opera. Composers such as Handel created many male hero roles for the castrato (Rinaldo, Radamisto, Ottone, Giulio Cesare, Tamerlano, Tolomeo, Orlando, Ariodante, and Serse, to name a few). Indeed, the castrato voice and body were initially considered more as a super-masculine creation, the *primo uomo*, in the chaotic period of excess and invention of seventeenth-century Italy. They were part of a spectacular world where mechanical ingenuity emerged alongside still-magical sensibilities. According to Bonnie Gordon, the audience for this new voice, which appeared inside a newly mechanized opera house, "experienced the castrato as a kind of human machine, a variation among other wondrous objects created by technological attempts to manipulate and supplement natural materials. Castrati were 'mechanized' to produce sounds in ways that 'unmechanized' bodies could not. . . . Operas and spectacles used the castrato as both machine and malleable object."[40] For Gordon, the castrato becomes a cyborgean figure and the glory of the age.

This celebrity status, which is well documented, was nevertheless short lived, and the tragic narrative of the castrato voice spans the trajectory from angel to monster in less than two centuries. This descent into ostracism and abject debasement comes not because of a change in attitude to the act of castration, but with a shift in appreciation for the timbre of the castrato voice, along with a rejection of their unusual social status and their physical alterity. By the 1780s, denunciations of castrati had become "de rigeur," as Martha Feldman explains: "To denounce castrati was to utter a liberal cry to preserve Nature by condemning any cruel perversions that might threaten to disfigure Her, where Nature was a new Enlightenment divinity that had to be protected from threats of disfiguration and where safeguarding her was a matter of social, political and metaphysical principle. . . . Castrati had become irreversible signs of things out of place . . . they were categorically wrong—men by origin but non-men or half-men in the social sphere and psyche."[41] As half-men and non-men, castrati had a short slide into the pit of animal caricature, infection, unnaturalness, social depravity, and ostracism, where "those who are afflicted with this disease are so apt to whinny like colts, croak like frogs, bellow like bulls, roar like lions, squeak like pigs and most commonly bray like asses."[42] The voice of the castrato was so abhorrent and filthy that it could take the form of a disease-carrying insect, such as the fly, which "slides through the ear and gets into the pineal gland where 'it dries out the ethereal spirit, which is the

essence of the soul, and produces . . . a total alienation of mind."[43] These tragic performers became "imbruted" in a campaign fueled by suspicion of their sexuality and jealousy of their riches, social status, access to royalty, and luxurious lifestyle. Their very presence brought into question what it was to be called human.[44]

It is important to remember in any discussion of the celebrity of the castrati that success was the privilege of a tiny minority. In the early 1700s, an estimated four thousand boys from southern Italy were castrated every year by their families in the hope that they might earn a living in the church choir or on the stage. The contemporary repulsion to the practice of genital mutilation always places the castrati as victims, but it is worth noting that many types of human and animal bodies of all genders were mutilated, trafficked, and traded in this period. Within this trade, the practice of castration came to Europe through Spain, where Moorish eunuchs were physically altered to be court singers in a centuries-old practice. Traditions betray bodies, however, and when the fashion for listening to the castrati dwindled, their voices became inaudible, and their bodies became unacceptable. Castrati in general suffered many ailments because of their alteration, which contorted their physical development as well as their voices. They were invariably barrel chested, unusually tall and ungainly, overweight, arthritic, and easily recognizable visually and vocally. Few lived beyond the age of forty. In Deleuze and Guattari's description of the countertenor and castrato voice, they visualize this machined and manipulated body in graphic detail. Quoting Fernandez, they say that this voice "operates inside the sinuses and at the back of the throat and the palate without relying on the diaphragm or passing through the bronchial tubes . . . the stomach voice of the castrati [is] 'stronger, more voluminous, more languid,' as if they gave carnal matter to the imperceptible, impalpable, and aerial."[45] In the machining of the castrato voice, the carnality and spectacle of the body pulls the flesh around the organ of speech and song, hiding its mysteries and sustaining its uncanny acousmatic power.

When the Snake Priestess appears in *The Minotaur*, the voice we hear resurrects the figure of the castrato. The mysteries of the throat and other hidden organs are unavoidably fascinating with this voice echoing the troubled body and its brutal history. Standing twenty feet tall in a bizarre trance, her breasts exposed like the Minoan sculptures of the goddesses of Knossos, the Snake Priestess addresses the theater with great seriousness and passion, though the song remains unintelligible:

SO LO THO. SO LO THO. SO LO THOO.
SO. THO SO NO. SO NO THO.
KEH KEH. MO MO MO THO. ESSS. AE AUK.
NEON NOMEN CONET CONET. UPTEN FILIAT.
OTEN KO NE MO.[46]

The Snake Priestess's language is a babble, which the attendant priest translates for Ariadne. It is the Snake Priestess who gives Ariadne the ball of red rope (in which "there is always sonority"[47]) that will lead Theseus in and out of the labyrinth. The electric performance by Watts revives something of the history and danger of this artificial or contrived voice precisely because of the babbling language. We are confronted directly and exclusively with the material and carnal dimension of this voice, which only pays lip service to the conventions of language, gender, and species.

After the young Athenian Innocents have been mauled by the Minotaur and left for dead, Birtwhistle and Harsent complete their collection of monstrous opera voices with the bloodied figure of a Ker. She is one of the Keres, who are half-human, scavenging bird-women who have access to both spoken language and their own screeching vocabulary of terror: "Ruuuuaaaak! Ruuuuaaaak! Ruuuuaaaak!"[48] Their world is also driven by abject desires and an insatiable hunger for fresh kill. Like their buzzard cousins, they perform an important function in the drama, cleaning up at the end of each act after the disasters of the human politics. Their job is to pick clean the remains of the victims of corrupt power and random death:

Bloodshed fetches us. Slaughter fetches us.
We darkened the sky at Thermopylae.
At Marathon, at Ephesus, at Syracuse
We fell like black rain.[49]

When the Minotaur collapses and is almost dead in the last scene of the opera, he finds his human voice just long enough to surmise that "between man and beast, Next—to—nothing."[50] But the last word goes to the Ker, who arrives to feed on his massive corpse, when she screams "Ruuuuuaaaaaark!"[51] Then the *opera*, the work of this drama, is finished.

The idea of language holding inside itself a more primitive locution is a developing concept in Birtwhistle's oeuvre, beginning with *The Mask of Orpheus* (1986) and expanded in the man-creature-myth dilemmas in *The*

Second Mrs. Kong (1994). When we reach the labyrinth in *The Minotaur*, the line of flight for this composer is his arrival into the psychodrama of the caged man-beast who has never seen the outside world, except in dreams. The labyrinth becomes the chamber for resounding the rehearsed human-animal voices that Birtwhistle had been collecting en route to staging the events at Crete. Inside this structure, the rules of language do not apply, and so the trio of hybrids—human-buzzard, male-priestess, and bull-man—find their voices and devour the air of the opera house. The labyrinth becomes a macrocosm of the human/animal interior of both the heart and the ear. The underground cavity of chambers becomes "a place with more dead ends, more flaws and fault lines than the human heart."[52] Inside the physical and metaphorical labyrinth is the place to "let the creature live. Let it live *there*."[53] The central pumping chambers of the body become the living space for the voice of the human-animal-monster-infant. The Minotaur merges his internal and external worlds of his not-man, but not-not-man, hybrid body, half lost in a psychic meta-prison, in this passage:

> In this place of despair, this place of silent weeping,
> this place of sorrow, of fear, of cries and whispers,
> this place of hellish visions, of *no way out*,
> I am mobbed by shadows, I'm lost inside myself.[54]

The labyrinth is therefore a rhizomatic structure in which dimensions confound directions and routes create more routes in an eternal series of openings and enfoldings; a place of contagion, a Kafkaesque miasma. Living somewhere in this underground air is a voice and its echoes—human, animal, architectural, carnal. When Deleuze describes the labyrinth as a metastructural manifestation of being and becoming, he does so in the shade of Nietzsche's elaborate use of labyrinthine metaphors. But in *The Fold*, Deleuze stretches the materiality of the labyrinth into the plastic, fluid, and elastic dynamics of matter inside the human body and mind, where "a fold is always folded within a fold, like a cavern in a cavern. The unit of matter, the smallest element of the labyrinth, is the fold. . . . A labyrinth is said, etymologically, to be multiple because it contains many folds. The multiple is not only what has many parts but also what is folded in many ways. A labyrinth corresponds exactly to each level: the continuous labyrinth in matter and its parts, the labyrinth of freedom and its predicates."[55] The labyrinth is a place of memory for Deleuze, where meaning and matter

collide in an eternal, repeating layering of experience folding over itself without end. Deleuze's labyrinth of the soul is therefore a counter-Cartesian proposal in which he puts forward a method of thinking that lacks a recti-linear structure and instead accepts a flexible multiplicity of open structures that fold and enfold into an eternal becoming. If Descartes did not discover a route through the labyrinth of the soul, it was because he thought in straight lines. Deleuze explains that Descartes "knew the inclension of the soul as little as he did the curvature of matter." Instead, Deleuze suggests we need a cryptographer, "someone who can at once account for nature and decipher the soul, who can peer into the crannies of matter and read into the folds of the soul . . . the souls down below, sensitive, animal."[56]

In the labyrinth, the literal and the metaphorical resonances that can exist and emerge from its rhizomatic structure are less problematic for Deleuze and Guattari than the concept of resonance by itself. Simon Bayly describes how they see resonance as "plagued by its own metaphorical depths, a black hole of an idea in which the plurality of 'rendering sonorous' is homogenized into a reverberant but meaningless bathos."[57] Without a structure around it, resonance is prone to expand uncontrollably without form. Instead, in the concept of a resonant cavity like the labyrinth, sono-rous communication can begin to respond to the structure and be shaped by its densities and dimensions. Without the structure—labyrinth, wormhole, earhole, mouth-hole, body chamber, theater chamber—resonance cannot be understood, or even heard. In Duncan's imaging, "vocal resonance seeps through porous bodies, remaining as haunting memories, haunting melodies."[58] Receptive interior spaces reinforce and prolong the vibrations and waves of communicative sounds, where other bodies, tissues, and cavities absorb them.

In the theater, resonance has a particularly special role; the sound of the speaking or singing body needs a host body, another receiver to rever-berate in and through. In the willing spectatorial body of the audience, in the acoustic architectural body of the building, and in the bodies of musical instruments, the vocalic body can re-sound its materiality of lungs, muscles, and larynx in an ecology of singing and listening. Substances are made airborne in the machine of the theater, which does not merely function as a place of exchange of communication. Bodies encounter each other in layered, multidimensional, shared air, in a becoming-resonant of both singer and listener in which something of each is reverberating in the other. Bayly suggests that "an encounter with resonance is always

uncanny, whether in the strange mutations wrought on sound by certain architectural or natural stone formations or in the buzzing felt in the filled cavities of one's teeth caused by a certain pitch and volume of voice."[59] In becoming-resonant, the body is both a complex producer of sound and also a complex receiver: "an organ, a body and an entire sensibility capable of being affected by vibrations of the air."[60] Just as the singer Järviö is taught to think of her body as "a large flute through which air flows, giving life to the flute," we can experience the exchange of sonic, sung air as the occasion when "the whole body opens into a living instrument, into a hollow pipe, through which the breath flows up and down, to and fro," and through which is communicated the labyrinthine cavities of the lungs, their sighing and strength, inducing a shared understanding of what it means to be alive, to be an acoustic creature.[61] In the theater and the opera house, voices do not just go in one ear and out the other. In becoming-resonant, traces of the reverberations of the singing voice are held in the listening body as remnants. Like Rebecca Schneider's theory of the "performance remains" of theatrical exchange, these sonic remnants behave like "a corporeal uncon-scious" in which "the voice that emanates from this body is one that carries remnants of the body with it, remnants of that gain, through propulsion, a weight of their own."[62] In the long history of exchanging air, matter, and mind in multispatial performance practices, it is the creatural acoustic that becomes audible in the voices of the living, to be resounded and carried through the resonant cavities of the sound-making body and the receiving body. Within these haunting acoustics, the creatural living voice and body reverberate, inducing an eternal becoming-resonant long after the heavily embroidered curtain has drawn the performance to a close.

CODA

'Songs of Praise'
Tonight, their simple church grown glamorous,
The proud parishioners of the outlying parts
Lift up their hymn-books and their hearts
To please the outside-broadcast cameras.
The darkness deepens; day draws to a close;
A well-bred sixth-former yawns with her nose.

Outside, the hymn dies among the rocks and dunes.
Conflicting rhythms of the incurious sea,
Not even contemptuous of these tiny tunes,
Take over where our thin ascriptions fail.
Down there in the silence of the laboratory,
Trombone dispatches of the beleaguered whale.

—DEREK MAHON

ACKNOWLEDGMENTS

It is a great privilege to have the opportunity to thank Kendra Boileau and Nigel Rothfels at the Pennsylvania State University Press for their belief in this book and for giving me the time and encouragement to strengthen the final manuscript. Being part of the Animalibus community of writers is an honor.

My sincere thanks go to my mentors Jennifer Parker-Starbuck and Garry Marvin. Both professors crossed disciplinary boundaries to create a unique space for my writing to flourish, and their careful guidance and encouragement allowed for creative exploration. For their wealth of knowledge so generously shared, as well as their friendship, I will be forever grateful.

The rich response and meticulous attention given to my manuscript by Steve Baker, PA Skantze, Martin Ulrich, and the anonymous reader informed every step of the process of writing this book. It was a privilege to receive their serious and enlightening thoughts and suggestions. My thanks for their time and for their careful and important contributions to my ideas.

The process of writing of this book would not have been possible without the constant support and trust I received from my dear friends Michael Beirne, David Cunningham, Maud Cotter, Morgan Doyle, Rita Hickey, Patricia Looby, Alice Maher, Eoin McQuinn, Michael Murphy, Linda Quinlan, and Arthur Steele.

My ally in wordcraft, Jean Cullinane, generously shared her own glittering scholarship and insight throughout the writing process. I will always treasure her delight in ideas and her guidance through the forest of philosophy. Marian Fitzgibbon's sharp intelligence and literary knowledge brought precision and finesse to her meticulous proofreading of the manuscript, and her kind words of encouragement have ever been a great gift to me. I take great pleasure in thanking Charlie McCarthy, to whom I owe so much. This book is deeply enriched by his constant support, insight, and rigorous attention to the detail of a sentence.

Finally, I thank my father, Terence, and my late mother, Mary Anthony, who have always shown an unwavering belief in my art practice and my writing. Their love resonates in my own becoming.

NOTES

Introduction

1. Dillard-Wright, "Thinking Across Species Boundaries," 53–71.
2. Deleuze and Guattari, *Thousand Plateaus*, 256–341.
3. Deleuze and Guattari, *What Is Philosophy?*, 169.
4. Deleuze and Guattari, *Thousand Plateaus*, 256–341.
5. Deleuze and Guattari, *Kafka*, 22.
6. See Steve Baker's enlightening analysis of Angela Singer's work in *Artist/Animal*, 165–75.
7. Marvin, "Unspeakability, Inedibility," 139–58.
8. Ibid.
9. Parker-Starbuck, "Becoming-Animate," 663.
10. Benjamin, *Origin of German Tragic Drama*, 211.
11. Rundle, "Hairy Ape's Humanist Hell," 7.
12. Harsent, *Minotaur*, 65.
13. Mahon, *New Collected Poems*, 104.

Chapter 1

1. Chaudhuri, "Animal Geographies," 116.
2. Connor, *Dumbstruck*, 13.
3. Ibid., 18.
4. Martinelli, *Of Birds, Whales, and Other Musicians*, 5.
5. Ihde, *Listening and Voice*, 256.
6. Ibid., 192.
7. According to Middlebrook and Everett in *Bomber Command War Diaries*, on May 19, 1942:

 197 aircraft—105 Wellingtons, 31 Stirlings, 29 Halifaxes, 15 Hampdens, 13 Lancasters, 4 Manchesters. 11 aircraft—4 Halifaxes, 4 Stirlings, 3 Wellingtons—lost. 155 aircraft reported hitting Mannheim but most of their bombing photographs showed forest or open country. When the raid did begin, bombs approximately equivalent to no more than 10 aircraft loads fell in the city. Concentrated group of about 600 incendiaries in the harbor area on the Rhine burnt out 4 small industrial concerns—a blanket factory, mineral-water factory, chemical wholesalers and a timber merchants. Only light damage was caused elsewhere in the city. The only fatal casualties were 2 firemen. (267)

8. Marquis, "Written on the Wind," 410.
9. Ibid., 412.
10. Ibid., 400.
11. However, the nightingale population declined by 53 percent between 1995 and 2008, and the figures from 2007–11 indicate that their range continued to contract toward the extreme southeast of England, despite massive, local conservation efforts in traditional coppice and scrub habitats. British Trust for Ornithology, https://www.bto.org/difference-we-make, accessed May 11, 2020.
12. Brumm and Todt, "Noise-Dependent Song."
13. "A Nightingale Sang in Berkeley Square" is a romantic British popular song written in 1939 with lyrics by Eric Maschwitz and music by Manning Sherwin.
14. Patel, Iversen, and Rosenberg, "Comparing the Rhythm," 3034–47.
15. Ball, "Concerto for the Mother Tongue," 507.
16. For example, penguin chicks identifying their parents' call from among the thousands of calling penguins on the

shore (Aubin and Jouventin, "Cocktail-Party Effect").

17. Witchell, *Evolution*, 12–21.
18. Ramachandran, "Mirror Neurons and Imitation Learning."
19. Heyes, " Where do Mirror Neurons come from?" 575.
20. Hickock, *Myth of Mirror Neurons*, 20.
21. With the possible exception of Bela Bartók (1881–1945). Maria Anna Harley builds a convincing case around the composer's interest in folk music and its connection to the voices of the natural world, claiming some ground for Bartók in her reframing of the origins of ecomusicological theory and practice. While Bartók's references to birdsong, and to the nightingale in particular, are many and delightful, his interpretations remain on the border between romanticism and modernism, technically present but less influential than what would emerge from Messiaen's field studies. In blunt terms, and in the context of this discussion of Messiaen, Bartók was not an ornithologist. This being said, Maria Anna Harley's perspicacious essay will hold sway in some of my examinations of ecophilosophical theories about aesthetic around animal voices in performance practices later in this book. See Harley, "Natura Naturans, Natura Naturata."
22. Rothenberg, *Why Birds Sing*, 193.
23. My thanks to Professor Martin Ulrich for his insightful clarification on this often cloudy contextualization of Messiaen's work.
24. Rothenberg, *Why Birds Sing*, 194.
25. Ibid., 195.
26. Messiaen, *Traité de rythme*.
27. Fallon, "Record of Realism," 52.
28. Hold, "Messiaen's Birds," 113.
29. Ibid., 117.
30. Hill, "For the Birds," 553.
31. Ibid., 555.
32. Ibid.
33. Gurewitsch, "Audubon in Sound," 92–96.
34. Hill, "For the Birds," 555.
35. Nancy, *Listening*, 26.
36. Eliade, *Shamanism*, 98.
37. Translated from the French by Arthur Goldhammer, this is a transcription by Jean Boivin of a recording of one of Messiaen's lectures made in the spring of 1959 by his student and future composer Francois-Bernard Mâche. The recently discovered recording is translated as "Bird Song," as it appeared in Messiaen, Boivin, and Goldhammer, "Bird Music."
38. In a letter (1991) sent to Nicholas Armfelt thanking him for his cassette recordings of native birds, Messiaen describes each sound in musical terms—the crescendo of the kōkako, the glissando of the kea, and so on. He went on to use these new birdsongs in some of his final works, *Couleurs de la cité celeste* (1991), *Éclairs sur l'au-dela* (1988–92), and *Concert à quatre* (1990–91). Letter reproduced by Nicholas Armfelt for Malcolm Ball's online resource, https://www.oliviermessiaen.org/writings, accessed May 9, 2020.
39. Catchpole and Slater, *Birdsong*, 274.
40. Darwin devoted almost half of the book to the study of birdsong and bird feathers and their special role in his concept of human aesthetics. In 1997, the annual Darwin College lectures at Cambridge, on the theme of "Sound" in evolution, used birdsong as their only example under discussion.
41. See https://www.performancecalls.com/product/snow-screamer-snow-goose-call, accessed May 28, 2020.
42. Downloaded from https://www.avosound.com/en/sound-effects/search/bird/swan/swan, accessed May 9, 2020.
43. Jonathan Harvey, *Bird Concerto with Pianosong*, with London Sinfonietta and Hideki Nagano (piano), NMC Recordings Ltd., 2011.

44. Damon Albarn also used a variety of strange and wonderful instruments in his opera *Monkey, Journey to the West* (2007), including a musical saw, ondes Martenot, a glass harmonica, and a klaxophone made of car horns attached to a keyboard.
45. Aleksander Kolkowski, *Recording Angels: "Mechanical Landscape with Bird,"* for eight singing canaries, Serinette (bird-organ), two phonographs, and a rotating string quartet with horned instruments. Commissioned by Maerz Musik—Festival für aktuelle Musik, Sophiensæle, Berlin, 2004.
46. Mundy, "Birdsong and the Image of Evolution," 206.
47. Auslander, "Evangelical Fervor," 178–83.
48. In the "Fourth Version" at the Lenthos Museum of Modern Art, Linz, Austria, entry to the art aviary for the visitor required walking through a red tunnel that vibrated with stroboscopes, which ensured that no finch would be persuaded to attempt an escape.
49. Keats, "Ode to a Nightingale," 538.
50. Trainor, "Céleste Boursier-Mougenot," 79.
51. Ihde, *Listening and Voice*, 186.
52. Ibid., 193.
53. Connor, *Dumbstruck*.
54. Broglio, *Surface Encounters*, 124.
55. Nancy, *Listening*, 7.

Chapter 2

1. See images of installation at http:// bungalowgermania.de/en/exhibition, accessed March 3, 2015.
2. For a clip of the opening of the pavilion installation of "Birds, Bonn" (1964), see http://vimeo.com/99372575, accessed March 3, 2015.
3. White, *Making Worlds* (2009), http://www.youtube.com/watch?v=8axNSdBnL1c, accessed May 11, 2020.
4. Shaffrey, "Through a Glass Darkly," 78.
5. Roach, "Performance," 1083.
6. Schafer, *Soundscape*, 52.

7. Schaeffer, *In Search of a Concrete Music.*
8. Iamblichus, *Life of Pythagoras*, 21.
9. Farquharson and Wilson-Goldie, "Get Together."
10. Connor, "Violence, Ventriloquism," 75.
11. Dolar, *Voice and Nothing More*, 70.
12. Connor, "Violence, Ventriloquism," 92.
13. Ibid.
14. See https://www.bighunter.it/Home/tabid/36/Default.aspx, accessed May 5, 2020.
15. Haraway, *When Species Meet*, 80.
16. Ibid.
17. For example, the most debated law among hunters and animal activists alike is Law 157 of 1992, art. 12, which describes a "hunting exercise" as "any act directed at the killing and hunting of wildlife" and which therefore can include a very broad range of "exercises," such as owning a gun or even "owning the funds allocated for this purpose," or in one case "completely objective elements liable to constitute a case of exercise of hunting." Uncertain as to what "action" can now be considered "hunting," the hunting lobby seeks clarification on the wording so as to define what can and cannot be defined as an action that might show an intention to hunt. Animal welfare activists demand an outright ban. See http://www.bighunter.it/Home/Blog/tabid/58/EntryId/510/nozione-di-esercizio-venatorio.aspx, accessed May 28, 2015.
18. Shukin, *Animal Capital*, 51.
19. Taussig, *Mimesis and Alterity*, xviii.
20. Shukin, *Animal Capital*.
21. From CABS press release, see http://www.komitee.de/en/homepage, accessed May 27, 2015.
22. Shukin, *Animal Capital*, 60.
23. Indeed, in Richard Schechner's own play, *Dionysus in 69* (1968), based on Euripides's *Bacchae* (405 BC), primal animal references build toward the anarchic climax, in which the followers of the god turn from sensual lovers into

growling and screaming cat-demons, who in turn tear apart the body of the king, Pentheus. Their mutation is signaled by their snarling, blood-curdling voices. "As Schechner reports, the women learnt to make their 'bodies into those of animals, especially big cats' for the 'animal chase.' This had the effect that 'pandemonium filled the Room, with screams of the audience joining our own' (Schechner, 1970)." Fischer-Lichte, *Dionysus Resurrected*, 42, citing Schechner, *Dionysus in 69*.

24. Montelle, *Palaeoperformance*, 11.
25. Derrida, *Animal That Therefore I Am*, 104.
26. Lawergren, "Origin of Musical Instruments and Sounds," 31; Gray et al., "Music of Nature," 52.
27. Montelle, *Palaeoperformance*, 120.
28. Turk et al., "Mousterian Musical Instrument," 589.
29. Armstrong Oma, "Between Trust and Domination," 175, and Orton, "Both Subject and Object, 188.
30. Overton and Hamilakis, "Manifesto," 111.
31. Brittain and Overton, "Significance of Others," 145.
32. Marvin, "Natural Instincts," 108–15.
33. Marvin, "Passionate Pursuit," 48–60.
34. Marvin, "Sensing Nature," 15–26.
35. Ibid., 15.
36. Marvin, "Passionate Pursuit," 48.
37. Marvin, "Unspeakability, Inedibility," 147.
38. Marvin, "Passionate Pursuit," 57.
39. Ibid., 58.
40. Ibid., 59.
41. Ibid., 58.
42. Ibid., 59.
43. Heidegger, *Being and Time*, 156.
44. Ibid.
45. Ibid.
46. Cattivelli, "UIT, Sound Performance."
47. Cattivelli, "Garrulus Glandarius," http://www.danielacattivelli.it/en/garrulus

-glandarius, accessed November 24, 2013.
48. Cattivelli, "UIT, Sound performance."
49. Cattivelli, "Garrulus Glandarius."
50. Cattivelli's second performance of *UIT*, at the Festival La Novela in the Jardin botanique Henri Gaussen, Muséum de Toulouse, was advertised thus: "Laissez-vous embarquer dans un environnement sonore dépaysant. Une expérience qui promet des surprises!" (Let yourself embark on an exotic soundscape. An experience that promises surprises!). See http://www.fete-connaissance.fr/uit, accessed June 4, 2014.
51. Cavarero, *For More Than One Voice*, 15–16.
52. Ibid., 165.
53. Ibid., 105.
54. Harrison, *Prolegomena*, 199.
55. Ibid.
56. Lawlor, "Following the Rats," 169–87.
57. Cattivelli, "Garrulus Glandarius."
58. Ibid.
59. Cattivelli, "Statement," http://www.danielacattivelli.it/en/uit, accessed March 12, 2020.
60. Cattivelli, "Garrulus Glandarius."
61. Lingis, *Community*, 96.
62. Ibid.

Chapter 3

1. Coates, *Journey to the Lower World*, n.p.
2. Ibid.
3. Marcus Coates, *Radio Shaman*, single-channel HD video, courtesy of the artist and Workplace Gallery, UK.
4. Broglio, *Surface Encounters*, 120.
5. Coates, *Journey to the Lower World*.
6. Charlesworth, "Art Is Good for You," n.p.
7. Boyd, *On the Origin of Stories*, 3.
8. Ibid., 14.
9. McConachie, "Evolutionary Perspective on Play," 36.
10. Ibid., 41.
11. Ibid., 40.

12. Willerslev, *Soul Hunters*, 1.
13. Ibid.
14. Ibid.
15. Bubandt and Willerslev, "Dark Side of Empathy," 20.
16. Willerslev, *Soul Hunters*, 172.
17. Ibid.
18. Bubandt and Willerslev, "Dark Side of Empathy," 18.
19. Ibid.
20. Ibid., 7.
21. Ibid., 29.
22. Viveiros de Castro, "Exchanging Perspectives," 466.
23. Ibid.
24. Ibid.
25. Ibid., 464.
26. Bubandt and Willerslev, "Dark Side of Empathy," 14.
27. Caillois and Shepley, "Mimicry and Legendary Psychasthenia," 25.
28. Ibid., 31.
29. Flaubert quoted in ibid., 31, emphasis original.
30. "The Deer Skin," in Coates, *Journey to the Lower World*, n.p.
31. Baker, *Postmodern Animal*, 64.
32. Ibid.
33. Baker, "Something's Gone Wrong Again," 4.
34. Phillips, *Terrors and Experts*, 7.
35. Pradier, "Animals, Angel and Performance," 12–13.
36. Ibid., 21.
37. Viveiros de Castro, "Exchanging Perspectives," 464.
38. Viveiros de Castro, "Cosmological Deixis and Amerindian Perspectivism," 472.
39. Adams, "Joseph Beuys," 30.
40. Ibid.
41. Television interview with Joseph Beuys, 1983, https://www.youtube.com/watch?v=Mo47lqk_QHo, accessed March 10, 2015.
42. Fischer-Lichte, *Transformative Power of Performance*, 104.
43. Ibid., 105.

44. Baker, *Artist/Animal*, 8.
45. Walters, "Artist as Shaman," 47.
46. Willerslev, *Soul Hunters*, 172.
47. Wallis, *Shamans/Neo-Shamans*, 195–201.
48. Krippner, "Conflicting Perspectives on Shamans," 963.
49. Lévi-Strauss, *Structural Anthropology*, 1:204.
50. Silverman, "Shamans and Acute Schizophrenia," 22.
51. Ibid., 23.
52. See the filmed document of Tanaka Min and La Borde at https://www.youtube.com/watch?v=VgErye7jXbI, accessed March 11, 2015.
53. Fraleigh, *Butoh*, 13.
54. Deleuze and Guattari, *Anti-Oedipus*, 18.
55. Cull, "Schizo-Theatre," 5.
56. Deleuze and Guattari, *What Is Philosophy?*, 70.
57. Ibid., 70.
58. Ibid., *Anti-Oedipus*, 18.
59. Cull, "Schizo-Theatre," 6.
60. Ibid., 20.
61. Aloi, "Editorial."
62. Deleuze and Guattari, *Thousand Plateaus*, 263.
63. Lawlor, "Following the Rats," 169–87.
64. Deleuze, *Essays Critical and Clinical*, 1.
65. Deleuze and Guattari, *Thousand Plateaus*, 262.
66. Lawlor, "Following the Rats," 170.
67. Colebrook, *Gilles Deleuze*, 128.
68. Ibid.
69. Ibid., 129.
70. Aloi, "In Conversation with Marcus Coates," 33.
71. Deleuze and Guattari, *Thousand Plateaus*, 163.
72. Baker, *Postmodern Animal*, 64.
73. Deleuze and Guattari, *Kafka*, 18.
74. Broglio, *Surface Encounters*, 110.
75. Deleuze and Guattari, *Kafka*, 22.
76. Caillois and Shepley, "Mimicry and Legendary Psychasthenia," 31.

Chapter 4

1. Bulgakov, *Dog's Heart*, 113.
2. Seckerson, Review of *A Dog's Heart*.
3. Sebeok, "Animal Communication."
4. Krause, *Great Animal Orchestra*, 222–26.
5. Fudge, "Dog Is Himself," 185–209.
6. Dobson, "Dog at All Things," 116–24.
7. Fudge, "Dog Is Himself," 189.
8. Shannon, "Poor, Bare, Forked," 168–96. Laurie Shannon's zoographical catalogue of animal references in *King Lear* alone is quite astonishing in its breadth, as it includes

 dragons, monsters, brutish villains, goatish dispositions, the Dragon's Tail and Ursa Major, mongrels, curs, coxcombs, apish manners, hedge-sparrows, cuckoos, asses, horses, sea-monsters, detested kites, serpent's teeth, wolvish visages, foxes, oysters, snails, a mongrel bitch, wagtails, rats, halcyon beaks, geese, bears, monkeys, ants, eels, sharp-toothed unkindness, vultures, wolves, owls, creatures, lions, cocks, lice, pelicans, hogs, dolphins, worms, sheep, civet cats, house cats, mastiffs, greyhounds, spaniels, bobtail tikes, swimming frogs, toads, tadpoles, wall-newts, mice, deer, vermin, nightingales, herring, boarish fangs, cowish terror, tigers, prey, dog-hearted daughters, crows, choughs, beetles, larks, wrens, furred gowns, swine, adders, butterflies, toad-spotted traitors, a dog, a horse, and a rat. This is not to count repetitions of these names or foul fiends, incubi, centaurs, demons, and spirits— to whatever taxonomic or cosmic order they may belong.

9. Ibid.
10. Ibid.
11. States, "Dog on the Stage."
12. Ibid., 369.
13. Dobson, "Dog at All Things," 119.
14. Ibid.

15. From notes on Eliza Fenwick's *The Life of the Famous Dog Carlo* (1804) on Centre for Textual Studies, DeMontfort University's Hockliffe Project, http://hockliffe.dmu.ac.uk/items/0162.html, accessed April, 28, 2013.
16. For example, a playbill from the Theatre Royal in Birmingham, dated August 8, 1827, features one Mr. Blanchard as well as a Mr. Simpson and "his Wonderful DOG." "The latter also appears in *Woodman and His Dog; or, The Castle of Rocella*, a melodrama written expressly for the famous performing dog, Carlo. The final scene represents 'The Castle in Flames, In which surprising Feats of Sagacity will be displayed by the WONDERFUL DOG CARLO.'" Texts from *Early American and British Popular Amusement: An exhibit from the personal collection of Professor Emeritus Don B. Wilmeth supplemented by items from Brown's Special Collections*, The John Hay Library, Brown University, September–October 2010, http://library.brown.edu/exhibits/wilmethCatalog.pdf, accessed May 1, 2013.
17. Kafka, *Complete Short Stories*, 281.
18. Ibid.
19. Ibid., 282.
20. Ibid.
21. Dolar, *Voice and Nothing More*, 186.
22. Kafka, *Complete Short Stories*, 286.
23. Ibid.; *Voice and Nothing More*, 186.
24. Kafka, *Complete Short Stories*, 316.
25. Magnum, "Dog Years, Human Fears," 45.
26. Howell, "Eugenics, Rejuvenation, and Bulgakov's Journey," 544–62.
27. Ibid., 556.
28. Ibid., 555.
29. Bulgakov, *Dog's Heart*, 46.
30. Ong, *Barbarian Within*, 263.
31. Poizat, *Angel's Cry*, 44.
32. Felman, *Scandal of the Speaking Body*, 115–16.
33. Ibid., 37.
34. Bulgakov, *Dog's Heart*, 112.

35. Lynch, "Sacrifice and the Transformation," 289.
36. Haraway, *When Species Meet*, 326.
37. Ibid., 72.
38. Benjamin, *Origin of German Tragic Drama*, 211.
39. Ridout, *Theatre and Ethics*, 70.
40. Fudge, "At the Heart of Home," 8.
41. Ibid., 9.

Chapter 5

1. Barthes, *Image, Music, Text*, 175.
2. Ibid., 176.
3. Dillard-Wright, "Thinking Across Species Boundaries," 69.
4. Ibid.
5. Ibid., 53.
6. Merleau-Ponty, *Phenomenology of Perception*, 211.
7. Dillard-Wright, "Thinking Across Species Boundaries," 55.
8. Rundle, "Hairy Ape's Humanist Hell," 7.
9. O'Neill, *Ah, Wilderness!*, 188–89.
10. Ibid., 137.
11. Ibid., 186.
12. Ibid., 7.
13. Scholtmeijer, "What Is 'Human'?" 139.
14. Rundle, "Hairy Ape's Humanist Hell," 7.
15. O'Neill, *Ah, Wilderness!*, 146.
16. Deleuze and Guattari, *Thousand Plateaus*, 262. When Deleuze says that when the human becomes animal, the animal becomes something else, it only becomes this something else *for the human*. John Mullarkey points out that in contrast to the vast options of human becomings, Deleuze never asks what this something else might be for the animal. Mullarkey concludes that, for Deleuze, "animal becoming does not interest him in as much as it might participate in anything affirmative *for it*." In Mullarkey, "Animal Spirits," 25.
17. Rundle, "Hairy Ape's Humanist Hell," 4.
18. Ibid.
19. Brugnoli, "Eulogy of the Ape," 52.
20. Ibid.
21. Ibid., 53.

22. Flaubert, *Early Writings*, 83.
23. Kafka, *Complete Short Stories*, 258.
24. Ibid., 253.
25. Corbey, *Metaphysics of Apes*, 41.
26. Buffon and Daubenton, *Histoire Naturelle*, cited in Corbey, *Metaphysics of Apes*, 49.
27. Corbey, *Metaphysics of Apes*, 54.
28. Allestree, *Government of the Tongue*, section I.
29. Polzonetti, "Tartini and the Tongue of Saint Anthony," 430.
30. Ibid., 468.
31. See http://alicemaher.com/exhibitions/portraits, accessed August 4.
32. In conversation with the artist, February 18, 2017.
33. See an image sequence of Vishtauroborg at http://doosungyoo.com/artwork/2856456_Vishtauroborg_version_3_1_Incompatibilit.html, accessed March 27, 2015.
34. Danta, "Might Sovereignty Be Devouring?" 44.
35. Ibid., 47.
36. Ibid., 48.
37. Derrida, *Animal That Therefore I Am*, 37.
38. Danta, "Might Sovereignty Be Devouring?" 47.
39. Derrida, *Animal That Therefore I Am*.
40. Agamben, *Open*, 27.
41. Scholtmeijer, "What Is 'Human'?"
42. Bayly, *Pathognomy of Performance*, 153.
43. Brugnoli, "Eulogy of the Ape."
44. Teevan, Kafka, and Young Vic Theatre Company, *Kafka's Monkey*, 15.
45. Ibid., 57.
46. Ibid.
47. Kafka, *Complete Short Stories*, 257.
48. This speech does not appear in the script. This is my transcription of Kathryn Hunter's performance of *Kafka's Monkey* acquired from Digital Theatre. See https://www.digitaltheatreplus.com/productions/kafkas-monkey.
49. Kafka, *Complete Short Stories*, 254.
50. Ibid.

51. Ibid., 252.
52. Ibid., 257.
53. Lippit, *Electric Animal*, 151.
54. Kafka, *Complete Short* Stories, 257.
55. Ibid., 91.
56. Lippit, *Electric Animal*, 148.
57. Deleuze and Guattari, *Kafka*, 35.
58. Bayly, *Pathognomy of Performance*, 177–78.
59. Ibid., 153. Bayly quotes the term "humanesque" from Macdonald, "In Extremis."
60. Spitz, "Primal Cavity," 215.

Chapter 6

1. Idhe, *Listening and Voice*, 189.
2. *Intraterrestrial Soundings* was first shown in "Sonic Difference" at the Biennale of Electronic Arts Perth (BEAP) in 2004, curated by Tura New Music and Sound Culture and in association with the City of Freemantle. Quoted from Amy Youngs statement about the piece on her website, http://hypernatural.com/about.html, accessed April 7, 2015.
3. Ibid.
4. Deleuze and Guattari, *Thousand Plateaus*, 340.
5. Ibid.
6. Duncan, "Operatic Scandal," 300.
7. Ibid.
8. Bayly, *Pathognomy of Performance*, 159.
9. Refers to the bone, not the art theater group Osseous Labyrint.
10. Tuzin et al., "Miraculous Voices," 580.
11. Ibid.
12. Ibid., 581.
13. Ibid., 586.
14. Ihde, *Listening and Voice*, 45.
15. Järviö, "Life and World of a Singer," 68.
16. Ibid., 69.
17. Lawergren, "Origin of Musical Instruments and Sounds" 32.
18. Parker-Starbuck, "Becoming-Animate," 650.
19. Ibid., 651.
20. Ibid.

21. Ball, *Music Instinct*, 152.
22. Dolar, *Voice and Nothing More*, 12.
23. Ibid.
24. Ibid., 30–31.
25. Braidotti, *Metamorphoses*, 154.
26. Ibid.
27. Ibid.
28. Ibid., 157.
29. Ibid., 157.
30. View Zehnder's throat singing at https://www.youtube.com/watch?v=YVzbVvfDVLA, accessed April 12, 2015, and http://new-space-mountain.ch/en/workshops/voice-research, accessed April 12, 2015.
31. Harsent, *Minotaur*, 23.
32. Ibid.
33. Ibid.
34. Sampson, "Myth Kitty," 42.
35. Ibid., 42.
36. Parker-Starbuck, "Becoming-Animate," 652.
37. Ibid., 663.
38. Duncan, "Operatic Scandal," 298.
39. Ibid., 296.
40. Gordon, "Castrato Meets the Cyborg," 95.
41. Feldman, "Denaturing the Castrato," 192.
42. *The Remarkable Trial of the Queen of Quavers and Her Associates, for Sorcery, Witchcraft, and Enchantments at the Assizes Held in the Moon, for The County of Gelding before the Rt. Hon. Sir Francis Lash, Lord Chief Baron of the Lunar Exchequer* ([London:] Printed for J. Bew, [1777]), quotes from 5–7. Cited in Feldman, "Denaturing the Castrato," 183–84. In the *Trial*, the prosecutor for the Crown describes the offensive castrati in this catalogue of zoomorphic insults, worth noting here:

It is in consequence of this amazing depravity of taste that seven exotic animals *yclep'd* castrati were lately imported from the Continent, at such a most enormous expense.—Such

filthy lumps of mortality as the wilds of Africa never produced!—They have the look of a crocodile, the grin of an ape, the legs of a peacock, the paunch of a cow, the shape of an elephant, the brains of a goose, the throat of a pig, and the tail of a mouse: to crown the whole, if you sit but a few moments in their company, you will be sure of having your nostrils perfumed in a strange manner; for they have continually about them the odoriferous effluvia of onion and garlic. . . . Indeed it is not possible to conceive a more nauseous and odious creature that a Castrato.

43. Feldman, "Denaturing the Castrato," 183.
44. Ibid.
45. Deleuze and Guattari, *Thousand Plateaus*, 334.
46. My transcription from the video extract, https://www.youtube.com/watch?v=XvGuUM5sLYo, accessed

March 15, 2015. Royal Opera House production of Birthwhistle, *Minotaur*, scene 10: The Oracle at Psychro.
47. Deleuze and Guattari, *Thousand Plateaus*, 343: "There is always sonority in Ariadne's thread. Or the song of Orpheus."
48. Harsent, *Minotaur*, 39.
49. Ibid., 37.
50. Ibid., 65.
51. Ibid.
52. Ibid., 47.
53. Ibid.
54. Ibid., 46, italics added.
55. Deleuze, *Fold*, 3.
56. Ibid.
57. Bayly, *Pathognomy of Performance*, 147.
58. Duncan, "Operatic Scandal," 304.
59. Bayly, *Pathognomy of Performance*, 153.
60. Ibid., 159.
61. Järviö, "Life and World of a Singer," 69.
62. Duncan, "Operatic Scandal," 303.

Abbate, Carolyn. *In Search of Opera*. Princeton: Princeton University Press, 2002.
———. *Unsung Voices: Opera and Musical Narrative in the Nineteenth Century*. Princeton: Princeton University Press, 1991.

Abram, David. *The Spell of the Sensuous: Perception and Language in a More-Than-Human World*. New York: Pantheon Books, 1996.

Adams, David. "Joseph Beuys: Pioneer of a Radical Ecology." *Art Journal* 51, no. 2 (Summer 1992): 26–34.

Adams, Maureen B. "Emily Brontë and Dogs: Transformation Within the Human-Dog Bond." *Society and Animals* 8, no. 2 (2000): 167–81.

Agamben, Giorgio. *The Open: Man and Animal*. California: Stanford University Press, 2004.

Allestree, R. *The Government of the Tongue*. Christian Classic Ethereal Library. http://www.ccel.org/ccel/allestree /government.html. Originally published 1674.

Aloi, Giovanni. *Art and Animals*. London: I. B. Tauris, 2012.
———. "Different Becomings." *Art and Research* 4, no. 1 (2011): 1–10.
———. "Editorial." *Antennae: The Journal of Nature in Visual Culture*, no. 4 (2007): 2.
———. "In Conversation with Marcus Coates." *Antennae: The Journal of Nature in Visual Culture*, no. 4 (2007): 32–35.

Anderson, Patricia K. "A Bird in the House: An Anthropological Perspective on Companion Parrots." *Society and Animals* 11, no. 4 (2003): 393–418. https:// doi.org/10.1163/156853003322796109.

Argent, Gala. "Inked: Human-Horse Apprenticeship, Tattoos, and Time in the Pazyryk World." *Society and Animals* 21, no. 2 (2013): 178–93.

Aristotle. *Ethics*. Translated by J. A. K. Thomson. London: Penguin, 1958.

Armfelt, Nicholas. "Emotion in the Music of Messiaen." *Musical Times* 106, no. 1473 (November 1965): 856–58.

Armstrong Oma, K. "Between Trust and Domination: Social Contracts Between Humans and Animals." *World Archaeology* 42, no. 2 (June 2010): 175–87.

Arseneault, Jesse. "On Canicide and Concern: Species Sovereignty in Western Accounts of Rwanda's Genocide." *ESC: English Studies in Canada* 39, no. 1 (2013): 125–47.

Aubin, Thierry, and Pierre Jouventin. "Cocktail-Party Effect in King Penguin Colonies." *Proceedings of the Royal Academy B* 265, no. 1406 (1998). https:// doi.org/10.1098/rspb.1998.0486.

Auslander, Philip. "Evangelical Fervor." *TDR: The Drama Review* 39, no. 4 (Autumn 1995): 178–83.

Austin, J. L. *How to Do Things with Words*. Edited by J. O. Urmson and Marina Sbisa. 2nd ed. Cambridge: Harvard University Press, 1975.

Bachelard, Gaston, and Maria Jolas. *The Poetics of Space*. Translated by Maria Jolas. Boston: Beacon Press, 1994.

Baker, Steve. *Artist/Animal*. Posthumanities 25. Minneapolis: University of Minnesota Press, 2013.
———. *Picturing the Beast: Animals, Identity and Representation*. Manchester: Manchester University Press, 1993.
———. *The Postmodern Animal*. London: Reaktion, 2000.

———. "Sloughing the Human." *Performance Research* 5, no. 2 (Summer 2000): 70.

———. "Something's Gone Wrong Again" *Antennae: The Journal of Nature in Visual Culture* no. 7 (2008): 4.

Ball, Phillip. "Concerto for the Mother Tongue." *New Scientist* 187, no. 2507 (2005): 32.

———. *The Music Instinct: How Music Works and Why We Can't Do Without It.* London: Vintage Books, 2011.

Baptista, Luis Felipe, and Robin A. Keister. "Why Birdsong Is Sometimes Like Music." *Perspectives in Biology and Medicine* 48, no. 3 (2005): 426–43.

Barbara, Gabriel, and Ilcan Suzan, eds. *Postmodernism and the Ethical Subject*: Montreal: McGill-Queen's University Press, 2004.

Barbier, Patrick. *The World of the Castrati.* Translated by Margaret Crosland. London: Souvenir, 1996.

Barney, Matthew. *Drawing Restraint.* Vol. 2, *Exhibition Publication.* Tokyo: Uplink, 2005.

Barthes, Roland. *Image, Music, Text.* Edited by Stephen Heath. Fontana Communications Series. London: Fontana, 1977.

Baylis, William, and Ernest Starling. "The Mechanism of Pancreatic Secretion." *Journal of Physiology* 28, no. 5 (1902): 325–53. PMID 16992627.

Bayly, Simon. *A Pathognomy of Performance.* Basingstoke, UK: Palgrave Macmillan, 2011.

Beck, Benjamin B. "Chimpocentrism: Bias in Cognitive Ethology." *Journal of Human Evolution* 11, no. 1 (1982): 3–17.

Beecher, Michael D., John M. Burt, Adrian L. O'Loghlen, Christopher N. Templeton, and S. Elizabeth Campbell. "Bird Song Learning in an Eavesdropping Context." *Animal Behaviour* 73, no. 6 (2007): 929–35.

Bekoff, Marc. *Animal Passions and Beastly Virtues: Reflections on Redecorating Nature.* Philadelphia: Temple University Press, 2006.

Benítez-Bribiesca, Luis, Patricia M. Gray, Roger Payne, Bernie Krause, and Mark J. Tramo. "The Biology of Music." *Science* 292, no. 5526 (2001): 2432–33.

Benjamin, Walter. *The Origin of German Tragic Drama.* Translated by John Osborne. London: Verso, 2002.

Bergman, Charles. "Inventing a Beast with No Body: Radio-Telemetry, the Marginalization of Animals, and the Simulation of Ecology." *Worldviews: Global Religions, Culture, and Ecology* 9, no. 2 (2005): 255–70.

Beuys, Joseph. *Energy Plan for the Western Man: Joseph Beuys in America: Writings by and Interviews with the Artist.* Edited by Carin Kuoni. New York: Four Walls Eight Windows, 1990.

Bird-David, Nurit. "'Animism' Revisited: Personhood, Environment, and Relational Epistemology." In "Culture—A Second Chance?" Special issue, *Current Anthropology* 40, no. S1 (February 1999): S67–S91.

Birke, Lynda. "Supporting the Underdog: Feminism, Animal Rights and Citizenship in the Work of Alice Morgan Wright and Edith Goode." *Women's History Review* 9, no. 4 (2000): 693–719.

Blacking, John. *How Musical Is Man?* Seattle: University of Washington Press, 2000.

Blanchot, Maurice. *The One Who was Standing Apart from Me.* Barrytown, NY: Station Hill Press, 1993.

Block, Gary. "The Moral Reasoning of Believers in Animal Rights." *Society and Animals* 11, no. 2 (2003): 167–80. https://doi.org/10.1163/156853003769233360.

Bogue, Ronald. "Rhizomusicosmology." In "Deleuze and Guattari." Special issue, *Substance* 20, no. 3 (1991): 85–101.

Bonnie Gordon. "The Castrato Meets the Cyborg." *Opera Quarterly* 27, no. 1 (2011): 94–121.

Boyd, Brian. *On the Origin of Stories: Evolution, Cognition, and Fiction.* Cambridge: Belknap Press of Harvard University Press, 2009.

Braidotti, Rosi. "Animals, Anomalies, and Inorganic Others." *PMLA* 124, no. 2 (March 2009): 526–32.

———. *Metamorphoses: Towards a Materialist Theory of Becoming.* Cambridge: Polity Press, 2002.

———. *The Posthuman.* Cambridge: Polity Press, 2013.

Brandt, Keri. "A Language of Their Own: An Interactionist Approach to Human-Horse Communication." *Society and Animals* 12, no. 4 (2004): 299–316. https://doi.org/10.1163/1568530043068010.

Brantz, Dorothee. *Beastly Natures: Animals, Humans, and the Study of History.* Charlottesville: University of Virginia Press, 2010.

Brittain, Marcus, and Nick Overton. "The Significance of Others: A Prehistory of Rhythm and Interspecies Participation." *Society and Animals* 21, no. 2 (2013): 134–49. https://doi.org/10.1163/15685306-12341298.

Broglio, Ron. *Surface Encounters: Thinking with Animals and Art.* Posthumanities 17. Minneapolis: University of Minnesota Press, 2011.

Bronner, Simon J. *Killing Tradition: Inside Hunting and Animal Rights Controversies.* Lexington: University Press of Kentucky, 2008.

Brugnoli, Annalisa. "Eulogy of the Ape: Paradigms of Alterity and Identity in Eugene O'Neill's the Hairy Ape." *Eugene O'Neill Review* 33, no. 1 (2012): 43–55.

Brumm, Henrik, and Dietmar Todt. "Noise-Dependent Song Amplitude Regulation in a Territorial Songbird." *Animal Behaviour* 63, no. 5 (May 2002): 891–97.

Bubandt, Nils, and Rane Willerslev. "The Dark Side of Empathy: Mimesis, Deception, and the Magic of Alterity."

Comparative Studies in Society and History 57, no. 1 (2015): 5–34.

Buchanan, Brett. *Onto-Ethologies: The Animal Environments of Uexküll, Heidegger, Merleau-Ponty, and Deleuze.* SUNY Series in Environmental Philosophy and Ethics. Albany: State University of New York Press, 2008.

Buffon, Georges Louis Leclerc de, and Louis Jean Marie Daubenton. *Histoire Naturelle générale et particulière avec la Description du Cabinet du Roy.* Amsterdam: Schneider, 1766.

Bulgakov, Mikhail. *A Dog's Heart: An Appalling Story.* Edited by Andrew Bromfield. Penguin Classics. London: Penguin, 2007. Originally published 1968 (written 1925).

Burgin, Diana L. "Bulgakov's Early Tragedy of the Scientist-Creator: An Interpretation of the Heart of a Dog." *Slavic and East European Journal* 22, no. 4 (Winter 1978): 494–508.

Burke, Edmund, and Adam Phillips. *A Philosophical Enquiry into the Origin of Our Ideas of the Sublime and Beautiful.* Oxford: Oxford University Press, 1998.

Burling, Robin. Review of *The Simian Tongue: The Long Debate About Animal Language,* by Gregory Radick. *Language* 86, no. 1 (2010): 244–47.

Butler, Judith. *Gender Trouble: Feminism and the Subversion of Identity.* New York: Routledge, 1990.

Caillois, Roger, and John Shepley. "Mimicry and Legendary Psychasthenia." *October* 31 (Winter 1984): 16–32.

Calarco, Matthew. *Zoographies: The Question of the Animal from Heidegger to Derrida.* New York: Columbia University Press, 2008.

Carlson, Marla. "Furry Cartography: Performing Species." *Theatre Journal* 63, no. 2 (2011): 191–208.

Carlson, Marvin A. "'I Am Not an Animal': Jan Fabre's Parrots and Guinea Pigs." *TDR: The Drama Review* 51, no. 1 (2007): 166–69.

Carrithers, Michael, Louise J. Bracken, and Steven Emery. "Can a Species Be a Person? A Trope and Its Entanglements in the Anthropocene Era." *Current Anthropology* 52, no. 5 (October 2011): 661–85.

Carter, Paul. *Parrot*. London: Reaktion, 2006.

Castellanos, Carlos, and Diane Gromala. "The Symbiogenic Experience: Towards a Framework for Understanding Human-Machine Coupling in the Interactive Arts." *Technoetic Arts: A Journal of Speculative Research* 8, no. 1 (2010): 11–18. https://doi.org/10.1386/tear.8.1.11/1.

Castellucci, Romeo, Carolina Melis, Valentina Valentini, and Ric Allsopp. "The Animal Being on Stage." *Performance Research* 5, no. 2 (Summer 2000): 23–28.

Catchpole, Clive, and Peter Slater. *Bird Song: Biological Themes and Variations*. 2nd ed. Cambridge: Cambridge University Press, 2008.

Cattivelli, Daniela, "UIT, sound performance." http://www.danielacattivelli.it/uit. Accessed November 13, 2014.

Cavarero, Adriana. *For More Than One Voice: Toward a Philosophy of Vocal Expression*. Translated by Paul A. Kottman. Stanford: Stanford University Press, 2005.

Cermatori, Joseph. "Notes on Opera's Exquisite Corpse." *PAJ: A Journal of Performance and Art* 35, no. 1 (2013): 4–18.

Charlesworth, J. J. "Art Is Good for You. Art Is Good for You." In Marcus Coates, *Journey to the Lower World: A Shamanic Performance by Marcus Coates After a Traditional Siberian Yakut Ritual for the Residents of Sheil Park, Liverpool, in January 2003*, edited by Alec Finlay, n.p. Bookscapes. Newcastle-upon-Tyne: Platform Projects / Morning Star, 2005.

Chaudhuri, Una. "Animal Geographies: Zooësis and the Space of Modern Drama." In *Performing Nature: Explorations in Ecology and the Arts*, edited by Gabriella Giannachi and Nigel Stewart, 103–19. Oxford: Peter Lang, 2005.

———. "(De)facing the Animals: Zooësis and Performance." *TDR: The Drama Review* 51, no. 1 (2007): 8–20.

———. "'Of All Nonsensical Things': Performance and Animal Life." *PMLA* 124, no. 2 (March 2009): 520–25.

Chauvet, Jean-Marie, Eliette Brunel Deschamps, and Christian Hillaire, eds. *Chauvet Cave: The Discovery of the World's Oldest Paintings*. London: Thames & Hudson, 1996.

Cixous, Hélène, Keith Cohen, and Paula Cohen. "The Laugh of the Medusa." *Signs* 1, no. 4 (Summer 1976): 875–93.

Clark, Xenos. "Animal Music, Its Nature and Origin." *American Naturalist* 13, no. 4 (April 1879): 209–23.

Coates, Marcus. *Journey to the Lower World: A Shamanic Performance by Marcus Coates After a Traditional Siberian Yakut Ritual for the Residents of Sheil Park, Liverpool, in January 2003*. Edited by Alec Finlay. Bookscapes. Newcastle-upon-Tyne: Platform Projects / Morning Star, 2005.

Colebrook, Claire. *Gilles Deleuze*. Routledge Critical Thinkers. London: Routledge, 2002.

Connor, Steven. *Dumbstruck: A Cultural History of Ventriloquism*. Oxford: Oxford University Press, 2000.

———. "Violence, Ventriloquism and the Vocalic Body." In *Performance and Psychoanalysis*, edited by Patrick Campbell and Adrian Kear, 75–93. London: Routledge, 2001.

Conroy, Colette. *Theatre and the Body*. Theatre&. New York: Palgrave Macmillan, 2010.

Corbey, Raymond. *The Metaphysics of Apes: Negotiating the Animal-Human Boundary*. Cambridge: Cambridge University Press, 2005.

Cull, Laura. "Affect in Deleuze, Hijikata, and Coates: The Politics of Becoming-Animal in Performance." *Journal of Dramatic Theory and Criticism* 1, no. 2 (2012): 189–203.

———. "Philosophy as Drama: Deleuze and Dramatization in the Context of Performance Philosophy." *Modern Drama* 56, no. 4 (2013): 498–520.

———. "Schizo-Theatre: Guattari, Deleuze, Performance and 'Madness.'" Paper presented at "Situating and Interpreting States of Mind" conference, Northumbria University, Newcastle upon Tyne, 2012.

Damasio, Antonio R. *Descartes' Error: Emotion, Reason, and the Human Brain.* New York: Putnam, 1994.

Danta, Chris. "Kafka's Mousetrap: The Fable of the Dying Voice." *Substance* 37, no. 3, issue 117: The Political Animal (2008): 152–68.

———. "Like a Dog . . . Like a Lamb": Becoming Sacrificial Animal in Kafka and Coetzee." *New Literary History* 38, no. 4 (2007): 721–37.

———. "The Metaphysical Cut: Darwin and Stevenson on Vivisection." *Victorian Review* 36, no. 2 (2010): 51–65.

———. "'Might Sovereignty Be Devouring?': Derrida and the Fable." *Substance* 43, no. 2 (2014): 37–49.

Danta, Chris, and Dimitris Vardoulakis. "The Political Animal." *Substance* 37, no. 3 (2008): 3–6.

Darwin, Charles. *The Expression of the Emotions in Man and Animals.* 3rd ed. London: Harper Collins, 1998.

———. *The Origin of Species.* Harmondsworth, UK: Penguin, 1977.

Dauvois, Michel. "Sonorous and Musical Instruments in Prehistory." In *Music in Prehistory.* Nemours: Musée de Préhistoire d'Île-de-France, 2002.

Davidov, Veronica M. "Shamans and Shams: The Discursive Effects of Ethnotourism in Ecuador." *Journal of Latin American and Caribbean Anthropology* 15, no. 2

(2010): 387–410. https://doi.org/10.1111/j.1935-4940.2010.01091.x.

Dawkins, Marian Stamp. "Through Animal Eyes: What Behaviour Tells Us." *Applied Animal Behaviour Science* 100, no. 1 (2006): 4–10. https://doi.org/10.1016/j.applanim.2006.04.010.

Deacon, Terrence W. *The Symbolic Species: The Coevolution of Language and the Brain.* New York: W. W. Norton, 1997.

Deleuze, Gilles. *Difference and Repetition.* London: Continuum, 2004.

———. *Essays Critical and Clinical.* Translated by Daniel W. Smith and Michael A. Greco. Minneapolis: University of Minnesota Press, 1997.

———. *The Fold.* Translated by Tom Conley. London: Continuum, 2006.

Deleuze, Gilles, and Felix Guattari. *Anti-Oedipus: Capitalism and Schizophrenia.* London: Continuum, 2000.

———. *Kafka: Toward a Minor Literature.* Minneapolis: University of Minnesota Press, 1986.

———. *A Thousand Plateaus: Capitalism and Schizophrenia.* London: Continuum, 2004.

———. *What Is Philosophy?* London: Verso, 1994.

Delgado, Maria M., and Caridad Svich, eds. *Theatre in Crisis? Performance Manifestos for a New Century.* Edited by Maria M. Delgado and Caridad Svich. Manchester: Manchester University Press, 2002.

Derrida, Jacques. *The Animal That Therefore I Am.* Edited by Marie-Louise Mallet. Perspectives in Continental Philosophy. New York: Fordham University Press, 2008.

———. *The Beast and the Sovereign.* Translated by Geoffrey Bennington. Vol. 1. Seminars of Jacques Derrida. Chicago: University of Chicago Press, 2009.

———. *Of Grammatology.* Baltimore: Johns Hopkins University Press, 1976.

Derrida, Jacques, and Alan Bass. *Writing and Difference*. London: Routledge, 2001.

Descartes, René. *Discourse on Method, and Other Writings*. Translated with an introduction by F. E. Sutcliffe. Penguin Classics. Harmondsworth, UK: Penguin, 1968.

Dillard-Wright, David B. "Bodies, Brains, and Minds: Against a Hierarchy of Animal Faculties." In *Experiencing Animal Minds: An Anthology of Animal-Human Encounters*, edited by Robert Mitchell and Julie Smith, 201–19. New York: Columbia University Press, 2012.

———. "Thinking Across Species Boundaries: General Sociality and Embodied Meaning." *Society and Animals* 17, no. 1 (2009): 53–71.

Dinstein, Ilan, Cibu Thomas, Marlene Behrmann, and David J. Heeger. "A Mirror Up to Nature." *Current Biology* 18, no. 1 (2008): R13–R18. https://doi.org/10.1016/j.cub.2007.11.004.

Dobson, Michael. "A Dog at All Things." *Performance Research* 5, no. 2 (Summer 2000): 116–24.

Dolar, Mladen. *A Voice and Nothing More*. Cambridge: MIT Press, 2006.

Donnellan, Declan. *The Actor and the Target*. London: Nick Hern Books, 2002.

Doupe, Allison J., and Patricia K. Kuhl. "Birdsong and Human Speech: Common Themes and Mechanisms." *Annual Review of Neuroscience* 22, no. 1 (1999): 567.

Dunayer, Joan. *Animal Equality: Language and Liberation*. Derwood, MD: Ryce, 2001.

Duncan, Michelle. "The Operatic Scandal of the Singing Body: Voice, Presence, Performativity." *Cambridge Opera Journal* 16, no. 3 (2004): 283–306.

Dundes, Alan. "A Psychoanalytic Study of the Bullroarer." *Man* 11, no. 2 (June 1976): 220–38.

Dunn, David D., and James P. Crutchfield. "Entomogenic Climate Change: Insect Bioacoustics and Future Forest Ecology." *Leonardo* 42, no. 3 (2009): 239–44.

Dyson, Frances. *Sounding New Media*. University of California Press, 2009.

Eliade, Mircea. *Shamanism: Archaic Techniques of Ecstasy*. Translated by Willard R. Trask. London: Arkana, 1989.

Esse, Melina. "Don't Look Now: Opera, Liveness, and the Televisual." *Opera Quarterly* 26, no. 1 (2010): 81–95.

———. "Performing Sentiment; or, How to Do Things with Tears." *Women and Music: A Journal of Gender and Culture* 14, no. 1 (2010): 1–21.

Etchells, Tim. "On the Skids: Some Years of Acting Animals." *Performance Research* 5, no. 2 (Summer 2000): 55.

Evans, Fred, and Leonard Lawlor. *Chiasms: Merleau-Ponty's Notion of Flesh*. SUNY Series in Contemporary Continental Philosophy. Albany: State University of New York Press, 2000.

Fallon, Robert. "The Record of Realism in Messiaen's Bird Styles." In *Olivier Messiaen: Music, Art and Literature*, edited by Christopher Dingle and Nigel Simone, 115–36. Aldershot, UK: Ashgate, 2007.

Farquharson, Alex, and Kaelen Wilson-Goldie. "Get Together." *Frieze*, no. 149 (September 2012).

Feldman, Martha. "Denaturing the Castrato." *Opera Quarterly* 24, nos. 3–4 (2008): 178–99.

Felman, Shoshana. "Benjamin's Silence." In "'Angelus Novus': Perspectives on Walter Benjamin." Special issue, *Critical Inquiry* 25, no. 2 (Winter 1999): 201–34.

———. *The Scandal of the Speaking Body: Don Juan with J. L. Austin, Or Seduction in Two Languages*. Meridian, Crossing Aesthetics. Translated by Catherine Porter. Stanford: Stanford University Press, 2003.

Fenwick, Eliza. *The Life of the Famouse Dog Carlo*. 1804. Centre for Textual Studies,

DeMontfort University's Hockliffe Project. http://hockliffe.dmu.ac.uk /items/0162.html. Accessed April 28, 2013.

Féral, Josette, and Ronald P. Bermingham. "Alienation Theory in Multi-Media Performance." In "Distancing Brecht." Special issue, *Theatre Journal* 39, no. 4 (December 1987): 461–72.

———. "Theatricality: The Specificity of Theatrical Language." In "Theatricality." Special issue, *Substance* 31, nos. 2–3 (2002): 94–108.

Féral, Josette, and Carol Tennessen. "What Is Left of Performance Art? Autopsy of a Function, Birth of a Genre." In "Performance Issue(s): Happening, Body, Spectacle, Virtual Reality." Special issue, *Discourse* 14, no. 2 (Spring 1992): 142–62.

Fischer-Lichte, Erika. *Dionysus Resurrected: Performances of Euripides' The Bacchae in a Globalizing World*. Chichester, UK: Wiley Blackwell, 2014.

———. *The Transformative Power of Performance: A New Aesthetics*. Abingdon, UK: Routledge, 2008.

Flaherty, Gloria. "The Performing Artist as the Shaman of Higher Civilization." *MLN* 103, no. 3 (April 1988): 519–39.

Flaubert, Gustave. *Early Writings*. Translated by Robert Griffin. Lincoln: University of Nebraska Press, 1991.

Forrest, Earle R. *The Snake Dance . . . of the Hopi Indians . . . Hopi Drawings by Don Louis Perceval*. Great West and Indian Series 21. New York: Tower Books, 1961.

Foucault, Michel. *Abnormal: Lectures at the Collège de France, 1974–1975*. Edited by Valerio Marchetti, Antonella Salomoni, and Arnold I. Davidson. Translated by Graham Burchell. 1st Picador USA ed. New York: Picador, 2003.

Fraleigh, Sondra Horton. *Butoh: Metamorphic Dance and Global Alchemy*. Urbana: University of Illinois Press, 2010.

Freccero, Carla. "Carnivorous Virility; or, Becoming-Dog." In "Interspecies." Special issue, *Social Text* 29.1, no. 106 (Spring 2011): 177–95.

Freeman, Carrie Packwood, Marc Bekoff, and Sarah M. Bexell. "Giving Voice to the 'Voiceless.'" *Journalism Studies* 12, no. 5 (2011): 590–607. https://doi.org/10 .1080/1461670X.2010.540136.

Freeman, Robin. "Courtesy Towards the Things of Nature: Interpretations of Messiaen's 'Catalogue d'Oiseaux.'" *Tempo* 192 (April 1995): 9–14.

Freud, Sigmund, and Sander L. Gilman. *Psychological Writings and Letters*. The German Library 59. New York: Continuum, 1995.

Fudge, Erica. "Animal Lives." *History Today* 54, no. 10 (2004): 21–27.

———. "Attempting Animal Histories." *Society and Animals* 19, no. 4 (2011): 425–31. https://doi.org/10.1163 /156853011X590060.

———. "At the Heart of Home: An Animal Reading of Mikhail Bulgakov's *The Heart of a Dog*." *Humanimalia: A Journal of Human/Animal Interface Studies* 1, no. 1 (2009).

———. "Beastly Natures: Animals, Humans, and the Study of History." *American Historical Review* 116, no. 4 (2011): 1074–75.

———. "The Dog Is Himself: Humans, Animals and Self Control in *The Two Gentlemen of Verona*." In *How to Do Things with Shakespeare*, edited by Laurie Maguire, 185–209. Oxford: Blackwell, 2007.

———. "How a Man Differs from a Dog." *History Today* 53, no. 6 (2003): 38.

———. "Introduction: Viewing Animals." *Worldviews: Global Religions, Culture, and Ecology* 9, no. 2 (2005): 155–65. https://doi.org/10.1163 /1568535054615330.

———. "Milking Other Men's Beasts." *History and Theory* 52, no. 4 (2013): 13–28. https://doi.org/10.1111/hith.10682.

———. "Monstrous Acts." *History Today* 50, no. 8 (2000): 20.

Fuller, Matthew. "Art for Animals." *Journal of Visual Art Practice* 9, no. 1 (2010): 17–33.

Gablik, Suzi. *Has Modernism Failed?* New York: Thames and Hudson, 1984.

———. *The Reenchantment of Art*. New York: Thames and Hudson, 1991.

Garcia, Christina. "The Ethics of Botched Taxidermy." *Antennae: The Journal of Nature in Visual Culture*, no. 7 (2008): 28–40.

Gaston, Sean. "(Not) Meeting without Name." *Symploke* 16, no. 1 (2008): 107–25.

Gilbert, Scott F., Jan Sapp, and Alfred I. Tauber. "A Symbiotic View of Life: We have Never been Individuals." *Quarterly Review of Biology* 87, no. 4 (December 2012): 325–41.

Goatly, Andrew. "Humans, Animals, and Metaphors." *Society and Animals* 14, no. 1 (2006): 15–37. https://doi.org/10.1163/156853006776137131.

Goddard, Michael, Benjamin Halligan, and Paul Hegarty. *Reverberations: The Philosophy, Aesthetics and Politics of Noise*. London: Continuum, 2012.

Goehr, Lydia. *The Quest for Voice: On Music, Politics and the Limits of Philosophy*. The Ernest Bloch Letures. Oxford: Clarendon Press, 1998.

Goldschmidt, Richard B. "Evolution, as Viewed by One Geneticist." *American Scientist* 40, no. 1 (January 1952): 84–98, 135.

Goodall, Jane. *The Chimpanzees of Gombe: Patterns of Behavior*. Cambridge: Belknap Press of Harvard University Press, 1986.

———. *Performance and Evolution in the Age of Darwin: Out of the Natural Order*. London: Routledge, 2002.

Gosling, Samuel D., and Oliver P. John. "Personality Dimensions in Nonhuman Animals: A Cross-Species Review."

Current Directions in Psychological Science 8, no. 3 (June 1999): 69–75.

Gourmont, Remy de. *The Natural Philosophy of Love*. Edited by Ezra Pound. London: Quartet Encounters, 1992.

Grandin, Temple. *Animals in Translation: Using the Mysteries of Autism to Decode Animal Behaviour*. Edited by Catherine Johnson. London: Bloomsbury, 2005.

Graves, Robert. *The Greek Myths*. Vol. 1. Harmondsworth, Middlesex: Penguin, 1978.

———. *The Greek Myths*. Vol. 2. London: Penguin, 1990.

Gray, Patricia M., Bernie Krause, Jelle Atema, Roger Payne, Carol Krumhansl, and Luis Baptista. "The Music of Nature and the Nature of Music." *Science* 291, no. 5501 (January 5, 2001): 52–54.

Greco, Emio, and Pieter C. Scholten. "Seven Thoughts on Orfeo Ed Euridice." *Opera Quarterly* 22, no. 1 (2006): 147–54.

Gross, Aaron, and Anne Vallely, eds. *Animals and the Human Imagination: A Companion to Animal Studies*. New York: Columbia University Press, 2012.

Groys, Boris. *Art Power*. Cambridge: MIT Press, 2008.

Gruter, Margaret, and Roger D. Masters. "Ostracism as a Social and Biological Phenomenon: An Introduction." *Ethology and Sociobiology* 7, no. 3–4 (1986): 149–58.

Guminski, Witold. "BIRD FOR DINNER: Stone Age Hunters of Dudka and Szczepanki, Masurian Lakeland, NE-Poland." *Acta Archaeologica* 76, no. 2 (2005): 111–47.

Gurewitsch, Matthew. "An Audubon in Sound." *Atlantic Monthly* 279, no. 3 (1997).

Hadas, Moses, ed. *The Complete Plays of Aristophanes*. New York: Bantam, 2006.

Haraway, Donna J. *The Companion Species Manifesto: Dogs, People, and Significant Otherness*. Paradigm 8. Chicago: Prickly Paradigm Press, 2003.

———. *Crystals, Fabrics, and Fields.* Berkeley: North Atlantic Books, 2004.

———. *The Haraway Reader.* New York: Routledge, 2003.

———. *Modest_Witness@Second _Millennium.FemaleMan_Meets _OncoMouse (TM): Feminism and Technoscience.* New York: Routledge, 1997.

———. *Primate Visions: Gender, Race and Nature in the World of Modern Science.* London: Verso, 1992.

———. *Simians, Cyborgs and Women: The Reinvention of Nature.* London: Free Association Books, 1991.

———. *When Species Meet.* Posthumanities 3. Minneapolis: University of Minnesota Press, 2008.

Harley, Maria Anna. "Birds in Concert: North American Birdsong in Bartók's Piano Concerto no. 3." *Tempo* no. 189 (June 1994): 8–16.

———. "'Natura Naturans, Natura Naturata' and Bartók's Nature Music Idiom." *Studia Musicologica Academiae Scientiarum Hungaricae* 36, no. 3/4 (1995): 329–50.

Harman, Graham. *The Quadruple Object.* Winchester, UK: Zero Books, 2011.

Harrison, Jan. "Singing in Animal Tongues: An Inner Journey." *PAJ: A Journal of Performance and Art* 33, no. 1 (2011): 28–38.

Harrison, Jane Ellen. *Prolegomena to the Study of Greek Religion.* 2nd ed. Cambridge: Cambridge University Press, 1908.

Harsent, David. *The Minotaur* (libretto). London: Boosey & Hawkes, 2008.

Harwood, Dane L. "Universals in Music: A Perspective from Cognitive Psychology." *Ethnomusicology* 20, no. 3 (September 1976): 521–33.

Heaney, Seamus. *Death of a Naturalist.* London: Faber and Faber, 1969.

———. *District and Circle.* London: Faber and Faber, 2006.

———. *Electric Light.* London: Faber and Faber, 2001.

———. *The Government of the Tongue: The 1986 T. S. Eliot Memorial Lectures and Other Critical Writings.* London: Faber and Faber, 1988.

———. *The Redress of Poetry: Oxford Lectures.* London: Faber and Faber, 1995.

Heidegger, Martin. *Being and Time.* Translated by John Macquarrie and Edward Robinson. San Francisco: HarperCollins, 1962.

———. *The Fundamental Concepts of Metaphysics: World, Finitude, Solitude.* Bloomington: Indiana University Press, 1995.

Helfgot, Daniel. *The Third Line: The Opera Performer as Interpreter.* Edited by W. Beeman. New York: Schirmer Books; Toronto: Maxwell Macmillan Canada; New York: Maxwell Macmillan International, 1993.

Heyes, Cecilia. "Where Do Mirror Neurons Come from?" *Neuroscience and Biobehavioral Reviews* 34, no. 4 (2010): 575–83.

Hickock, Gregory. *Myth of Mirror Neurons: The Real Neuroscience of Communication and Cognition.* London: W. W. Norton, 2014.

Higgins, Reynold. *Minoan and Mycenaen Art.* London: Thames and Hudson, 1981.

Hill, Peter. "For the Birds." *Musical Times* 135, no. 1819 (September 1994): 552–55.

Hold, Trevor. "Messiaen's Birds." *Review in Music and Letters* 52, no. 2 (1971): 113–22.

Hollan, Douglas. "Being There: On the Imaginative Aspects of Understanding Others and Being Understood." *Ethos* 36, no. 4 (2008): 475–89. https://doi.org /10.1111/j.1548-1352.2008.00028.x.

———. "Emerging Issues in the Cross-Cultural Study of Empathy." *Emotion Review* 4, no. 1 (January 2012): 70–78. https://doi.org/10.1177 /1754073911421376.

Hollan, Douglas, and C. Jason Throop. "Whatever Happened to Empathy?

Introduction." *Ethos* 36, no. 4 (2008): 385–401. https://doi.org/10.1111/j.1548 -1352.2008.00023.x.

Hollier, Denis, and William Rodarmor. "Mimesis and Castration 1937." *October* 31 (Winter 1984): 3–15.

Holton, Gerald. "Sociobiology: The New Synthesis?" *Newsletter on Science, Technology, and Human Values*, no. 21 (October 1977): 28–43.

Hopkins, William D., Jared P. Taglialatela, and David A. Leavens. "Chimpanzees Differentially Produce Novel Vocalizations to Capture the Attention of a Human." *Animal Behaviour* 73, no. 2 (2007): 281–86.

Howell, Yvonne. "Eugenics, Rejuvenation, and Bulgakov's Journey into the Heart of Dogness." *Slavic Review* 65, no. 3 (Autumn 2006): 544–62.

Iamblichus. *The Life of Pythagoras, Abridged.* Translated by Thomas Taylor. Los Angeles: Theosophical Publishing, 1905.

Ihde, Don. *Listening and Voice: Phenomenologies of Sound.* 2nd ed. Albany: State University of New York Press, 2007.

Ingold, Tim. "From the Master's Point of View: Hunting is Sacrifice." *Journal of the Royal Anthropological Institute* 21, no. 1 (2015): 24–27.

———. "Hunting and Gathering as Ways of Perceiving the Environment." In *Animals and the Human Imagination*, edited by Aaron Gross and Anne Valley, 31–54. New York: Columbia University Press, 2012.

Irvine, William. *Apes, Angels and Victorians: A Joint Biography of Darwin and Huxley.* Readers Union ed. London: Weidenfeld & Nicolson, 1956.

Ivashkin, Alexander. "The Paradox of Russian Non-Liberty." *Musical Quarterly* 76, no. 4 (Winter 1992): 543–56.

Jakobsen, Merete Demant. *Shamanism: Traditional and Contemporary Approaches to the Mastery of Spirits and Healing.* New York: Berghahn Books, 1999.

Janusch, John Buettner. *Evolutionary and Genetic Biology of Primates.* Vol. 2. New York: Academic Press, 1963.

Järviö, Päivi. "The Life and World of a Singer: Finding My Way." *Philosophy of Music Education Review* 14, no. 1 (2006): 65–77.

Jiménez, Alberto Corsín, and Rane Willerslev. "'An Anthropological Concept of the Concept': Reversibility Among the Siberian Yukaghirs." *Journal of the Royal Anthropological Institute* 13, no. 3 (September 2007): 527–44.

Johnson, Mark. *The Meaning of the Body: Aesthetics of Human Understanding.* Chicago: University of Chicago Press, 2007.

Johnson, Robert Sherlaw. *Messiaen.* 2nd paperback ed. Updated and additional text by Caroline Rae. London: Omnibus Press, 2008.

Johnson, Terry. *Cries from the Mammal House.* London: Methuen, 1984.

Jolly, Alison. *Evolution of Primate Behavior.* London: Macmillan, 1972.

Joralemon, Donald. "The Selling of the Shaman and the Problem of Informant Legitimacy." *Journal of Anthropological Research* 46, no. 2 (Summer 1990): 105–18.

Kafka, Franz. *The Complete Short Stories.* Edited by Nahum N. Glatzer. London: Vintage, 2005.

Karnicky, Jeffrey. "What Is the Red Knot Worth? Valuing Human/Avian Interaction." *Society and Animals* 12, no. 3 (2004): 253–66.

Karpf, Anne. *The Human Voice: How this Extraordinary Instrument Reveals Essential Clues About Who we are.* 1st US ed. New York: Bloomsbury, 2006.

Kean, Hilda. *Animal Rights: Political and Social Change in Britain Since 1800.* London: Reaktion, 1998.

Kear, Adrian, and Joe Kelleher. "The Wolf-Man." *Performance Research* 5, no. 2 (Summer 2000): 82.

Keats, John. "Ode to a Nightingale." In *Romantic Poetry and Prose: The Oxford Anthology of English Literature*, edited by Harold Bloom and Lionel Trilling, 541–45. Oxford: Oxford University Press, 1973.

Kelleher, Joe. "How to Act, how to Spectate (Laughing Matter)." *Performance Research* 13, no. 4 (2008): 56–63. https:// doi.org/10.1080/13528160902875630.

———. Review of *Theatre, Intimacy, and Engagement: The Last Human Venue*, by Alan Read. *TDR: The Drama Review* 54, no. 2 (2010): 181–83.

———. *Theatre and Politics*. Basingstoke, UK: Palgrave Macmillan, 2009.

Kelleher, Joe, and Nick Ridout. *Contemporary Theatres in Europe: A Critical Companion*. London: Routledge, 2006.

Kemmerer, Lisa A. "Verbal Activism: 'Anymal.'" *Society and Animals* 14, no. 1 (2006): 9–14. https://doi.org/10.1163 /156853006776137186.

Kennedy, A. L. *On Bullfighting*. London: Yellow Jersey, 1999.

Kivy, Peter. *Osmin's Rage: Philosophical Reflections on Opera, Drama, and Text*. Princeton: Princeton University Press, 1988.

Knight, John. "The Anonymity of the Hunt: A Critique of Hunting as Sharing." *Current Anthropology* 53, no. 3 (June 2012): 334–55.

Koestenbaum, Wayne. *The Queen's Throat: Opera, Homosexuality, and the Mystery of Desire*. London: Penguin, 1994.

Komarova, Natalia L., and Simon A. Levin. "Eavesdropping and Language Dynamics." *Journal of Theoretical Biology* 264, no. 1 (2010): 104–18.

Kramer, Lawrence. *Opera and Modern Culture: Wagner and Strauss*. Berkeley: University of California Press, 2004.

Krause, Bernard L. *The Great Animal Orchestra: Finding the Origins of Music in the World's Wild Places*. London: Profile Books, 2012.

Krauss, Rosalind. "A Note on Photography and the Simulacral." *October* 31 (Winter 1984): 49–68.

Krippner, Stanley C. "Conflicting Perspectives on Shamans and Shamanism: Points and Counterpoints." *American Psychologist* (November 2002): 962–77.

———. "The Epistemology and Technologies of Shamanic States of Consciousness." *Journal of Consciousness Studies* 7, nos. 11–12 (2000): 93–118.

Kristeva, Julia. *Powers of Horror: An Essay on Abjection*. European Perspectives. New York: Columbia University Press, 1982.

Kunej, Brago, and Ivan Turk. "New Perspectives on the Beginnings of Music: Archeological and Musical Analysis of a Middle Paleolithic Bone 'Flute.'" In *The Origins of Music*, edited by Nils L. Wallin, Bjorn Merker, and Steven Brown. Cambridge: MIT Press, 2000.

Lakoff, George, and Mark Johnson. *Philosophy in the Flesh: The Embodied Mind and its Challenge to Western Thought*. New York: Basic Books, 1999.

Laland, Kevin N., and Bennett G. Galef, eds. *The Question of Animal Culture*. Cambridge: Harvard University Press, 2009.

Lancaster, Jane B. "Primate Social Behavior and Ostracism." *Ethology and Sociobiology* 7, no. 3–4 (1986): 215–25.

Lane, Harlan. *The Wild Boy of Aveyron*. Cambridge: Harvard University Press, 1976.

Larsen, R. R. "On Comparing Man and Ape: An Evaluation of Methods and Problems." *Man* 11, no. 2 (June 1976): 202–19.

Latour, Bruno. *Reassembling the Social: An Introduction to Actor-Network-Theory*. Clarendon Lectures in Management Studies. Oxford: Oxford University Press, 2005.

———. *We Have Never Been Modern*. New York: Harvester Wheatsheaf, 1993.

Lawergren, Bo. "The Origin of Musical Instruments and Sounds." *Anthropos* 83, nos. 1/3 (1988): 31–45.

Lawlor, Leonard. "'Animals Have No Hands': An Essay on Animality in Derrida." *CR: The New Centennial Review* 7, no. 2 (2007): 43–69.

———. "Auto-Affection and Becoming (Part II)." *Environmental Philosophy* 6, no. 1 (2009): 1–19.

———. "Following the Rats: Becoming-Animal in Deleuze and Guattari." *Substance* 37, no. 3 (2008): 169–87.

Levinas, Emmanuel. *The Levinas Reader.* Edited by Sean Hand. Oxford: Basil Blackwell, 1989.

Levi-Strauss, Claude. *Structural Anthropology.* Vol. 1. Translated by Claire Jacobson and Brooke Grundfest Schoepf. New York: Doubleday Anchor Books, 1963.

Levy, Jerrold E. *In the Beginning: The Navajo Genesis.* Berkeley: University of California Press, 1998.

Lewis-Williams, David. *The Mind in the Cave.* London: Thames & Hudson, 2002.

Lingis, Alphonso. *The Community of Those Who Have Nothing in Common.* Bloomington: Indiana University Press, 1994.

———. "Quadrille." *Performance Research* 5, no. 2 (Summer 2000): 1.

Lippit, Akira Mizuta. "The Death of an Animal." *Film Quarterly* 56, no. 1 (Fall 2002): 9–22.

———. *Electric Animal: Toward a Rhetoric of Wildlife.* Minneapolis: University of Minnesota Press, 2000.

Little, Pippa. "Becoming." *Irish Arts Review* 29, no. 4 (Winter 2012): 72–73.

Lorenz, Konrad. *The Natural Science of the Human Species: An Introduction to Comparative Behavioral Research; The "Russian Manuscript" (1944–1948).* Edited by Agnes von Cranach. Cambridge: MIT Press, 1996.

Loxley, James. *Performativity.* The New Critical Idiom. Abingdon, UK: Routledge, 2006.

Luckert, Karl W. *Coyoteway: A Navajo Holyway Healing Ceremonial.* Tucson: University of Arizona Press, 1979.

Lurz, Robert W. *The Philosophy of Animal Minds.* Cambridge: Cambridge University Press, 2009.

Lynch, Michael E. "Sacrifice and the Transformation of the Animal Body into a Scientific Object: Laboratory Culture and Ritual Practice in the Neurosciences." *Social Studies of Science* 18, no. 2 (May 1988): 265–89.

Macdonald, Amanda. "In Extremis: Hergé's Graphic Exteriority of Character." *Other Voices* 1, no. 2 (1998). http://www.othervoices.org/1.2/amacdonald/herge.php.

Magnum, Teresa. "Dog Years, Human Fears." In *Representing Animals: Theories of Contemporary Culture,* edited by Rigel Rothfels, 35–47. Bloomington: University of Indiana Press, 2002.

Mahon, Derek. *New Collected Poems.* Loughcrew, Ireland: The Gallery Press, 2011.

Mahoney, Anne. "Key Terms in 'Birds.'" *Classical World* 100, no. 3 (Spring 2007): 267–78.

Mansfield, Orlando A. "The Cuckoo and Nightingale in Music." *Musical Quarterly* 7, no. 2 (April 1921): 261–77.

Margulis, Lynn. "Kingdom Animalia: The Zoological Malaise from a Microbial Perspective." *American Zoologist* 30, no. 4 (1990): 861–75.

———. *Symbiotic Planet: A New Look at Evolution.* Science Masters Series. New York: Basic Books, 1998.

Markx, Francien. *E.T.A.Hoffman, Cosmopolitanism, and the Struggle for German Opera.* Leiden: Brill, 2016.

Marquis, Alice Goldfarb. "Written on the Wind: The Impact of Radio During the 1930s." *Journal of Contemporary History* 19, no. 3 (July 1984): 385–415.

Martinelli, Dario. *Of Birds, Whales, and Other Musicians: An Introduction to Zoomusicology*. Approaches to Postmodernity 3. Scranton: University of Scranton Press, 2009.

Marvin, Garry. "Natural Instincts and Cultural Passions: Transformations and Performances in Foxhunting." *Performance Research* 5 (2000): 108–15.

———. "A Passionate Pursuit: Foxhunting as Performance." *Sociological Review* 51, no. 2 (October 2003): 48.

———. "Sensing Nature: Encountering the World in Hunting." *Etnofoor* 18, no. 1 (2005): 15–26.

———. "Unspeakability, Inedibility, and the Structures of Pursuit in the English Foxhunt." In *Representing Animals*, edited by Nigel Rothfels, 139–58. Bloomington: Indiana University Press, 2002.

———. *Wolf*. London: Reaktion, 2012.

Masson, J. Moussaieff, and Susan McCarthy. *When Elephants Weep: The Emotional Lives of Animals*. London: Vintage, 1996.

May, Shaun. "Abject Metamorphosis and Mirthless Laughter." *Performance Research* 19, no. 1 (2014): 72–80. https://doi.org/10.1080/13528165.2014.908086.

May, Theresa J. "Beyond Bambi: Toward a Dangerous Ecocriticism in Theatre Studies." *Theatre Topics* 17, no. 2 (2007): 95–110.

McConachie, Bruce. "An Evolutionary Perspective on Play, Performance, and Ritual." *TDR: The Drama Review* 55, no. 4 (2011): 33–50.

McGrew, W. C. *The Cultured Chimpanzee: Reflections on Cultural Primatology*. Cambridge: Cambridge University Press, 2004.

McHugh, Susan. "'A Flash Point in Inuit Memories': Endangered Knowledges in the Mountie Sled Dog Massacre." *ESC: English Studies in Canada* 39, no. 1 (2013): 149–75.

———. "Video Dog Star: William Wegman, Aesthetic Agency, and the Animal in Experimental Video Art." *Society and Animals* 9, no. 3 (2001): 229–51. https://doi.org/10.1163/156853001753644390.

Medeiros, Paulo. "Simian Narratives at the Intersection of Science and Literature." *Modern Language Studies* 23, no. 2 (Spring 1993): 59–73.

Merleau-Ponty, Maurice. *Phenomenology of Perception*. Edited by Donald A. Landes. London: Routledge, 2010.

Messiaen, Olivier. *Traité de rythme, de couleur, et d'ornithologie (1949–92)*. Completed by Yvonne Loriod. 7 parts in 8 vols. Paris: Leduc, 1994–2002.

Messiaen, Olivier, Jean Boivin, and Arthur Goldhammer. "Bird Music." *Grand Street*, no. 55 (Winter 1996): 134–39.

Michel, George F., and Celia L. Moore. *Developmental Psychobiology: An Interdisciplinary Science*. Cambridge: MIT Press, 1995.

Middlebrook, Martin, and Chris Everett. *The Bomber Command War Diaries: An Operational Reference Book, 1939–45*. Harmondsworth, UK: Viking, 1985.

Midgley, Mary. *Beast and Man: The Roots of Human Nature*. Routledge Classics. London: Routledge, 2009.

Mieszkowski, Jan. "Kafka Live!" *MLN* 116, no. 5 (2001): 979–1000.

Miller, Greg. "Mirror Neurons may Help Songbirds Stay in Tune." *Science* 319, no. 5861 (2008): 269–69.

Mills, Steve. *Auditory Archaeology: Understanding Sound and Hearing in the Past*. London: Routledge, 2014.

Mitchell, Robert W., Nicholas S. Thompson, and H. Lyn Miles. *Anthropomorphism, Anecdotes, and Animals*. SUNY Series in Philosophy and Biology. Albany: State University of New York Press, 1997.

Mok, Christine. "Theatre-ologies." *PAJ: A Journal of Performance and Art* 34, no. 3 (2012): 105–10.

Montelle, Yann-Pierre. *Palaeoperformance: The Emergence of Theatricality as Social Practice*. Calcutta: Seagull Books, 2009.

Morgan, Susan and Joan Jonas. *Joan Jonas: I Want to Live in the Country (and Other Romances)*. One Work. London: Afterall Books, 2006.

Morris, Paul, Margaret Fidler, and Alan Costall. "Beyond Anecdotes: An Empirical Study of 'Anthropomorphism.'" *Society and Animals* 8, no. 2 (2000): 151–65.

Morton, Timothy. "Ecologocentrism: Unworking Animals." *Substance* 37, no. 3 (2008): 73–96.

Mullan, B., and Marvin, G. *Zoo Culture*. Edited by Marvin, Garry. 2nd ed. Urbana: University of Illinois Press, 1999.

Mullarkey, John. "Animal Spirits: Philosomorphism and the Background Revolts of Cinema." *Angelaki: Journal of the Theoretical Humanities* 18, no. 1 (2013): 11–29.

Mullin, Molly. "Animals and Anthropology." *Society and Animals* 10, no. 4 (2002): 387–93. https://doi.org/10.1163/156853002320936854.

Mundy, Rachel. "Birdsong and the Image of Evolution." *Society and Animals* 17, no. 3 (2009): 206–23. https://doi.org/10.1163/156853009X445389.

Murray Schafer, R. *The Soundscape: Our Sonic Environment and the Tuning of the World*. Rochester, VT: Destiny Books, 1994.

Mynott, Jeremy. *Birdscapes: Birds in our Imagination and Experience*. Princeton: Princeton University Press, 2009.

Nagel, Thomas. "What Is It Like to Be a Bat?" *Philosophical Review* 83, no. 4 (October 1974): 435–50.

Nancy, Jean-Luc. *Being Singular Plural*. Stanford: Stanford University Press, 2000.

———. *Corpus*. New York: Fordham University Press, 2008.

———. *The Inoperative Community*. Minneapolis: University of Minnesota Press, 1991.

———. *Listening*. Translated by Charlotte Mandell. New York: Fordham University Press, 2007.

Nelson, Amy. "The Legacy of Laika." In *Beastly Natures: Animals, Humans, and the Study of History*, edited by Dorothea Brantz, 204–24. Charlottesville: University of Virginia Press, 2010.

Newton, Michael. *Savage Girls and Wild Boys: A History of Feral Children*. London: Faber and Faber, 2002.

Nietzsche, Friedrich Wilhelm. *The Birth of Tragedy*. Translated by Douglas Smith. Oxford World's Classics. Oxford: Oxford University Press, 2000.

Novak, Jelena. "Throwing the Voice, Catching the Body: Opera and Ventriloquism in Philip Glass / Jean Cocteau's 'La Belle et la Bête.'" *Music, Sound, and the Moving Image* 5, no. 2 (2011): 137–56.

Oliver, Kelly. *Animal Lessons: How They Teach Us to Be Human*. New York: Columbia University Press, 2009.

O'Neill, Eugene. *Ah, Wilderness! and Other Plays*. Harmondsworth, UK: Penguin, 1960.

Ong, Walter J. *The Barbarian Within and Other Fugitive Essays and Studies*. New York: Macmillan, 1962.

Orozco García, Lourdes. *Theatre and Animals*. Theatre&. Houndmills, UK: Palgrave Macmillan, 2013.

Orton, David. "Both Subject and Object: Herding, Inalienability and Sentient Property in Prehistory." *World Archaeology* 42, no. 2 (June 2010): 188–200.

Overton, Nick J., and Y. Hamilakis. "A Manifesto for a Social Zooarchaeology: Swans and Other Beings in the Mesolithic." *Archaeological Dialogues* 20, no. 2 (2013): 111–36.

Page, Tony. *Vivisection Unveiled: An Expose of the Medical Futility of Animal Experimentation*. Charlbury: Jon Carpenter, 1997.

Pardo, Enrique. "Figuring Out the Voice: Object, Subject, Project." *Performance Research* 8, no. 1 (2003): 41.

Parker-Starbuck, Jennifer. "Animal Ontologies and Media Representations: Robotics, Puppets, and the Real of War Horse." *Theatre Journal* 65, no. 3 (2013): 373–93.

———. "Becoming-Animate: On the Performed Limits of 'Human.'" In "Film and Theatre." Special issue, *Theatre Journal* 58, no. 4 (December 2006): 649–68.

———. *Cyborg Theatre: Corporeal/Technological Intersections in Multimedia Performance*. Basingstoke, UK: Palgrave Macmillan, 2011.

———. "Diagnosing the Symptoms of a Culture of Excess." *Women and Performance* 18, no. 2 (2008): 133–51. https://doi.org/10.1080/07407700802107044.

———. "The Spectator and Her Double: Seeing Performance Through the Eyes of Another." *Theatre Topics* 24, no. 2 (2014): 125–36.

———. "The Spectatorial Body in Multimedia Performance." *PAJ: A Journal of Performance and Art* 33, no. 99 (2011): 60–71.

Patel, Aniruddh D., John R. Iversen, and Jason C. Rosenberg. "Comparing the Rhythm and Melody of Speech and Music: The Case of British English and French." *Journal of the Acoustical Society of America* 119, no. 5 (2006): 3034–47. https://doi.org/10.1121/1.2179657.

Peckham, Morse. *Romanticism and Ideology*. Hanover: University Press of New England for Wesleyan University Press, 1995.

Pedersen, Morten A. "Totemism, Animism and North Asian Indigenous Ontologies." *Journal of the Royal Anthropological Institute* 7, no. 3 (September 2001): 411–27.

Perkins, Judith. "Animal Voices." *Religion and Theology* 12, no. 3 (2005): 385–96.

Pfeiffer, John. E. *The Creative Explosion*. New York: Harper and Row, 1982.

Phelan, Peggy. *Unmarked: The Politics of Performance*. London: Routledge, 1992.

Phillips, Adam. *Terrors and Experts*. Cambridge: Harvard University Press, 1996.

Philo, Chris, and Chris Wilbert, eds. *Animal Spaces, Beastly Places: New Geographies of Human-Animal Relations*. Critical Geographies. London: Routledge, 2000.

Pick, Anat. *Creaturely Poetics: Animality and Vulnerability in Literature and Film*. New York: Columbia University Press, 2011.

Plato. *The Republic*. Translated by H. D. P. Lee. Hamondsworth, Middlesex: Penguin, 1972.

Poizat, Michel. *The Angel's Cry: Beyond the Pleasure Principle in Opera*. Ithaca: Cornell University Press, 1992.

Polzonetti, Pierpaolo. "Tartini and the Tongue of Saint Anthony." *Journal of the American Musicological Society* 67, no. 2 (Summer, 2014): 429–86.

Pomerance, Bernard. *The Elephant Man: A Play*. New York: Grove Press, 1979.

Pradier, Jean-Marie. "Animals, Angel and Performance." *Performance Research* 5, no. 2 (Summer 2000): 11.

Praz, Mario. *The Romantic Agony*. New York: Meridian, 1960.

Raleigh, Michael J., and Michael T. McGuire. "Animal Analogues of Ostracism: Biological Mechanisms and Social Consequences." *Ethology and Sociobiology* 7, nos. 3–4 (1986): 201–14.

Ramachandran, Vilayanur. "Mirror Neurons and Imitation Learning as the Driving Force Behind 'the Great Leap Forward' in Human Evolution." Edge Foundation, May 31, 2000. https://www.edge.org/conversation/mirror-neurons-and-imitation-learning-as-the-driving-force-behind-the-great-leap-forward-in-human-evolution.

Ramachandran, V[ilayanur]. S., and British Broadcasting Corporation. *The*

Emerging Mind: The Reith Lectures 2003. London: Profile, 2003.

Raphael, Max. *Prehistoric Cave Paintings*. Edited by Norbert Guterman. Translated by Norbet Guterman. Bollingen Series 4. New York: Pantheon Books, 1946.

Read, Alan. "Acknowledging the Imperative of Performance in the Infancy of Theatre." *Performance Research* 5, no. 2 (Summer 2000): 61.

———. *Theatre and Everyday Life: An Ethics of Performance*. New ed. London: Taylor & Francis, 1995.

Ridout, Nicholas Peter. *Stage Fright, Animals, and Other Theatrical Problems*. Cambridge: Cambridge University Press, 2006.

———. *Theatre and Ethics*. New York: Palgrave Macmillan, 2009.

Rilke, Rainer Maria. *The Selected Poetry of Rainer Maria Rilke*. Edited and translated by Stephen Mitchell. Introduction by Robert Hass. London: Picador, 1982.

Rilling, James K. "Neuroscientific Approaches and Applications Within Anthropology." *American Journal of Physical Anthropology* 137, no. S47 (2008): 2–32. https://doi.org/10.1002/ajpa.20947.

Risi, Clemens. "Opera in Performance—In Search of New Analytical Approaches." *Opera Quarterly* 27, no. 2 (2011): 283–95.

Ritvo, Harriet. "Our Animal Cousins." *Differences: A Journal of Feminist Cultural Studies* 15, no. 1 (2004): 48–68.

Roach, Joseph. "Performance: The Blunders of Orpheus." *PMLA* 125, no. 4 (2010): 1078–86.

Rodriguez-Pereyra, Gonzalo. "What Is the Problem of Universals?" *Mind* 109, no. 434 (April 2000): 255–73.

Rollin, Bernard E. *The Unheeded Cry: Animal Consciousness, Animal Pain and Science*. New York: Oxford University Press, 1990.

Root-Bernstein, Meredith. "A Bird in the Microcosm: An Environment of Found Objects Constructed to Create Arbitrary Preferences in Starlings." *Leonardo* 41, no. 5 (2008): 506–7.

Rosmini, Antonio. *Psychology*. Vol. 3, *Laws of Animality*. Durham: Rosmini House, 1999.

Rothenberg, David. "David Rothenberg Searches for the Elusive Lyrebird." *World Literature Today* 80, no. 1 (January–February 2006): 29–31.

———. "Whale Music: Anatomy of an Interspecies Duet." *Leonardo Music Journal* 18, no. 1 (2008): 47–53.

———. *Why Birds Sing: One Man's Quest to Solve an Everyday Mystery*. New York: Basic Books, 2006.

Rothfels, Nigel. *Representing Animals*. Theories of Contemporary Culture 26. Bloomington: Indiana University Press, 2002.

Rundle, Erika. "Caliban's Legacy: Primate Dramas and the Performance of Species." *TDR: The Drama Review* 51, no. 1 (2007): 49–62.

———. "The Hairy Ape's Humanist Hell: Theatricality and Evolution in O'Neill's 'Comedy of Ancient and Modern Life.'" *Eugene O'Neill Review* 30 (2008): 48–144.

———. "'The Monkey Problem': Notes on Staging *The Ape*." *Eugene O'Neill Review* 31 (2009): 122–49.

Rush, Michael. "A Noisy Silence." *PAJ: A Journal of Performance and Art* 21, no. 1 (January 1999): 2–10.

Ryder, Richard D. *Animal Revolution: Changing Attitudes Toward Speciesism*. Rev. and updated ed. Oxford: Berg, 1999.

Sampson, Fiona. "The Myth Kitty—Interview with David Harsent." In *The Minotaur*. London: Royal Opera House, 2013.

Schaeffer, Pierre. *In Search of a Concrete Music*. Oakland: University of California Press, 2013.

Schechner, Richard. "Behavior, Performance, and Performance Space." In

"Theater, Theatricality, and Architecture." Special issue, *Perspecta* 26 (1990): 97–102.

———. *Between Theater and Anthropology.* Philadelphia: University of Pennsylvania Press, 1985.

———. *Dionysus in 69.* New York: Farrar, Straus and Giroux, 1970.

———. "The End of Humanism." In "The American Imagination: A Decade of Contemplation." Special issue, *Performing Arts Journal* 4, nos. 1/2 (May 1979): 9–22.

———. *Future of Ritual: Writings on Culture and Performance.* London: Routledge, 1993.

———. "Happenings." *Tulane Drama Review* 10, no. 2 (Winter 1965): 229–32.

———. *Performance Studies: An Introduction.* 2nd ed. New York: Routledge, 2006.

———. "Performance Studies: The Broad Spectrum Approach." *TDR: The Drama Review* 32, no. 3 (Autumn 1988): 4–6.

———. *Performance Theory.* Rev. and exp. ed. London: Routledge, 2003.

———. "Performers and Spectators Transported and Transformed." *Kenyon Review* 3, no. 4 (Autumn 1981): 83–113.

———. "Speculations on Radicalism, Sexuality, and Performance." In "Politics and Performance." Special issue, *TDR: The Drama Review* 13, no. 4 (Summer 1969): 89–110.

———. "Who Killed Cock Robin?" In "Post War Italian Theatre." Special issue, *Tulane Drama Review* 8, no. 3 (Spring 1964): 11–14.

Schellekens, Elisabeth. *Aesthetics and Morality.* Continuum Aesthetics. London: Continuum, 2007.

Schimmel, Paul, Kristine Stiles, and Museum of Contemporary Art. *Out of Actions: Between Performance and the Object, 1949–1979.* Los Angeles: The Museum of Contemporary Art; New York: Thames and Hudson, 1998.

Schneider, Arnd, and Christopher Wright. *Between Art and Anthropology: Contemporary Ethnographic Practice.* Oxford: Berg, 2010.

Schneider, Rebecca. "Performance Remains." *Performance Research: A Journal of the Performing Arts* 6, no. 2 (2001): 100–108.

———. *Performing Remains: Art and War in Times of Theatrical Reenactment.* Abingdon, UK: Routledge, 2011.

Scholtmeijer, Marian. "'What Is 'Human'? Metaphysics and Zoontology in Flaubert and Kafka." In *Animal Acts: Configuring the Human in Western History,* edited by Jennifer Ham and Matthew Senior, 127–43. London: Routledge, 1997.

Scully, Matthew. *Dominion: The Power of Man, the Suffering of Animals, and the Call to Mercy.* New York: St. Martin's Griffin, 2002.

Sebeok, Thomas A. "Animal Communication." *Science* 147, no. 3661 (February 26, 1965): 1006–14.

———. "Zoosemiotics." *American Speech* 43, no. 2 (May 1968): 142–44.

Seckerson, Edward. Review of *A Dog's Heart,* by Alexander Raskatov, directed by Simon McBurney, English National Opera. *Independent,* November 21, 2010. http://www.independent.co.uk /arts-entertainment/classical/reviews /raskatov-a-dogs-heart-english -national-opera-2140048.html. Accessed November 28, 2010.

Serjeantson, Richard. "The Passions and Animal Language, 1540–1700." *Journal of the History of Ideas* 62, no. 3 (2001): 425–44.

Serpell, James A. "Anthropomorphism and Anthropomorphic Selection—Beyond the 'Cute Response.'" *Society and Animals* 11, no. 1 (2003): 83–100. https://doi .org/10.1163/156853003321618864.

Shaffrey, Cliodhna. "Through a Glass Darkly." *Irish Arts Review* 27, no. 3 (2010): 78–81.

Shannon, Laurie. "Poor, Bare, Forked: Animal Sovereignty, Human Negative Exceptionalism, and the Natural History of King Lear." *Shakespeare Quarterly* 60, no. 2 (2009): 168–96.

Shukin, Nicole. *Animal Capital: Rendering Life in Biopolitical Times.* Minneapolis: University of Minnesota Press, 2009.

———. "Security Bonds: On Feeling Power and the Fiction of an Animal Governmentality." *ESC: English Studies in Canada* 39, no. 1 (2013): 177–98.

Silverman, Julian. "Shamans and Acute Schizophrenia." *American Anthropologist* 69, no. 1 (1967): 21–31.

Simmons, J. L. "The Tongue and Its Office in the Revenger's Tragedy." *PMLA* 92, no. 1 (January 1977): 56–68.

Singer, Peter. *Animal Liberation.* 2nd ed. London: Pimlico, 1995.

Smart, Mary Ann. "Defrosting Instructions: A Response." *Cambridge Opera Journal* 16, no. 3, Performance Studies and Opera (November 2004): 311–18.

Spielmann, Yvonne. *Leonardo* 34, no. 3 (2001): 277–79.

Spitz, René A. "The Primal Cavity: A Contribution to the Genesis of Perception and Its Role for Psychoanalytic Theory." *Psychoanalytic Study of the Child* 10 (1955): 215–40.

Starobinski, Jean. *Jean-Jacques Rousseau, Transparency and Obstruction.* Translated by Arthur Goldhammer. Chicago: University of Chicago Press, 1988.

States, Bert O. "The Dog on the Stage: Theater as Phenomenon." In "On Convention: II." Special issue, *New Literary History* 14, no. 2 (Winter 1983): 373–88.

Steintrager, James A. "Humanity Gone Wild." *Eighteenth-Century Studies* 38, no. 4 (Summer 2005): 681–86.

Stibbe, Arran. "Language, Power and the Social Construction of Animals." *Society and Animals* 9, no. 2 (2001): 145–61. https://doi.org/10.1163/15685300175363925l.

Stine, Peter. "Franz Kafka and Animals." *Contemporary Literature* 22, no. 1 (Winter 1981): 58–80.

Strum, Shirley C., and Linda Marie Fedigan. *Primate Encounters: Models of Science, Gender, and Society.* Chicago: University of Chicago Press, 2000.

Stuckrad, Kocku von. "Reenchanting Nature: Modern Western Shamanism and Nineteenth-Century Thought." *Journal of the American Academy of Religion* 70, no. 4 (December 2002): 771–99.

Sumner, Alaric. "Monkey Theatre (1972)." *Performance Research* 5, no. 1 (Spring 2000): 74.

Szerszynski, Bronislaw, Wallace Heim, and Claire Waterton, eds. *Nature Performed: Environment, Culture and Performance.* Edited by Bronislaw Szerszynski, Wallace Heim, and Claire Waterton. The Sociological Review Monographs. Oxford: Blackwell, 2003.

Taussig, Michael T. "Dying Is an Art, Like Everything Else." In "Things." Special issue, *Critical Inquiry* 28, no. 1 (Autumn 2001): 305–16.

———. *Mimesis and Alterity: A Particular History of the Senses.* New York: Routledge, 1993.

———. *Shamanism, Colonialism, and the Wild Man: A Study in Terror and Healing.* Chicago: University of Chicago Press, 1991.

Taylor, Diana. *The Archive and the Repertoire: Performing Cultural Memory in the Americas.* Durham: Duke University Press, 2003.

Teevan, Colin, Franz Kafka, and Young Vic Theatre Company. *Kafka's Monkey.* Oberon Modern Plays. London: Oberon Books, 2009.

Toadvine, Ted. "Ecological Aesthetics." In *Handbook of Phenomenological Aesthetics,* edited by H. R. Sepp and L. Embree, 85–91. Contributions of Phenomenology 59. Dordecht, Netherlands: Spinger, 2010.

———. "'Strange Kinship': Merleau-Ponty on the Human–Animal Relation." In *Phenomenology of Life from the Animal Soul to the Human Mind*, book 1, *In Search of Experience*, edited by Anna-Teresa Tymieniecka, 17–32. Analecta Husserliana 93. Dordecht, Netherlands: Springer, 2007.

Tomasello, Michael. *Origins of Human Communication*. The Jean Nicod Lectures. Cambridge: MIT Press, 2008.

Tomlinson, Gary. *Metaphysical Song: An Essay on Opera*.

Toop, David. "Sound Body: The Ghost of a Program." *Leonardo Music Journal* 15, no. 1 (2005): 28–35.

Trainor, J. "Celeste Boursier-Mougenot." *Frieze*, no. 64 (January–February 2002). https://frieze.com/article/celeste -boursier-mougenot. Accessed May 11, 2020.

Turk, Matija, , Ivan Turk, Ljuben Dimkaroski, Bonnie A. B. Blackwell, Francois Zoltan Horusitzky, Marcel Otte, Giuliano Bastiani, Lidija Korat, "The Mousterian Musical Instrument from the Divje Babe I Cave (Slovenia): Arguments on the Material Evidence for Neanderthal Musical Behaviour." *L'anthropologie* 122, no. 4 (2018): 589–708.

Tuzin, Donald, John Blacking, Deborah Gewertz, José Jorge de Carvalho, Jaan Kaplinski, Henry Kingsbury, Mahesh C. Pradhan, Ruth Caro Salzberger, Geoffrey Samuel, and Michael W. Young. "Miraculous Voices: The Auditory Experience of Numinous Objects" (with comments and replies). *Current Anthropology* 25, no. 5 (December 1984): 579–96.

Umiker-Sebeok, Jean and Thomas A. Sebeok. "Clever Hans and Smart Simians: The Self-Fulfilling Prophecy and Kindred Methodological Pitfalls." *Anthropos* 76, nos. 1/2 (1981): 89–165.

Verwoert, Jan. "The Boss: On the Unresolved Question of Authority in Joseph Beuys' Oeuvre and Public Image." *Eflux Journal* 1 (2008).

Viveiros de Castro, Eduardo. "Cosmological Deixis and Amerindian Perspectivism." *Journal of the Royal Anthropological Institute* 4, no. 3 (September 1998): 469–88.

———. "Exchanging Perspectives: The Transformation of Objects into Subjects in Amerindian Ontologies." *Common Knowledge* 10, no. 3 (2004): 463–84.

Waal, Franz de. *The Ape and the Sushi Master: Cultural Reflections by a Primatologist*. New York: Basic Books, 2001.

———. "Joint Ventures Require Joint Payoffs: Fairness Among Primates." *Social Research: An International Quarterly* 73, no. 2 (2006): 349–64.

Wallis, Robert J. "Queer Shamans: Autoarchaeology and Neo-Shamanism." In "Queer Archaeologies." Special issue, *World Archaeology* 32, no. 2 (October 2000): 252–62.

———. *Shamans/Neo-Shamans: Ecstasy, Alternative Archaeologies, and Contemporary Pagans*. London: Routledge, 2003.

Walters, Michael. *A Concise History of Ornithology*. New Haven: Yale University Press, 2003.

Walters, Victoria. "The Artist as Shaman: The Work of Joseph Beuys and Marcus Coates." In *Between Art and Anthropology: Contemporary Ethnographic Practice*, edited by Arnd Schneider and Christopher Wright, 35–47. Oxford: Berg, 2010.

Warr, Tracey, and Amelia Jones, eds. *The Artist's Body: Themes and Motives*. London: Phaidon, 2000.

Welberg, Leonie. "Mirror Neurons: Singing in the Brain." *Nature Reviews Neuroscience* 9, no. 3 (2008): 163. https://doi.org /10.1038/nrn2340.

Wheeler, Wendy. "Delectable Creatures and the Fundamental Reality of Metaphor: Biosemiotics and Animal Mind." *Biosemiotics* 3, no. 3 (2010): 277–87.

Willerslev, Rane. "Not Animal, Not Not-Animal: Hunting, Imitation and Empathetic Knowledge Among the Siberian Yukaghirs." *Journal of the Royal Anthropological Institute* 10, no. 3 (September 2004): 629–52.

——. *Soul Hunters: Hunting, Animism, and Personhood Among the Siberian Yukaghirs*. Berkeley: University of California Press, 2007.

Willerslev, Rane, Piers Vitebsky, and Anatoly Alekseyev. "Sacrifice as the Ideal Hunt: A Cosmological Explanation for the Origin of Reindeer Domestication." *Journal of the Royal Anthropological Institute* 21, no. 1 (2014): 1–23.

Williams, David. "Inappropriate/d Others; or, The Difficulty of Being a Dog." *TDR: The Drama Review* 51, no. 1 (2007): 92–118.

——. "The Right Horse, the Animal Eye—Bartabas and Théâtre Zingaro." *Performance Research* 5 (2000): 29–40.

Wispé, Lauren. "The Distinction Between Sympathy and Empathy: To Call Forth a Concept, a Word Is Needed." *Journal of Personality and Social Psychology* 50, no. 2 (1986): 314–21. https://doi.org/10.1037/0022-3514.50.2.314.

Witchell, Charles A., *The Evolution of Birdsong*. (1896) Norderstedt, Germany: Hanse Books, 2016.

Wolch, Jennifer R., and Jody Emel, eds. *Animal Geographies: Place, Politics, and Identity in the Nature-Culture Borderlands*. London: Verso, 1998.

Wolfe, Cary. *Animal Rites: American Culture, the Discourse of Species, and Posthumanist Theory*. Chicago: University of Chicago Press, 2003.

——. "From *Dead Meat* to Glow in the Dark Bunnies Seeing 'the Animal Question' in Contemporary Art." *Parallax* 12, no. 1 (January 2006): 95–109. https://doi.org/10.1080/13534640500448775.

——. *Zoontologies: The Question of the Animal*. Minneapolis: University of Minnesota Press, 2003.

Yeon, Seong Chan. "The Vocal Communication of Canines." *Journal of Veterinary Behavior: Clinical Applications and Research* 2, no. 4 (2007): 141–44. https://doi.org/10.1016/j.jveb.2007.07.006.

Zarrilli, Phillip B. "Embodying the Lion's 'Fury.'" *Performance Research* 5, no. 2 (Summer 2000): 41.

Žižek, Slavoj, and Mladen Dolar. *Opera's Second Death*. New York: Routledge, 2002.

acoustics, 2, 8, 26, 36, 89, 97
 becoming, 49
 creatureliness, 3, 19, 23, 32, 39, 46, 75, 153
 instrumentation, 12, 50, 55, 142
 phenomenology, 13, 32, 39
 resonance, 137, 147
 spatiality, 38, 49, 51, 52, 54, 135
acousmatics, 6, 38, 55, 75
 Pythagoras, 39
 ventriloquism, 40
 Schaeffer, Pierre, 38
 Schafer, R. Murray, 38
Allestree, Richard, 120
Aesop, 125–26
Allora, Jennifer and Calzadilla, Guillermo
 Raptor, 40
animals
 apes, 112–27
 birds, 11, 28, 34, 37, 56, 147
 bull, 137, 145
 crocodile, 124
 deer, 50, 71, 75, 137
 dodo, 10
 dogs, 90–107
 finches, 29
 giraffe, 123
 hounds, 52, 90
 leopard, 124
 nightingale, 13, 16
 swans, 25–27, 50, 51, 74
 vultures, 40, 50
 worms, 134–37
 zebra finches, 31
Auslander, Philip, 28
Austin, J.L., 116

Baker, Steve,
 botching, 84, 96
 postmodern animal, 88
Bayly, Simon, 164
 counterlingual, 138

humanesque, 143
 mouth, 131
Barthes, Roland, 110, 117
becoming, 4
 acoustic, 49
 alongside, 58, 60
 animate, 146
 audible, 23
 botched, 84, 86, 125
 canine, 98
 implementation, 83
 lingual, 127, 129
 resonant, 136, 153
becoming-animal, 3, 39, 58, 80, 82, 142
Beuys, Joseph, 63, 76–77
 Coyote, 74
 Dead Hare, 74
 Der Chef, 75
Benjamin, Walter, 108
Beckett, Samuel
 Not I, 130
Boursier-Mougenot, Céleste, 29
 From Ear to Ear, 30
birdsong, 11
 hunting, 56
 mirror neurons, 18
 music, 19, 21, 59
 performance, 27, 33–34, 36
 recording technology, 12, 24, 27, 33
Birtwistle, Harrison, 144
 The Minotaur, 146–48, 150–51
 The Second Mrs Kong, 151
Braidotti, Rosi, 142–43
Brugnoli, Annalisa, 115
Broglio, Ron, 34
British Union Against Vivisection, BUAV,
 99
Bulgakov, Michael, 89
 A Dog's Heart, 88
Butler, Judith, 103

Cattivelli, Daniela, 6, 36, 55–60
 chioccolatori, 39, 55, 57
 Garrulus glandarius, 59
 UIT, 55
 Birds, Bonn, 1964, 36
Cage, John, 136
Caillois, Roger, 70
Camper, Petrus, 120
chioccolatori, 6, 36, 57
 art of chioccolo, 42
 Sacile competition, 42
 hunting, 43, 55
Coates, Marcus, 62, 71, 77
 Dawn Chorus, 32–34, 64
 Finfolk, 84–86
 Journey to the Lower World, 63
 Radio Shaman, 62
Colebrook, Claire, 83
Committee Against Bird Slaughter, CABS,
 45
Complicité, puppetry, 88
Connor, Steven, 39
 ventriloquial body, 11, 33, 152
 ventriloquism, 40–41

Danta, Chris, 125–26

Darwin, Charles, 25, 112, 114, 126, 127
Delibes, Léo
 Lakmé, 103
Descartes, René, 82, 119, 152
Dillard-Wright, David B.
 extra-human communication, 111–12
Deleuze, Gilles and Guattari, Felix
 becoming, 3, 4
 becoming-animal, 3, 16, 39, 76
 botching, 72
 deterritorialization, 4, 39, 85, 86, 130,
 135, 142
 Kafka, 130
 labyrinth, 152
 lines of flight, 81, 130
 mutliplicities of selfhood, 6, 62, 146
 rhizome, 3, 81
 schizophrenia, 77–81
 Thousand Plateaus, A, 3
Derrida, Jacques
 anthropological machine, 126

carnophallogocentrism, 48, 59
dogs
 Carlo, 95
 Crab, 90, 94
 Flush,100
 Laika, 106
 Moustache, 95
 Sharik, 87–88, 102–3, 108
 Snuppy, 107
Dog's Heart, A
 novella, 7, 88, 98
 opera, 7, 88–90, 100–102, 105, 108–9
Dolar, Mladen, 41, 97, 98, 141, 144
Dobson, Michael, 91, 93, 94
Duncan, Michelle, 136, 146, 152

Eliade, Michel, 23, 79, 115
English National Opera, 88
ethics of artists, 4, 108
ethnomusicology, 49

Fenwick, Elizabeth, 95
Felman, Shoshana, 103
Feldman, Martha, 148
Flaubert, Gustave, 86
 St. Anthony, 71
 Djalioh, 116
Forsythe, William
 Birds, Bonn, 1964, 36
Fox, Anselmo
 La Lingua della lingua, 124
Fudge, Erica, 90, 109

Guattari, Félix
 and La Borde, 79
 See also Deleuze

Haraway, Donna J.
 animal killing, 43
 companionship, 106
 laboratory dogs, 107
Harrison, Jane Ellen
 Siren myth, 70
Heidegger, Martin
 Dabeisein, 54
 Dasein, 53
Harsent, David, 145, 150
Howell, Yvonne, 100–101

Hunter, Kathryn, 7, 127, 128, 131
Hunting
 activism, 45
 birds, 37, 42, 44
 bone flutes, 49
 elk, 66–68
 ethics, 46
 foxes, 52–53
 mimesis, 44
 Paleolithic, 47–48, 49
 performance, 5–6, 38, 43, 52
 poaching, 45
 techniques, 50, 51

Idhe, Don
 listening intentionally, 30
 phenomenology of voice, 44

Järivö, Päivi, 139, 153

Kafka, Franz
 freedom, 83, 96–98, 116–17, 130
 Investigations of a Dog, 96–98
 Metamorphosis, The, 129, 130
 Report to an Academy, 116, 127, 128

Lawlor, Leonard, 82, 83
Lingis, Alphonso, 60
Linneaus, Carolus, 119
Lippit, Akira Mizuta, 130

Maher, Alice
 Cassandra's Necklace, 122
Marvin, Garry
 foxhunting, 5, 53
 hunting as performance, 51, 53
 hound music, 52
Messiaen, Olivier, 19
 Abyss of the Birds, 20
 Catalogue of the Birds, 21
 synesthesia, 21
 sound technology, 23
mimicry, 21
 apes, 119
 camouflage, 70–71
 hunting, 56, 66, 68
 mimesis, 44
 performance, 36, 64, 85

Magnum, Theresa, 99
Montelle, Yann-Pierre
 Paleolithic culture, 46
 paleoperformance, 48
 bone flutes, 50
 bull roarer, 49
Mullarney, Janet
 Cortocircutio, 37
Mundy, Rachel
 spectrograph, 28

Nancy, Jean-Luc
 listening, 23, 35

Ong, Walter J., 103
O'Neill, Eugene
 The Hairy Ape, 112–15

Parker-Starbuck, Jennifer
 becoming-animate, 140

Poizat, Michel, 103

Raskatov, Alexander
 A Dog's Heart, 87–89, 102–3, 108–9
Rautavaara, Einojuhani
 Cantus Articus, 25, 26
Ridout, Nicholas, 108
Rothenberg, David, 19, 20
Roach, Joseph, 37, 42
Rundle, Erica, 114
 primate drama, 112, 115

Schizophrenia, 62, 71
 philosophy, 80
 shamanism, 77, 79–81
Schechner, Richard, 46, 23n157
Schneider, Rebecca, 153
Shamanism, 73
 animal spirits, 61, 68, 85
 Beuys, 74
 Coates, 63, 77
 Deleuze and Guattari, 77, 79
 neo-shamanism, 78
 See also Schizophrenia

Shukin, Nicole
 biopower, 44, 45

Shakespeare, William
 Two Gentlemen of Verona, 90
 King Lear, 92–93
States, Bert O., 93

Taussig, Michael, 44
Teevan, Colin
 Kafka's Monkey, 116, 131
Tomlinson, John, 144, 146
tongue
 babble, 85, 147, 150
 barbarian, 103
 foul, 101
 food, 125
 mother tongue, 17, 123
 mediating muscle, 110, 131
 organ, 93, 117, 120
 physiology, 120
 prop, 123
 spitting, 129
 St. Anthony of Padua, 121
 sculpture, 123, 124, 125
 veneration, 122
Tulp, Nicholas, 118
Tuzin, Donald, 138
Tyson, Edward, 118

Vivieros de Castro, Eduardo
 animism, 70
 multinaturalism, 69
 perspectivism, 69
 shamanism, 69
Voice
 bass, 33, 52, 144
 castrato, 147–49
 countertenor, 88, 102, 147
 creatureliness, 142
 choir, 33
 female voice, 57
 instrument, 138, 139, 140
 larynx, 120
 machine, 140
 operatic voice, 141
 singing, 32, 33, 41, 43, 58, 152
 Sirens, 57–58
 speech, 131, 127, 104
 species difference, 112, 127
 soprano, 141
 technology, 12, 29, 33
 ventriloquism
 vocalic body, 139, 152

White, Pae
 Fare Mondi/Making Worlds, 37
Willerslev, Rane
 animism, 68
 elk hunting, 67
 shamanism, 70
 Yukaghir, 66–70

Yoo, Doo Sung
 Organ-Machine Hybrid, 123
Youngs, Amy
 Interestrial Soundings, 134

Zehnder, Christian
 Stimmhorn, 144
zooarchaeology, 2, 47, 48, 55
zoomusicology, 2, 19, 23, 26, 34, 48
 Martinelli, Dario, 12, 17
 Ulrich, Martin, 12

Printed in the United States
by Baker & Taylor Publisher Services